MW01119253

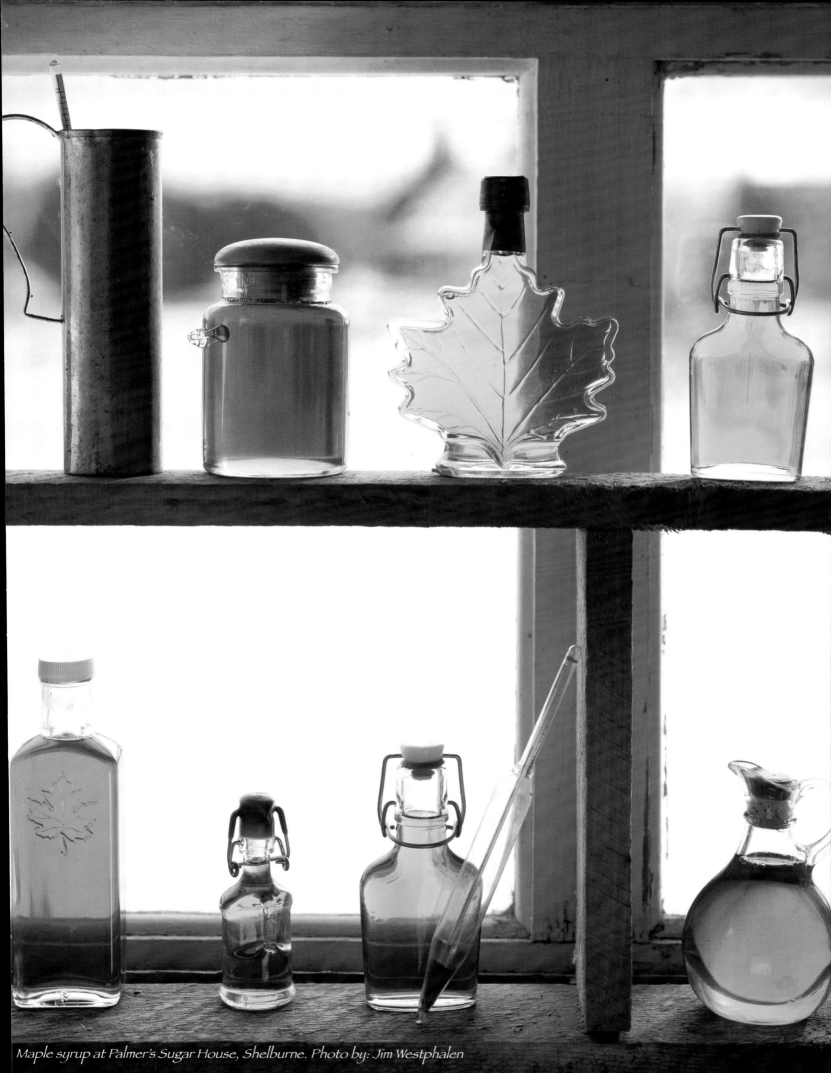

Maple syrup at Palmer's Sugar House, Shelburne. Photo by: Jim Westphalen

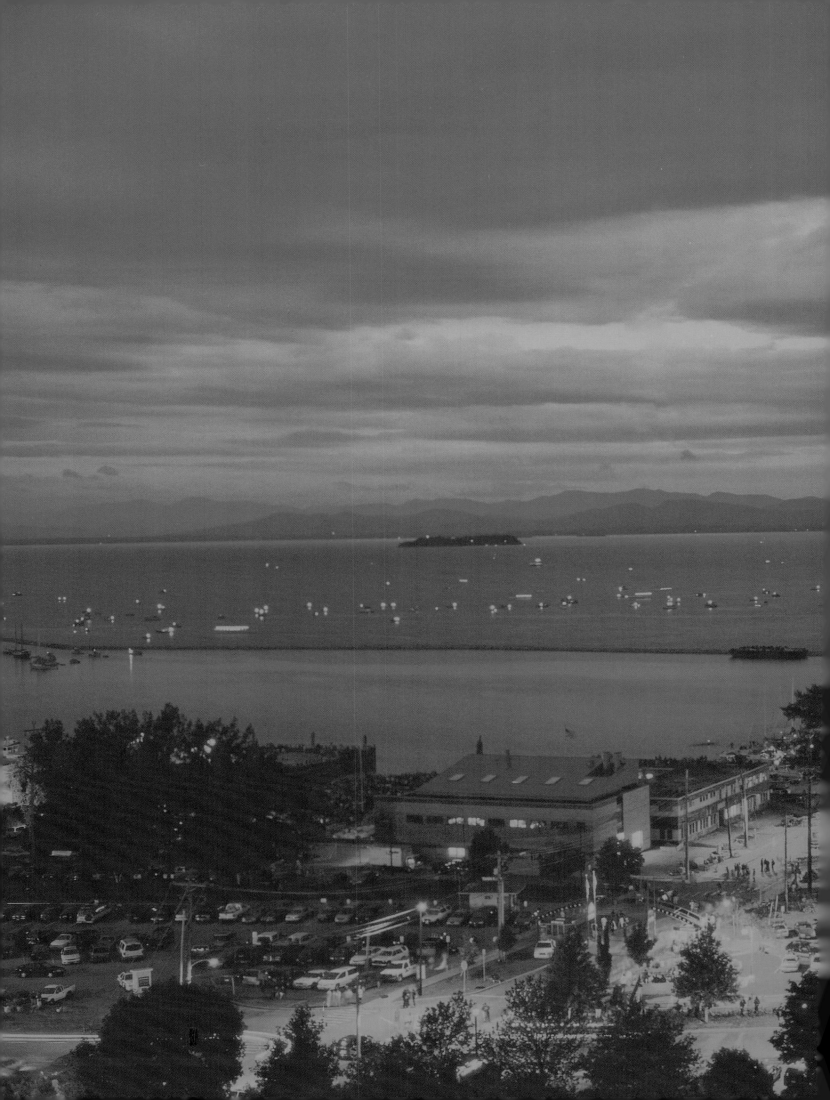

Lake Champlain Visions

Early evening overlooking Lake Champlain and the Burlington waterfront.
Photo by: Jim Westphalen

Lake Champlain Visions

By
Senator Patrick Leahy

Stephen Hung, Publisher

Staff for *Lake Champlain Visions*
Art Director: Thad Pickett
Managing Editor: Julie Clark
Sales Manager: Henry Hintermeister
Profile Writer: Mary D. Chaffee
Photo Editor: Steve Mease

PAGODA GROUP
PUBLISHING SOLUTIONS
Needham, Massachusetts

© 2004 Pagoda Group
All Rights Reserved

First Edition
ISBN: 0-9759736-0-6

Every effort has been made to ensure the accuracy of the informations herein. However, the author and Pagoda Group are not responsible for any errors or omissions which might have occurred.

A perfect autumn day in Stowe. Photo by: Jim Westphalen

CITYSCAPES
SERIES

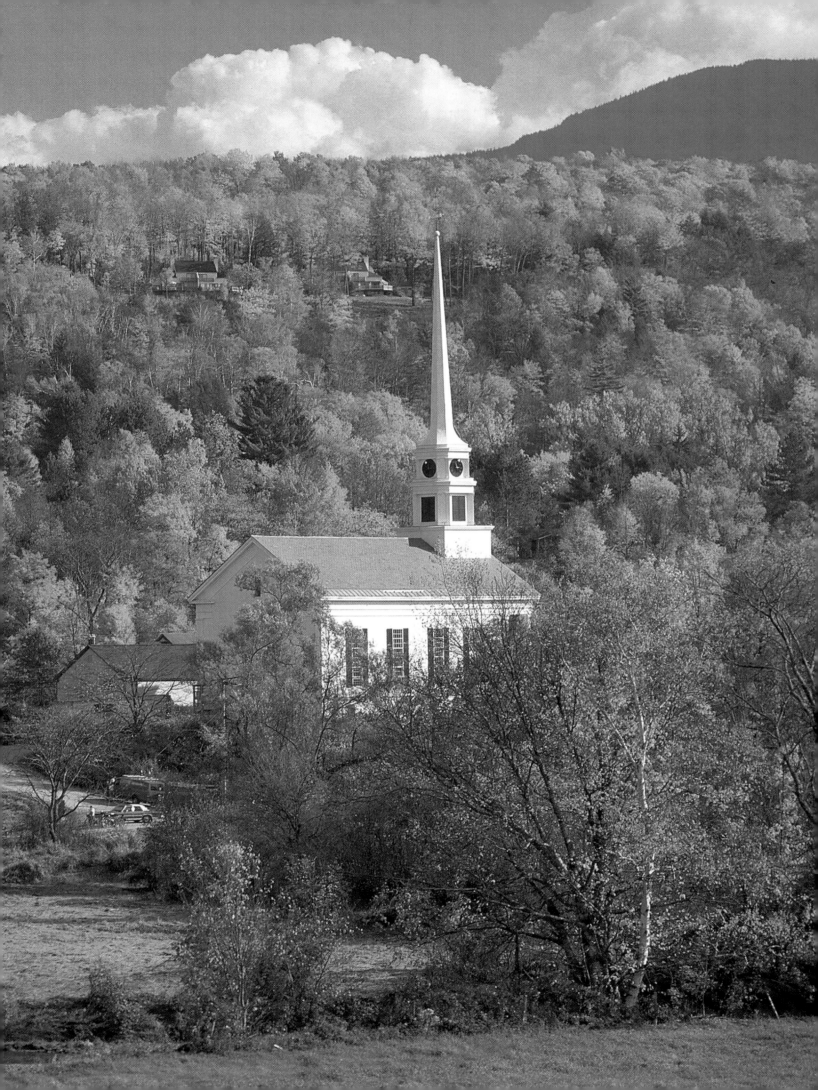

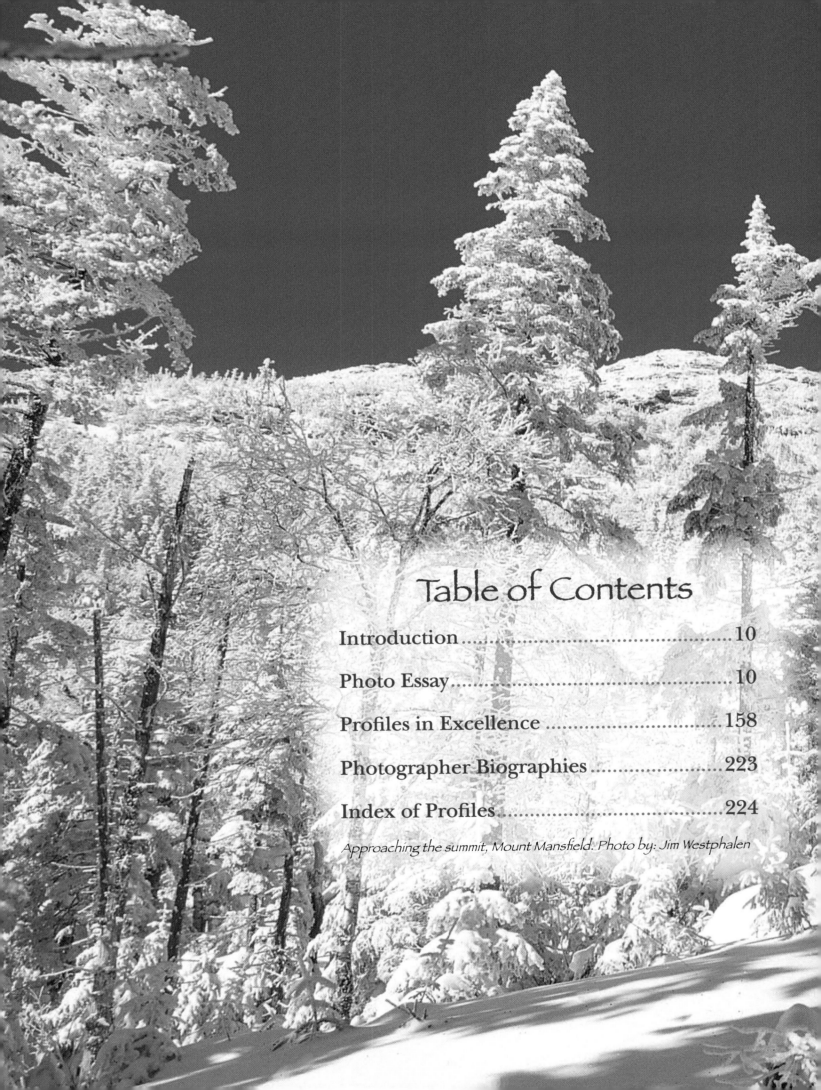

Table of Contents

Introduction ... 10

Photo Essay ... 10

Profiles in Excellence 158

Photographer Biographies 223

Index of Profiles 224

Approaching the summit, Mount Mansfield. Photo by: Jim Westphalen

Champlain Valley Balloon Festival, Essex Fairgrounds. Photo by: Jim Westphalen

We're not in Kansas any more. Vermonters also grow sunflowers by the field full. Photo by: Cheryl Dorschner

Burlington: An Exquisite Blend

By Vermont's U.S. Senator Patrick Leahy

On summer nights – like so many Vermonters and visitors – my wife Marcelle and I sometimes find ourselves sitting on a rocking bench on the Burlington waterfront, enjoying a sunset framed by the Adirondack Mountains. The cool, calming breeze drifting across Burlington Harbor reminds us that summer doldrums make no claims on us this far north.

Boat house weather vane, Fishbladder
Island, Lake Champlain, Vermont.
Photo by: Tom Way

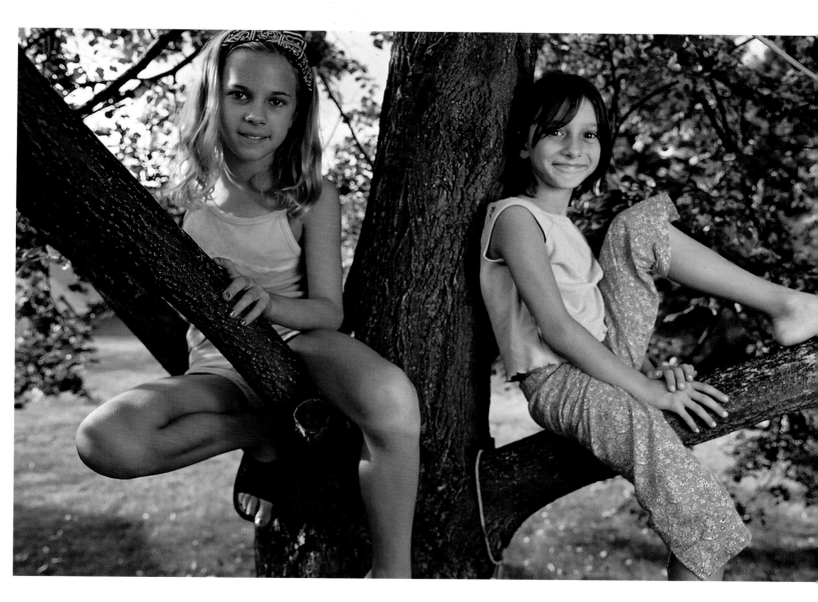

Monumental scenery and human-scale urbanity are side-by-side amenities that make Burlington one of America's most livable cities and a marvelous place to live, to work, to play and to raise a family.

The Baker (left) and Wetzel girls of South Burlington are neighborhood friends. Photo by: Andy Duback

Notched on a hillside overlooking Lake Champlain, the City of Burlington sits just south of the Winooski River at the widest section of Lake Champlain, an expansive seven-and-a-half mile stretch of prime lakefront property that commands one of Vermont's most famous and fabled scenic vistas. Burlington's history and rich cultural heritage are tied to the lake and to the river which have nurtured it.

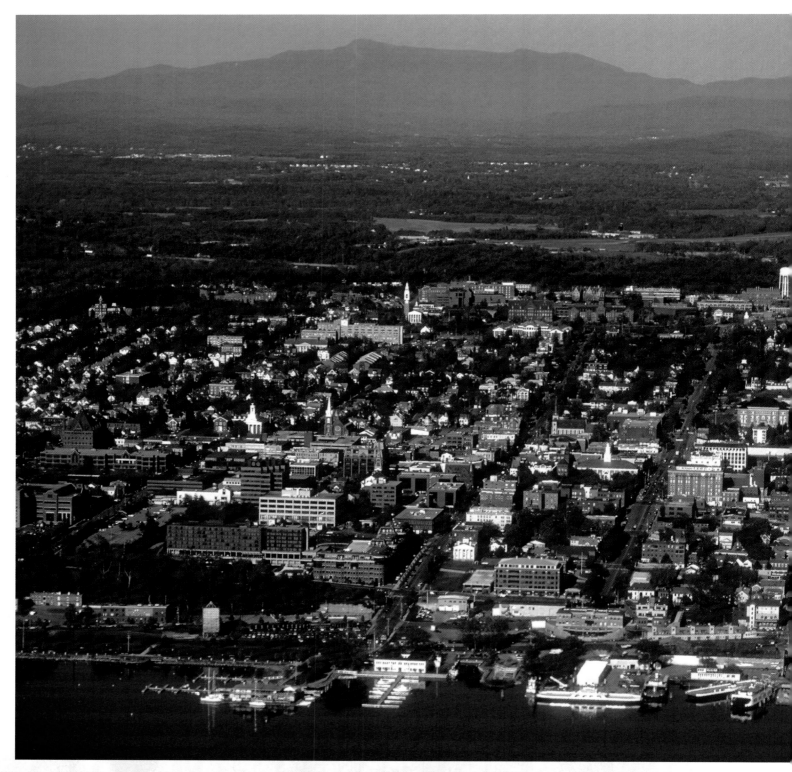

Burlington sits on the shores of Lake Champlain with Vermont's highest mountain, Mount Mansfield, in the distance. Photo by: Jeb Wallace-Brodeur

When Samuel de Champlain first came to Vermont in 1609, an estimated 10,000 Native American people – Mohawks, Mohicans and Abenaki – already had strong ties to the land and to the lake – a lake they called Biawbagok, or 'the waters in between.' Despite the vast differences between the cultures of the land's original inhabitants and the newly arriving settlers, the land and the lake wove them together.

In 1763, New Hampshire Governor Benning Wentforth chartered Burlington, years before the storied Allen family began settling the city, and for years the fledgling settlement would remain one of Vermont's smallest colonial towns.

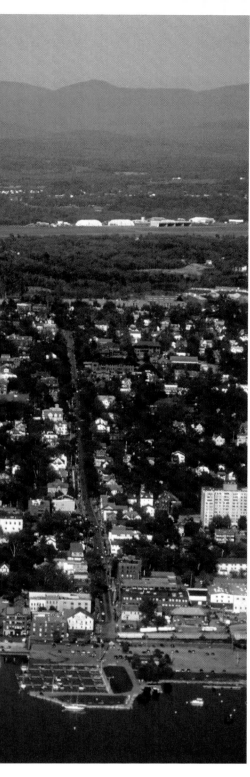

Sailing Shelburne Bay, VT with
Camels Hump background.
Photo by: Paul Boisvert

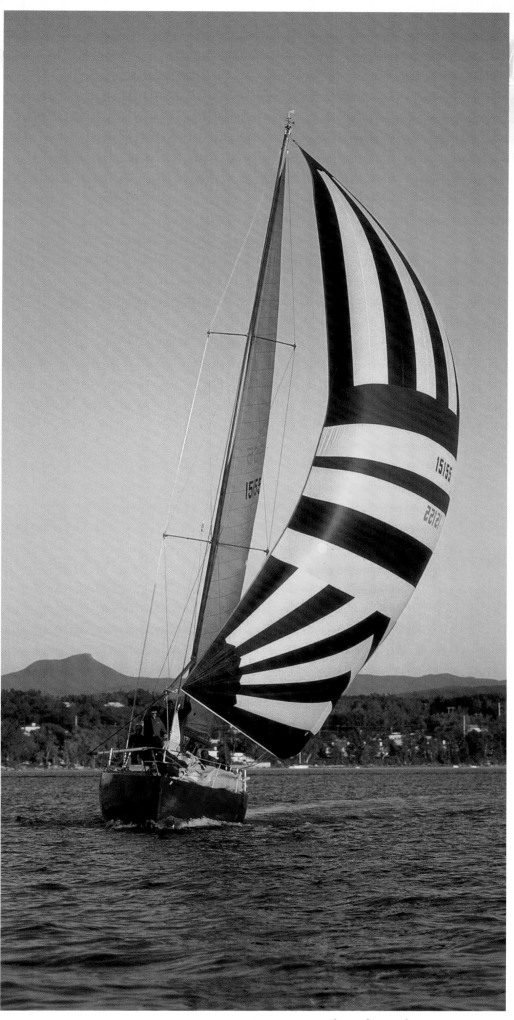

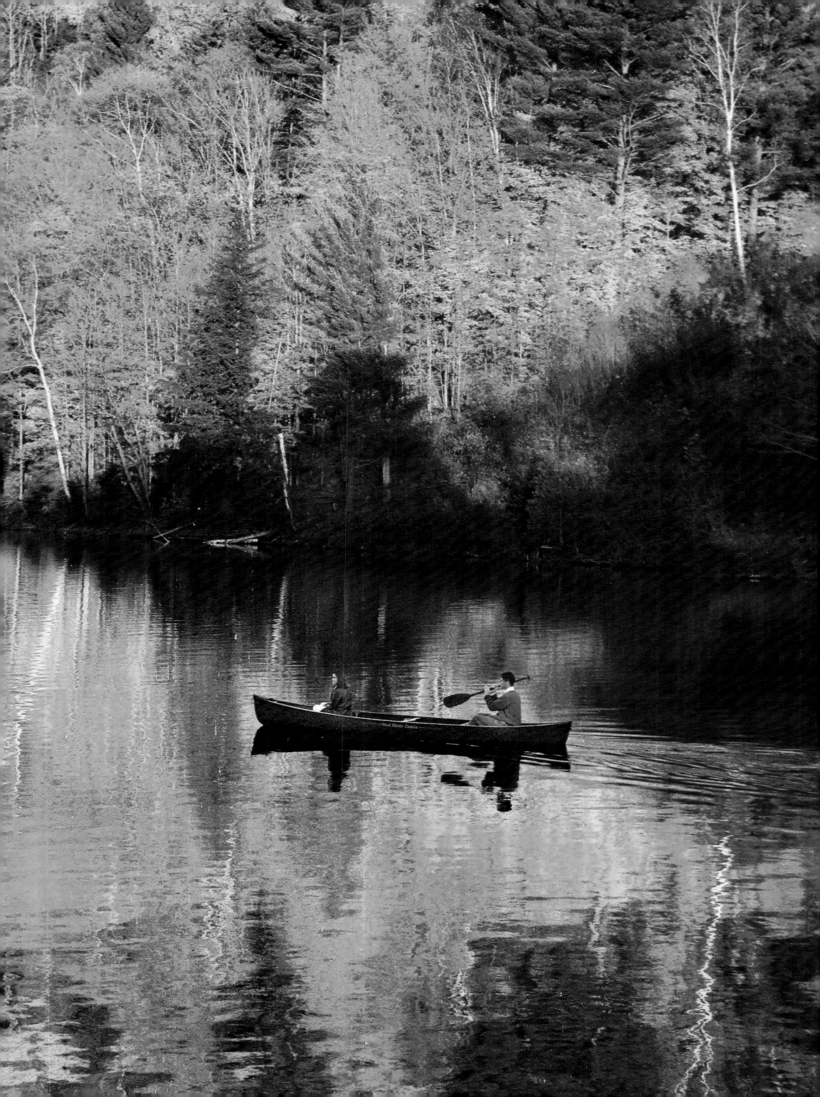

Calais, Vermont, one of the many un-spoiled rural areas, is a blaze of glory as fall colors envelop people in a canoe. Photo by: Adam Riesner

Basin Harbor Club with Lake Champlain the the background. Photo by: Sandy Macy

A Natural Place

Three distinctive geographical features define Burlington: our lake, our river and our prominent high ground. Ira Allen, brother to the famous Ethan Allen of the Green Mountain Boys, settled on the shores of the French River – today's Winooski River. He plotted lots and later built Burlington's first schooner, the Liberty. He built Fort Frederick as protection for the city and his interests, and he built Burlington's first sawmill in 1786. With many who followed, he used Burlingtonís natural assets to help forge an economy based on trading, shipping and timber.

Daylilies are one of the signature plants of the Vermont garden in July.
Photo by: Cheryl Dorschner

A mother towing her child on a sled up Church Street in Burlington.
Photo by: Sandy Macy

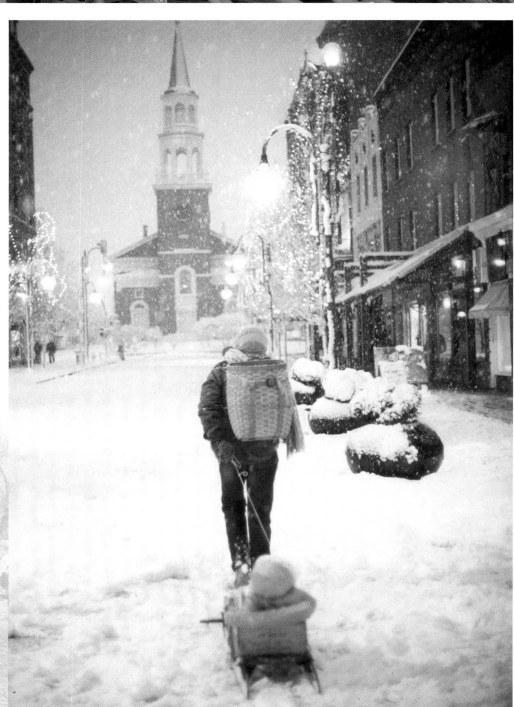

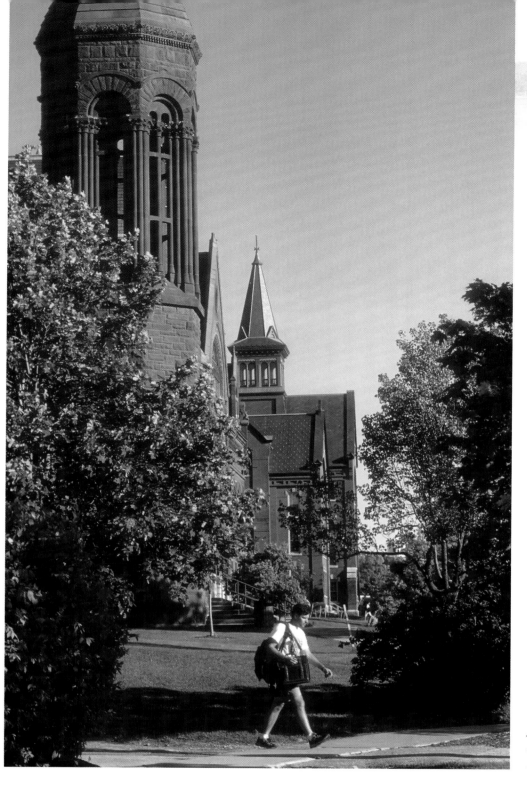

A student crosses the campus at The University of Vermont in Burlington. Photo by: Jeb Wallace-Brodeur

The Campus On The Hill

On top of our hill, the fifth university in New England was founded. In 1791, the same year that Vermont became a state, the University of Vermont was founded, on land donated by Ira Allen. The first campus building was paid for by the citizens of Burlington, and after a fire destroyed it, they helped finance its replacement. The University has grown, and so has its reputation and its influence on the city, on Vermont, and beyond.

One of the many famed UVM graduates was John Dewey, a native Burlingtonian. As a philosopher and leading advocate of student-centered education, Dewey's ideas continue to influence American education.

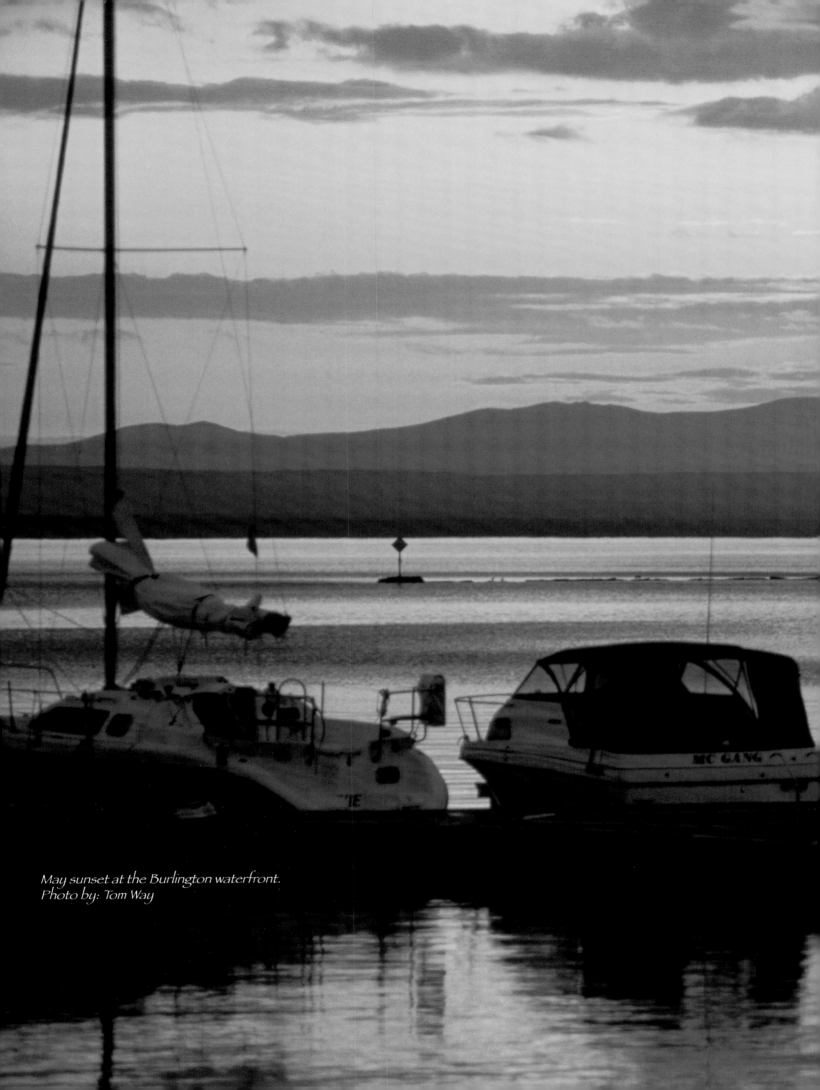

May sunset at the Burlington waterfront.
Photo by: Tom Way

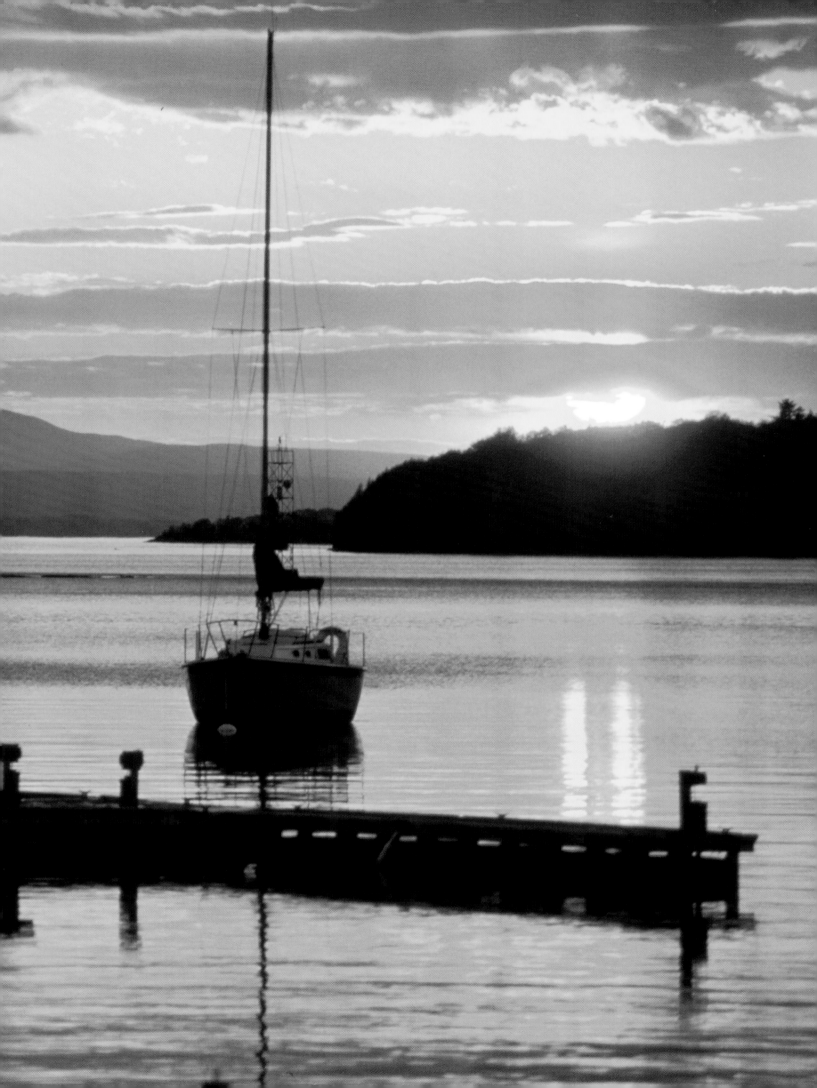

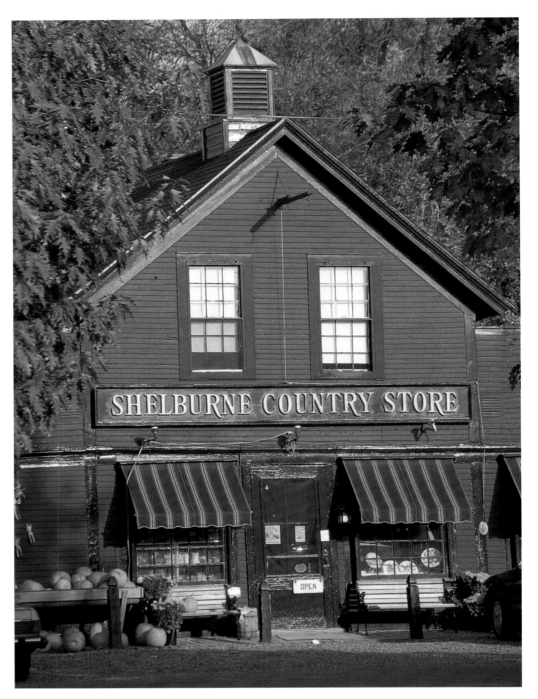

The Shelburne Country Store.
Quintessential Vermont.
Photo by: Jim Westphalen

Below: Willsboro Bay N.Y.
Photo by: Paul Boisvert

Photo by: David Seaver

Photo by: David Seaver

Photo by: David Seaver

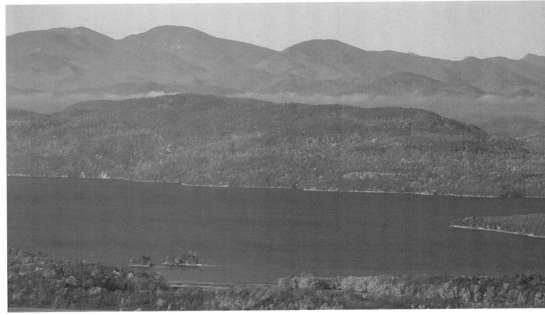

'Great' Lake Champlain

Lake Champlain, the nation's sixth-largest lake – and to Vermonters, a 'Great' lake like its cousins farther west – has been Burlington's defining feature, and no lake in the nation has harbored such riveting and crucial history. She hosted pivotal naval battles during the Revolutionary War. It was her waters that carried the nation's second commercial steamboat in 1808.

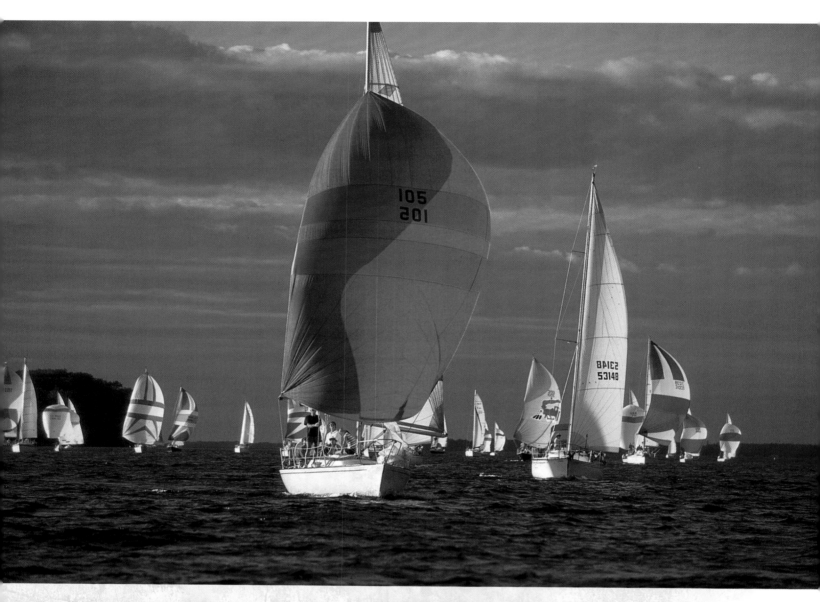

Wednesday night race Lake Champlain Yacht Club Shelburne Bay, VT.
Photo by: Paul Boisvert

During the War of 1812, Burlington became a major naval hub, housing 4000 troops, and the harbors and broad waters of Lake Champlain formed the front lines of battle for American forces fighting the British to keep the lake under American colors. Lt. Thomas Macdonough commanded the men packed into the area surrounding modern-day Battery Park, where modest memorials today mark the area.

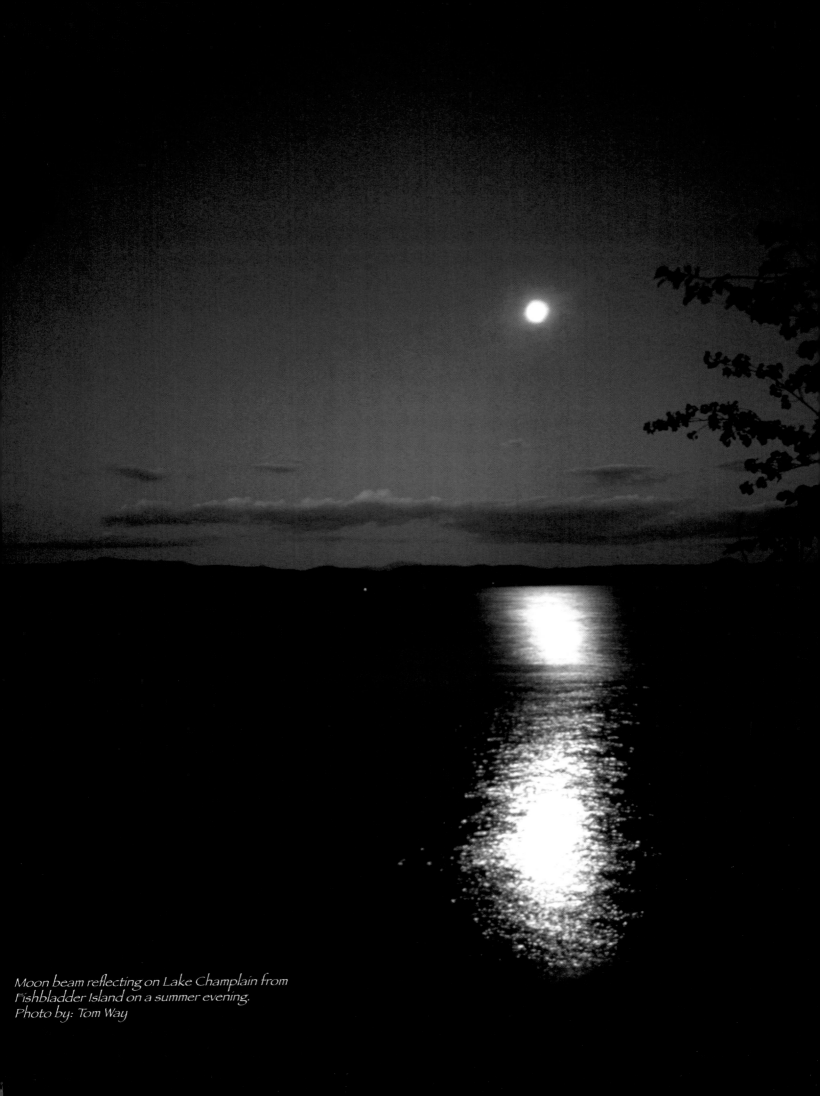

Moon beam reflecting on Lake Champlain from
Fishbladder Island on a summer evening.
Photo by: Tom Way

Burlington Community Boathouse.
Photo by: Paul Boisvert

Photo by: David Seaver

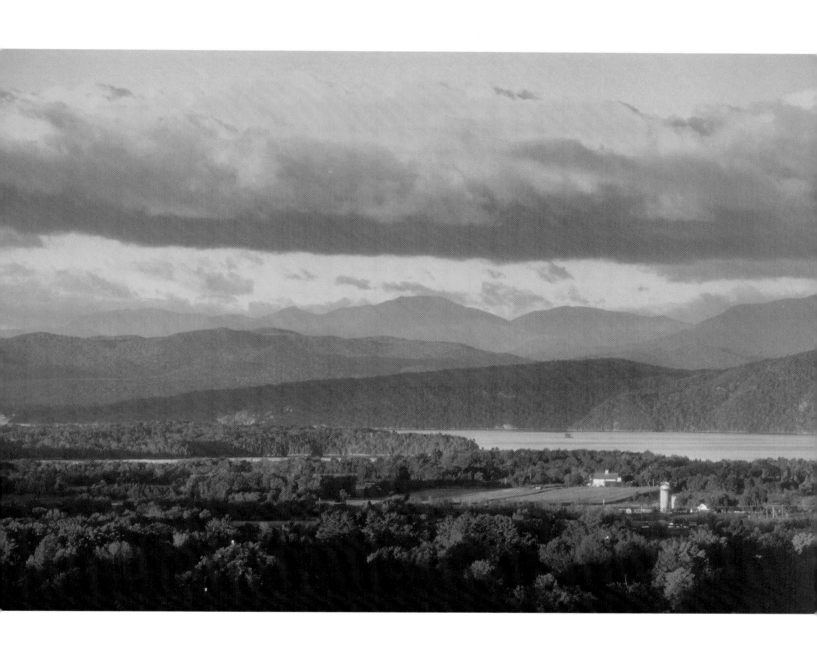

A Bustling Inland Port

Through the late 19th Century, Burlington grew to become one of North America's busiest lumber ports. The Winooski Falls produced the power to operate the sawmills, the large pine forests in the area provided the timber needed for building and trade, and clear cutting yielded large fields for farming.

The rising sun illuminates Lake Champlain and the Adirondacks in this view from Charlotte. Photo by: Jeb Wallace-Brodeur

A few years ago, my good friend Art Cohn of the Lake Champlain Maritime Museum and Marcelle and I hoisted our scuba gear to do a little exploring underwater in Burlington Harbor. It was there that Marcelle and I saw a relic of the era when Burlington grew from lakeside town to nationally recognized shipping port. Resting on the bottom of the harbor is a canal schooner, preserved by the lake's cold waters. The schooner, which was commemorated in 2004 with the launch of the replica canal schooner Lois McClure, was one of many canal boats that once shipped goods throughout the lake and eventually throughout the region.

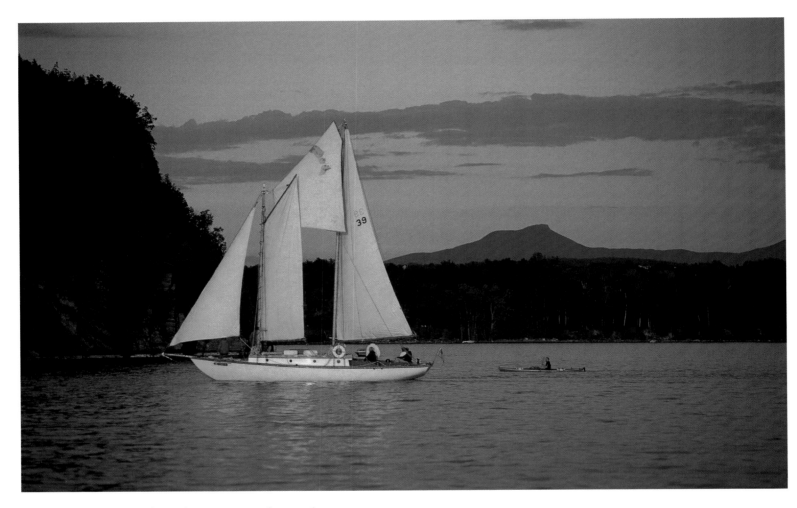

Red Rocks Park South Burlington, VT. with Camels Hump.
Photo by: Paul Boisvert

Photo by: David Seaver

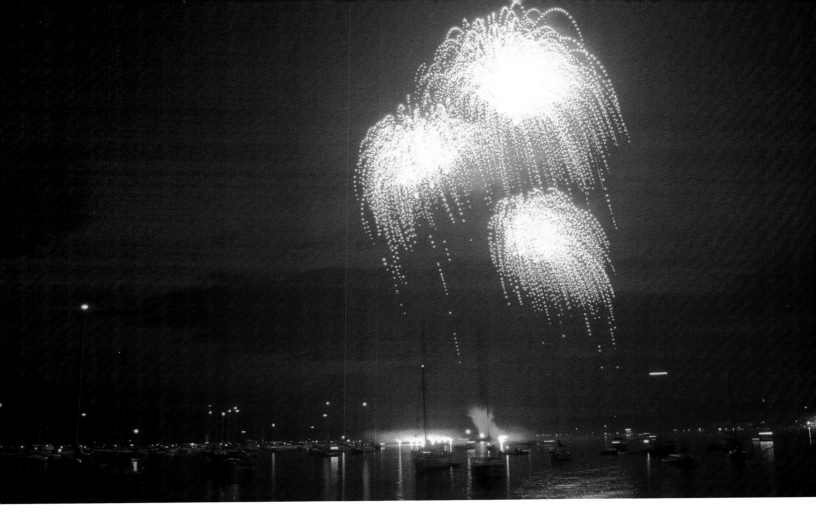

Chipman Point Orwell, VT. Photo by: Paul Boisvert

Fourth of July fireworks Burlington, VT.
Photo by: Paul Boisvert

Photo by: David Seaver

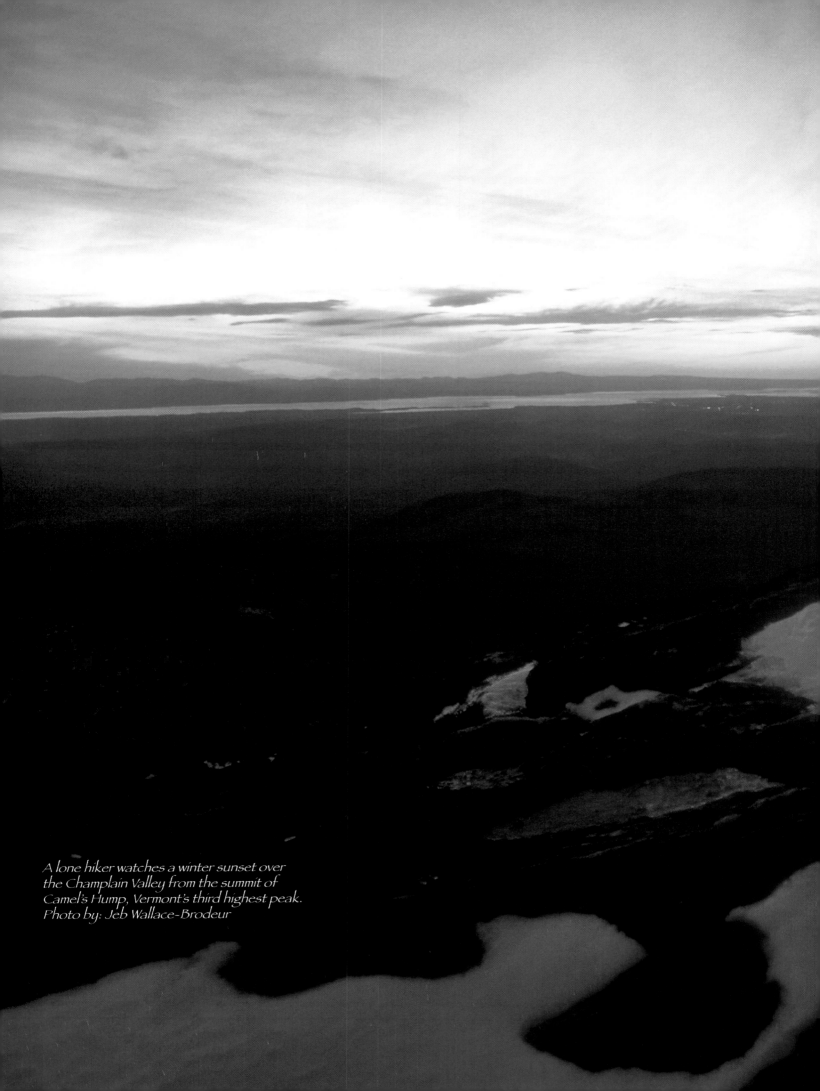

A lone hiker watches a winter sunset over the Champlain Valley from the summit of Camel's Hump, Vermont's third highest peak. Photo by: Jeb Wallace-Brodeur

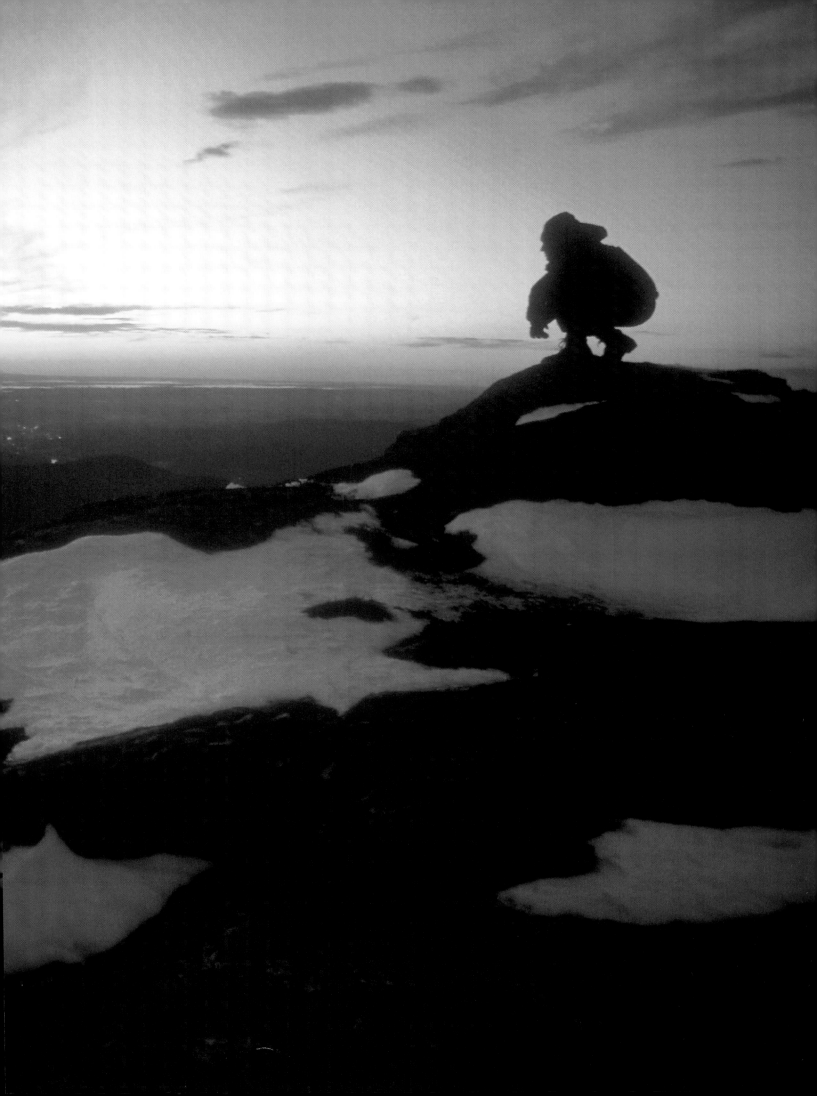

Autumn meets winter at the sign of the first frost – usually around October 15. Here a maple leaf and alpine strawberries say au revoir. Photo by: Cheryl Derschner

Sabin Gratz of Burlington releases his ball at the Champlain Lanes in South Burlington. Photo by: Andy Duback

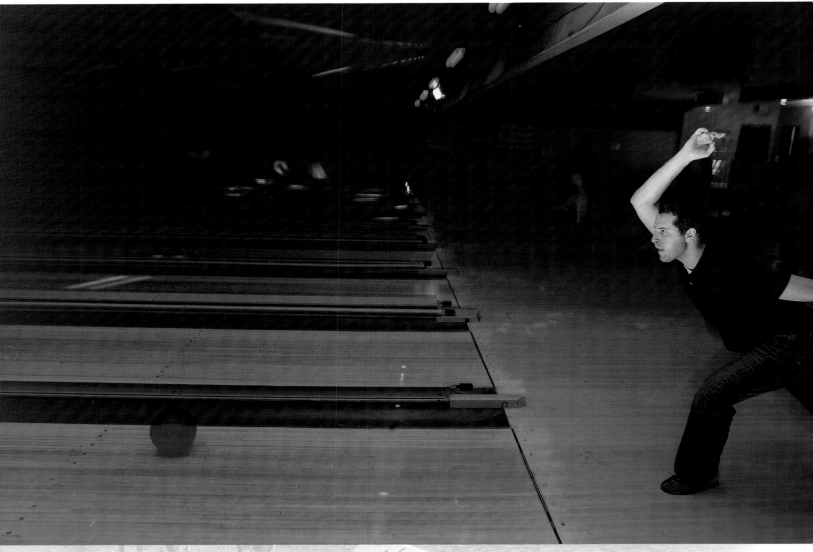

The year 1823 marked perhaps the single most important development in Lake Champlain commerce, with the opening of the Champlain Canal. It connected the lake to the Atlantic through the Hudson River – a southern route that gave goods from Northern Vermont, Canada and Northern New York easy access to thriving cities of Southern New England and New York. Soon after, the Erie Canal connected the lake to the St. Lawrence. But only 25 years after the canals were completed, two rail lines cut a gap through the Green Mountains, delivering not one but two rail lines to Burlington from New York and Boston.

Between the 1820s and 1850s, the transportation breakthroughs produced a boom in economic growth and development. Burlington Harbor was rimmed with a breakwater to protect the canal boats and the harbor from wind and waves – a breakwater that we have rejuvenated in recent years.

Photo by: David Seaver

Lake Champlain Visions – 33

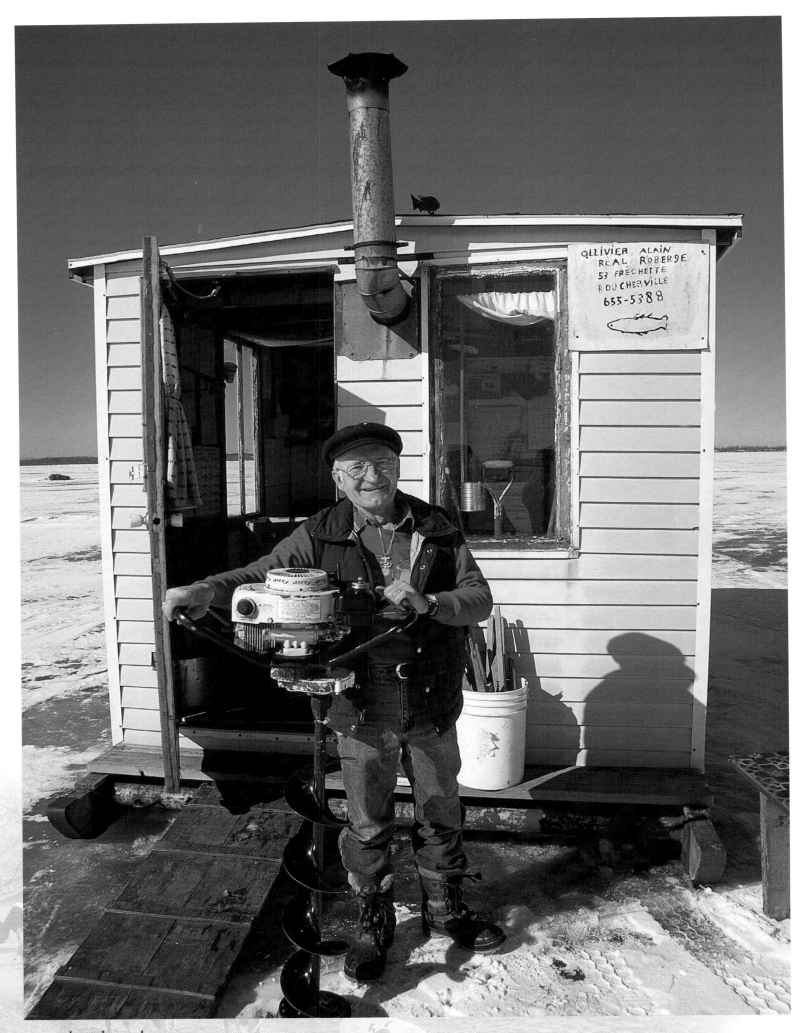

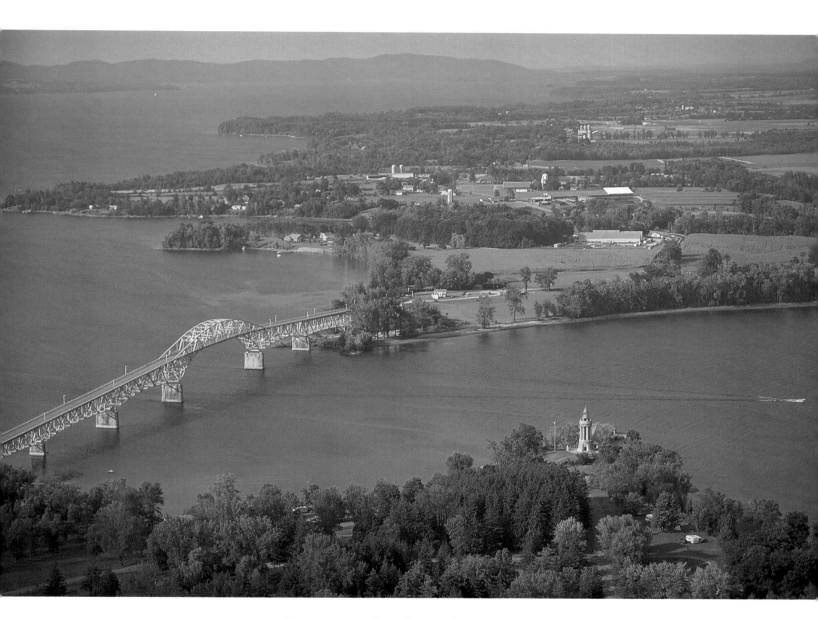

Chimney Point Champlain Bridge Addison, VT. Photo by: Paul Boisvert

Icefishing Swanton, VT. Photo by Paul Boisvert

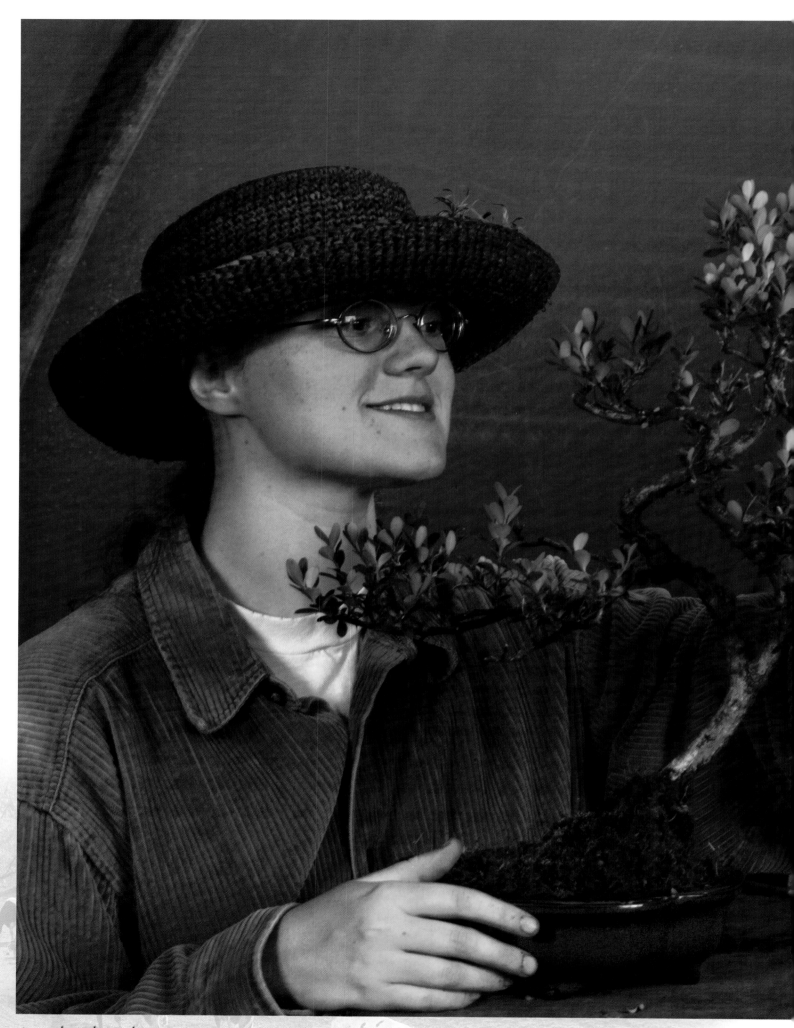

Janet Anderson works with a tree at Mill Brook Bonsai, Jericho, Vermont.
Photo by: Tom Way

Curious sheep on a cold day in North Hero. Photo by: Jim Westphalen

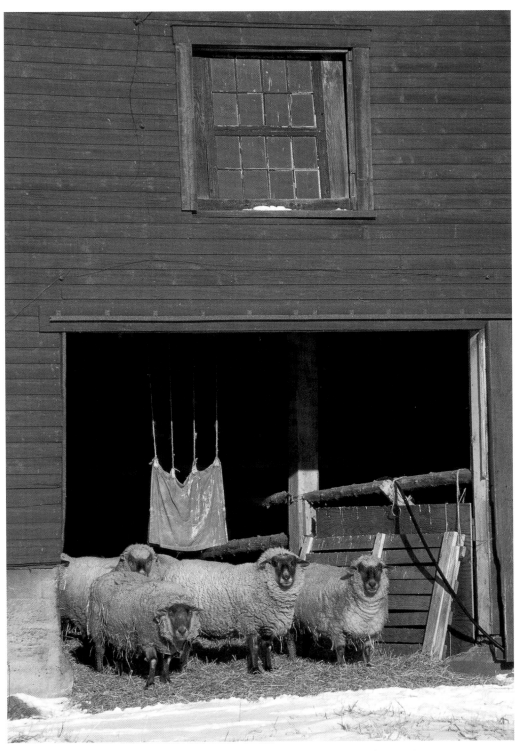

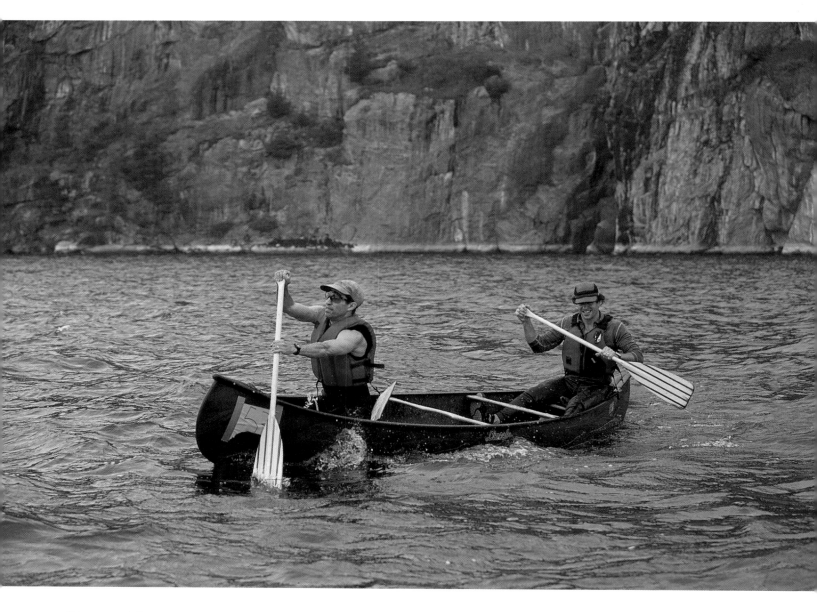

Small boat paddle race LCMM Ferrisburg, VT. Photo by: Paul Boisvert

As the timber trade strengthened throughout the 1820s and 1830s, its success was paralleled with a boom in the sheep farming industry. Wool was used by textile firms like the Burlington Mill Company. A little more than 60 years after Burlington's first settlers arrived, Burlington became the most populated town in Vermont with 4000 residents – though the residents were still outnumbered by nearly 3000 sheep.

The middle of the 19th Century brought the Civil War. And, as they did during the Revolutionary War and the War of 1812, Burlingtonians responded to the call to duty in extraordinary numbers. As the nation was fighting the Civil War, the town of Burlington had its own split between its rural areas and its "urban" downtown. In February of 1865 the larger southern part of Burlington split away from the smaller, more densely populated area that defines downtown Burlington.

Like the streets of so many other busy towns across the country, Burlington's were soon lit by electricity, and electric trolleys operated up and down its growing thoroughfares.

Burlington, VT UVM green.
Photo by: Paul Boisvert

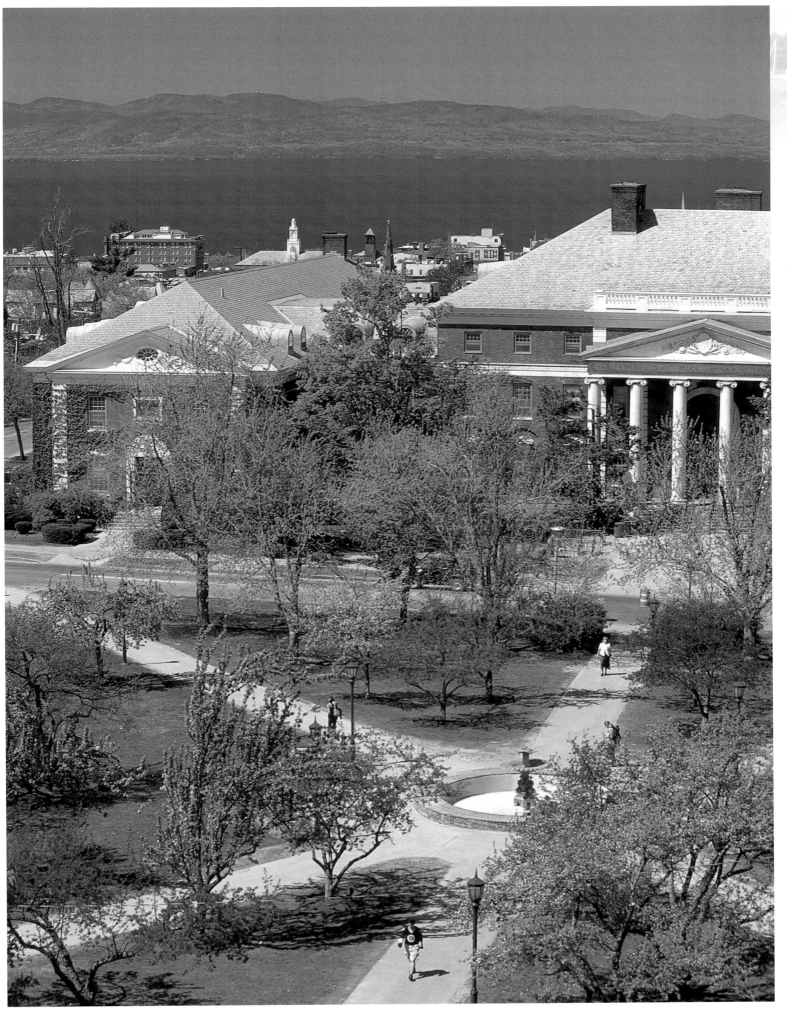

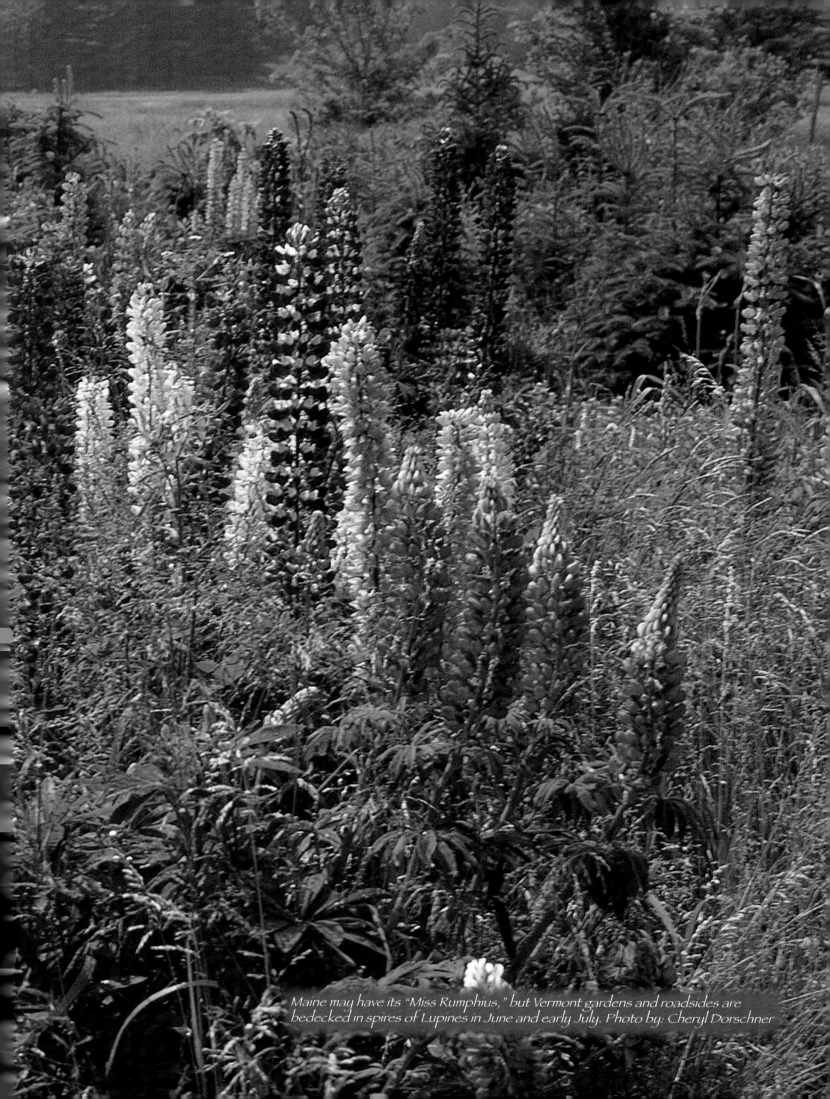

Maine may have its "Miss Rumphius," but Vermont gardens and roadsides are bedecked in spires of Lupines in June and early July. Photo by: Cheryl Dorschner

Burlington, VT Church Street Marketplace. Photo by: Paul Boisvert

A Focus On A Downtown Culture

Burlington's strength as a major lumber port eventually faded in the late 19th Century and early 20th Century, and the once-vibrant docks and waterside businesses became dormant with inactivity. The once-industrious textile plants closed one by one.

Vigorous logging and clearing fields for farming left much of Vermont, especially the area surrounding Burlington, without old-growth forests. The softwood forests turned to crowded-hardwood and less-valued stands of trees.

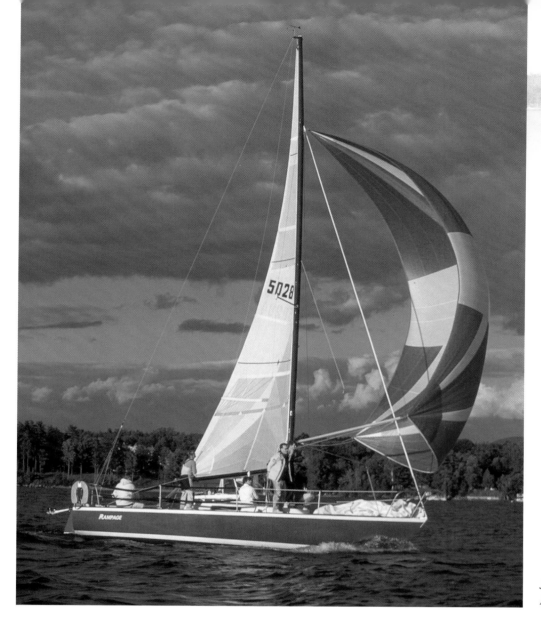

Sailing Wednesday night race Shelburne
Bay, VT. Photo by: Paul Boisvert

Photo by: David Seaver

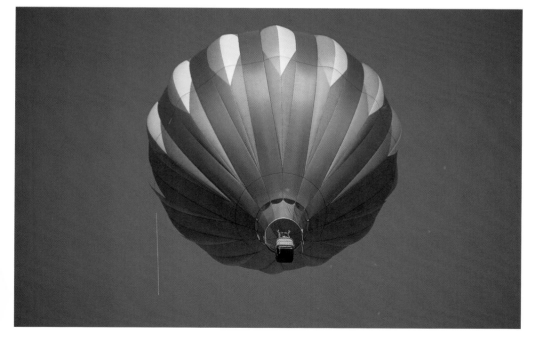

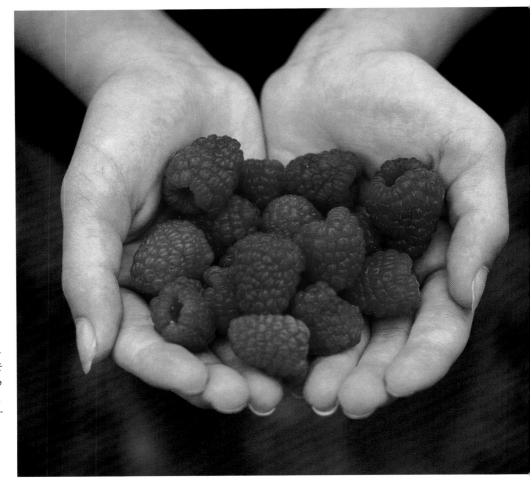

One of the jewels of summer, Vermont-grown raspberries are so delicious that both city and country-dwellers flock to nearby pick-your-own farms to stock up.
Photo by: Cheryl Dorschner

Springtime grazing in Ferrisburg.
Photo by: Jim Westphalen

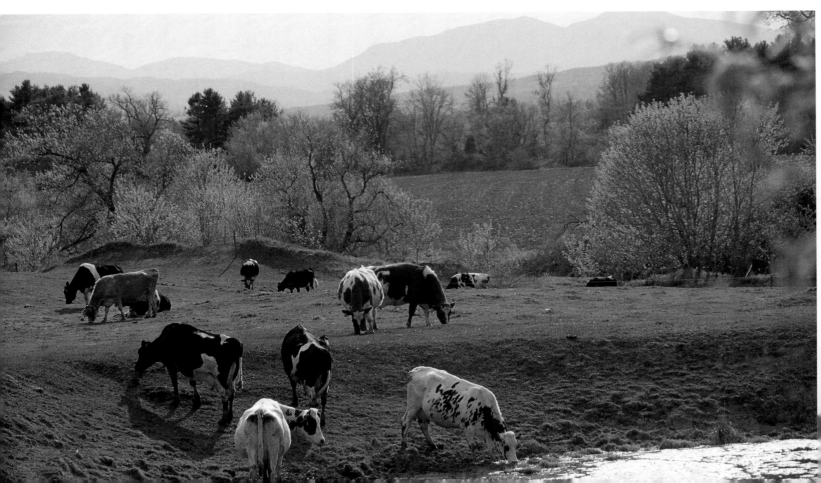

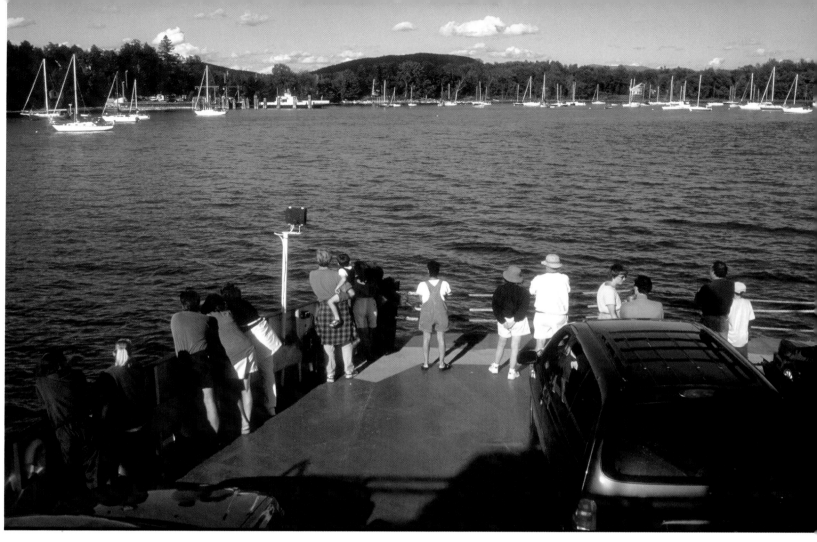

Travelers anticipate the approach of Charlotte, Vt., on a Lake Champlain Ferry. Photo by: Jeb Wallace-Brodeur

University of Vermont mathematics student, Marisa Debowski, stands before part of her masters program thesis. Photo by: Andy Duback

As seen from Overlook Park in South Burlington, a favorite place to view the sunsetting over the Adirondack mountains. Photo by: Adam Riesner

Curtis Wheeler (right) from North
Country Union High School poised
before his race at Caribbean Dreamin'
Classic Race at the Sleepy Hollow Inn Ski
and Bike Center in Huntington.
Photo by: Andy Duback

Burlington had changed. It was becoming Vermont's largest city, but no longer because of its port. The infrastructure created in the 19th Century transformed Burlington into a 20th Century urban hub where businesses found workers and workers found jobs. The city all but abandoned its port.

As more mansions were built on the hill overlooking the lake, the University grew, the suburbs grew, the streets were paved, and the once-blue collared town of timber workers, farmers and merchants was transformed into Vermont's center of high society.

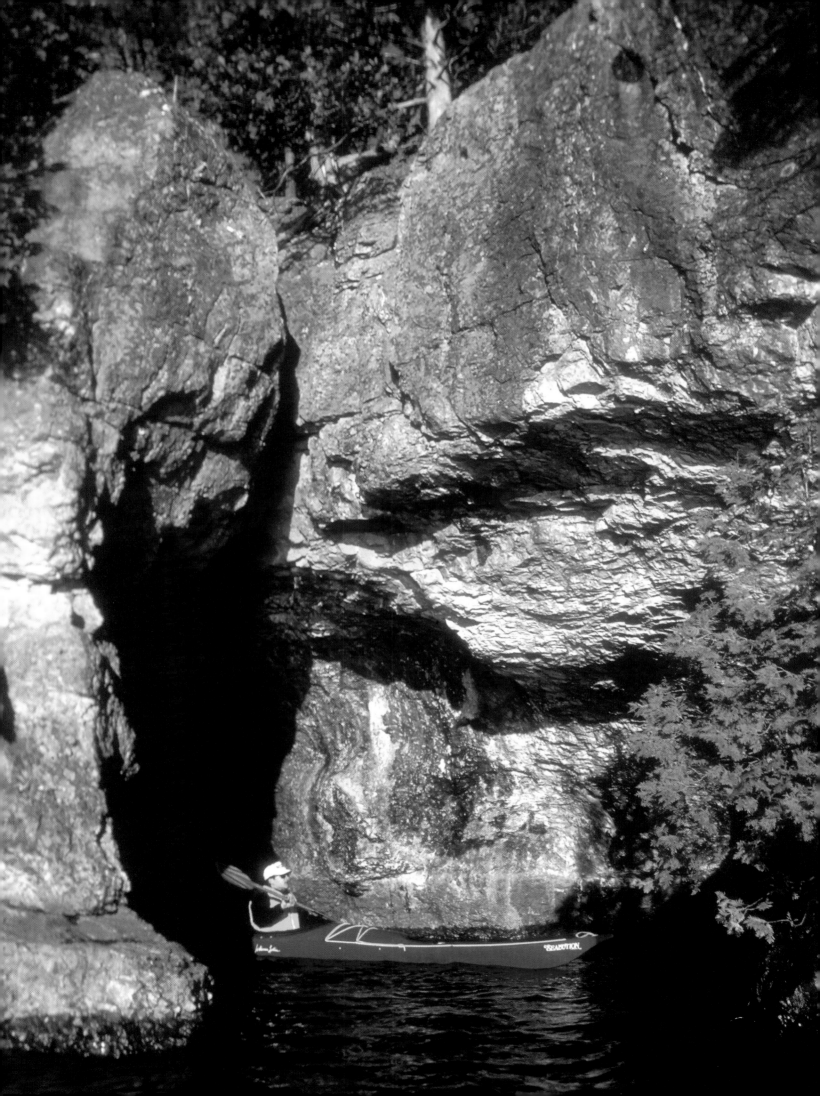

A kayaker paddles out of a cave found
on an island in Lake Champlain's Mallett's
Bay. Photo by: Jeb Wallace-Brodeur

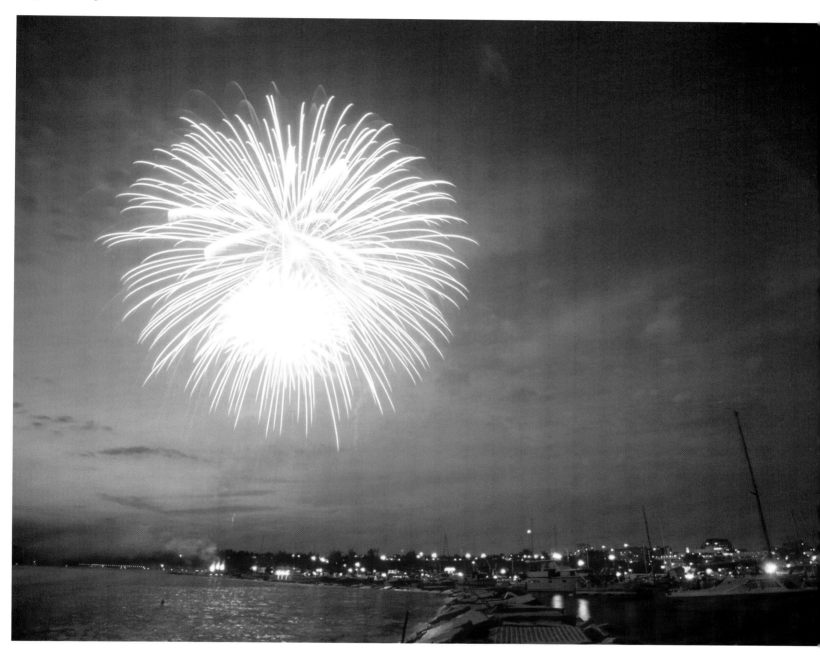

Independence Day fireworks explode over Burlington harbor. Photo by: Jeb Wallace-Brodeur

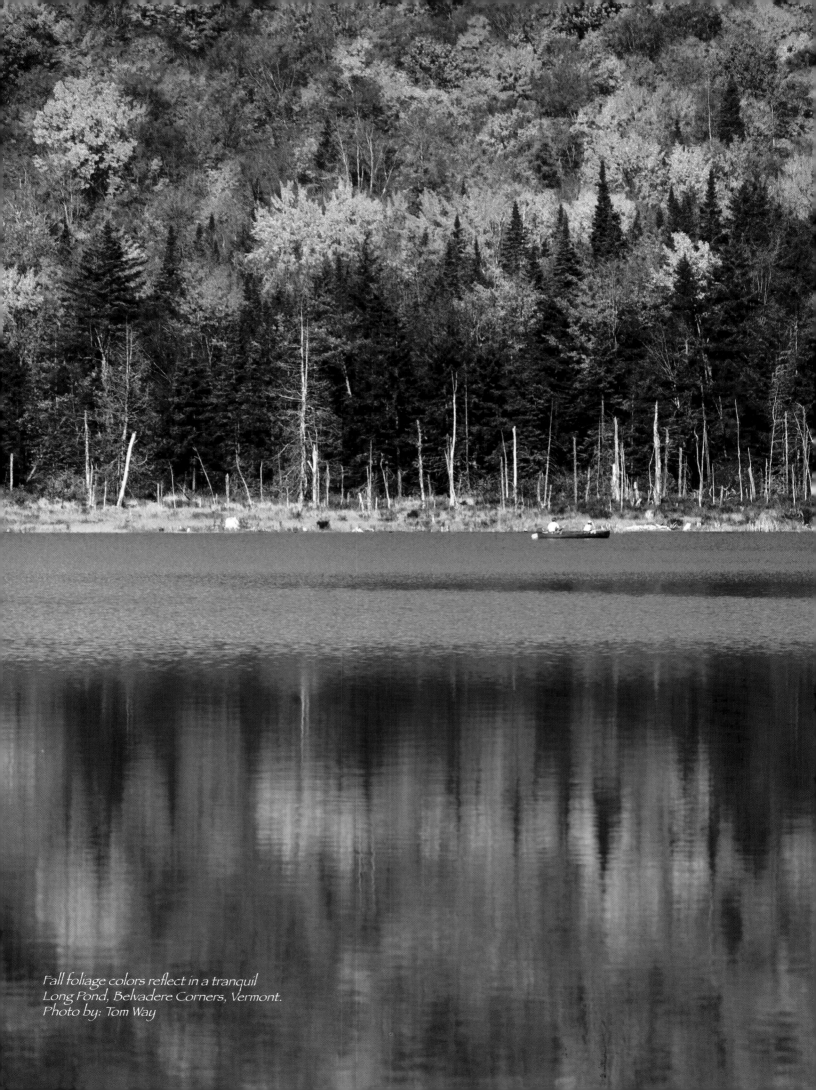

*Fall foliage colors reflect in a tranquil
Long Pond, Belvadere Corners, Vermont.
Photo by: Tom Way*

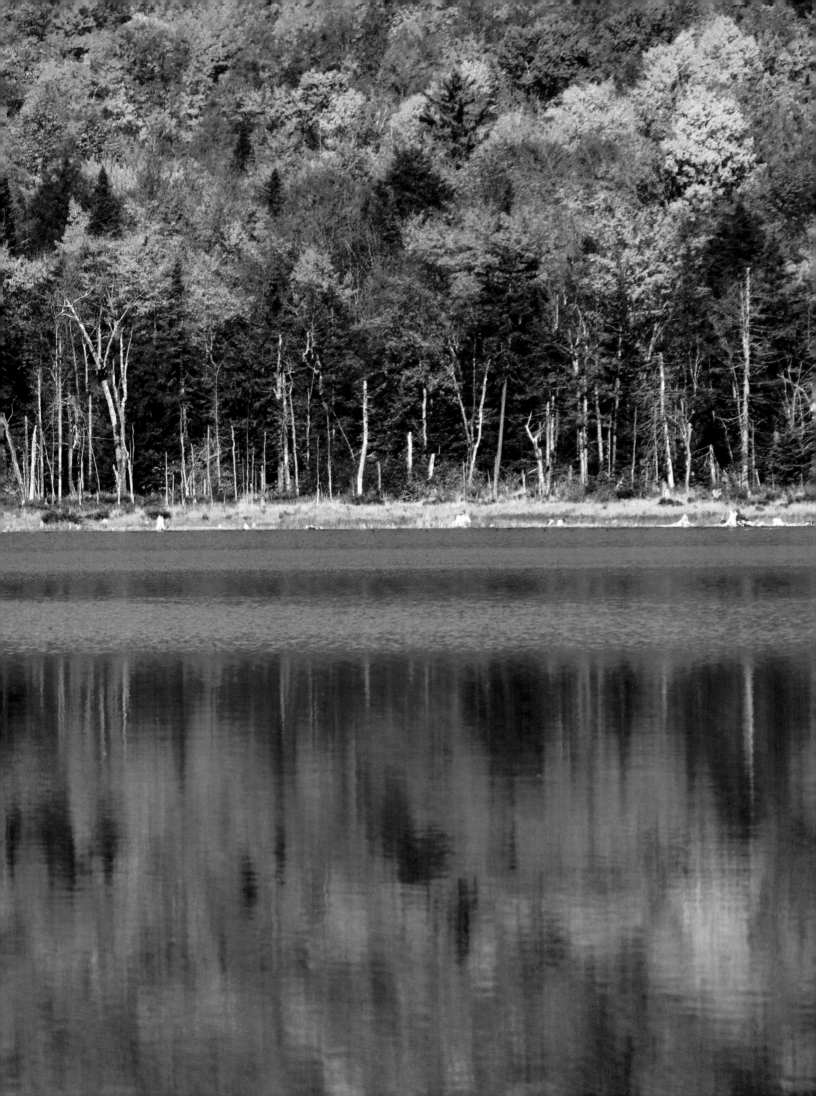

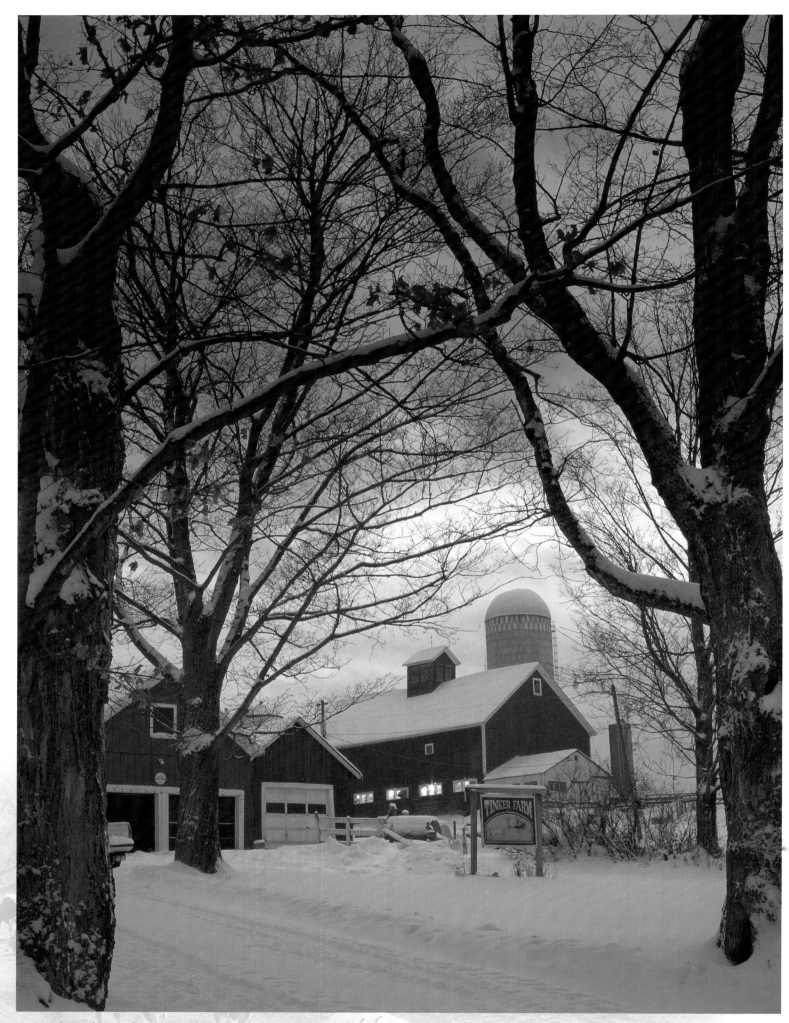

Wooden boat show Burlington, VT.
Photo by: Paul Boisvert

When the Flynn Theater opened in1930 it was the largest stage in the state, and today it remains a focal point of Vermont's theater scene, along with vibrant theaters in Rutland and Montpelier.

Through the early to mid-20th Century, the city continued to grow. The city and several entrepreneurs laid the groundwork for well-known landmarks like Union Station, one of Burlington's most beautiful buildings, and North Beach, a place to cool off that I frequented as a young college graduate. Despite the great flood of 1927 and the Great Depression that followed, through the two world wars and into the fabulous fifties, Burlington became what it is today: New England's most beautiful city.

Winter settles in on Tinker Farm, Fletcher.
Photo by: Jim Westphalen

Dusk often renders colors only seen for
a few minutes as snow covered trees glow
in Williston, Vermont.
Photo by: Adam Riesner

Photo by: David Seaver

Because of its flamboyant autumns
followed by chilly winters, Vermont is the
perfect climate for garden plants grown
from bulbs. Vermont gardeners treat
tulips such as these as annuals – digging
them out after bloom and planting fresh
ones each fall. Burlington is the American
home of bulb purveyor, Dutch Gardens.
Photo by: Cheryl Dorschner

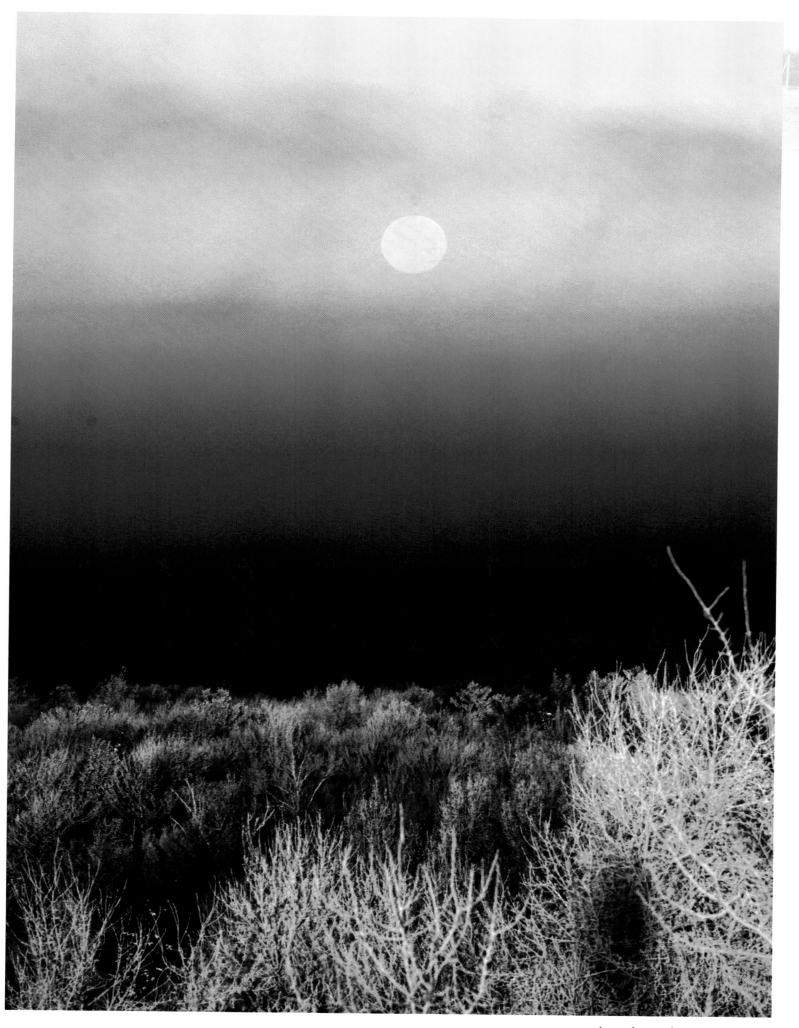

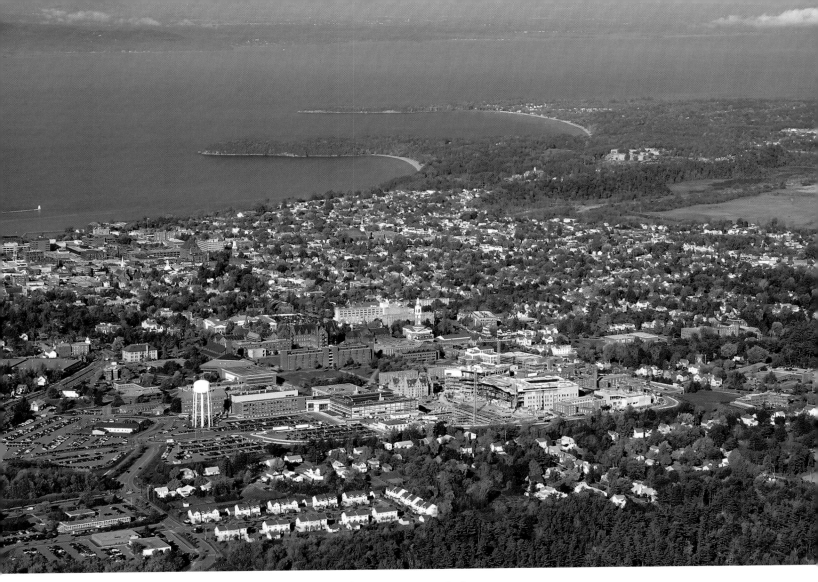

Burlington, Vermont as seen looking west with the University of Vermont in the foreground and Lake Champlain and the Adirondack mountains in the background. Photo by: Adam Riesner

Revitalizing A Model City

The last 50 years have ushered in major changes to Burlington's economy. The suburbs, including South Burlington, Williston, Colchester, Winooski, Essex and Shelburne, began growing as Vermonters, like most Americans, moved into bedroom communities. But urban renewal in downtown Burlington opened the doors to a future that would capture the attention of architects and urban planners across the country recapturing the vitality of downtown Burlington by tapping the city's roots, and capping the effort with a renewed focus on the waterfront. Church Street Marketplace has become one of Burlington's most popular attractions – the hub of Burlington culture, lined with specialty shops, galleries, cafes and eateries.

More recently the city has turned its attention to the waterfront. The forgotten old port needed sprucing up. Now the waterfront attracts Vermonters and tourists alike, welcoming all with mid-summer fireworks, ferry rides and fun. And thanks to the hard work of so many, the waterfront today also is the home of a new museum and science center where both children and adults can learn about Vermont's enduring connections to our lake, at ECHO at the Leahy Center for Lake Champlain. As you might expect, I'm a mite proud of and partial to the place.

Private gardens are tucked away in many a Burlington back yard. This one, in Burlington's "hill section," accomplishes colorful flowers well into October, some years – even later. Photo by: Cheryl Dorschner

A hot air balloon lifts off surrounded by fall colors in Underhill, Vermont.
Photo by: Adam Riesner

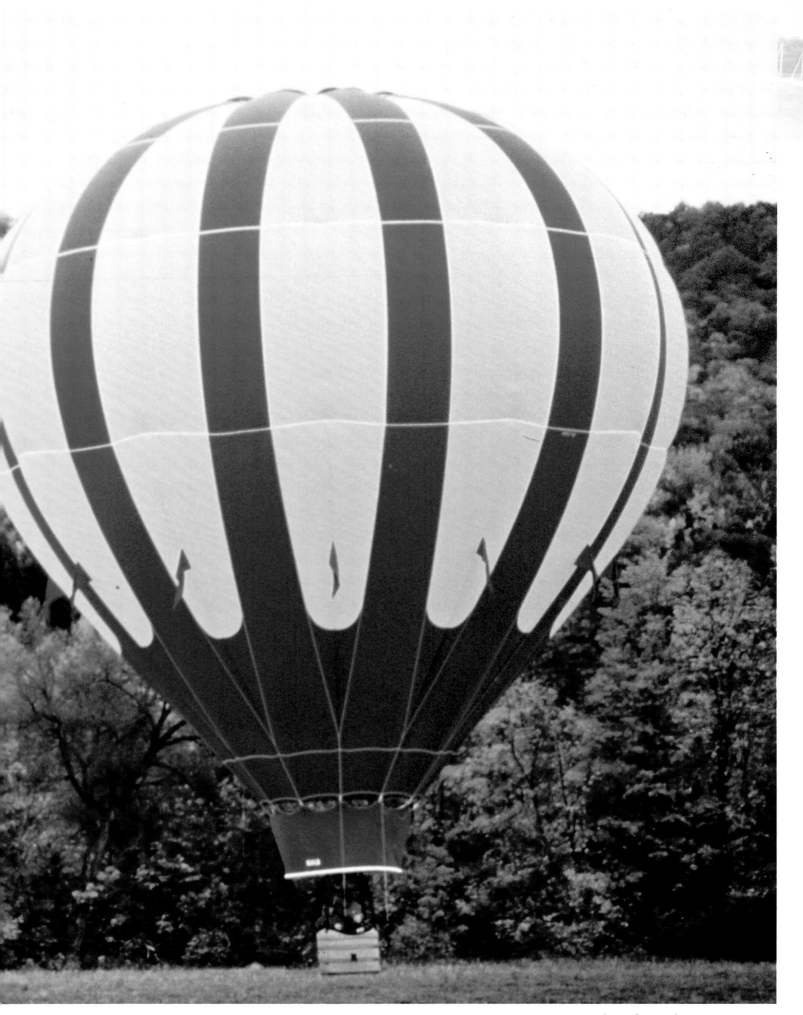

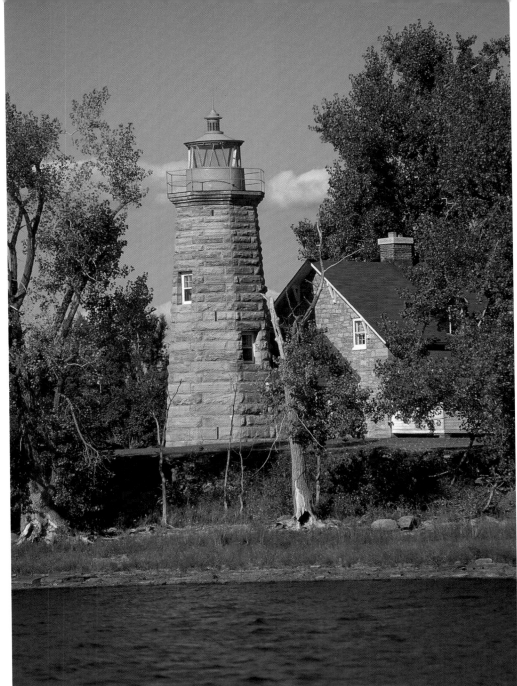

Lighthouse in Alburg, VT.
Photo by: Paul Boisvert

An Interstate 89 overpass between exits #14 and #15 over the Winooski River as seen during a 5 minute timed exposure at night. Photo by: Andy Duback

All of Burlington's hard work and civic-mindedness have produced solid evidence of success. Burlington now routinely shows up at the top of lists of America's most livable cities. The National Historic Trust has recognized Church Street Marketplace as a "Great American Main Street." And national magazines tout Burlington as the perfect place to raise children, live a healthy lifestyle or enjoy a rich cultural life.

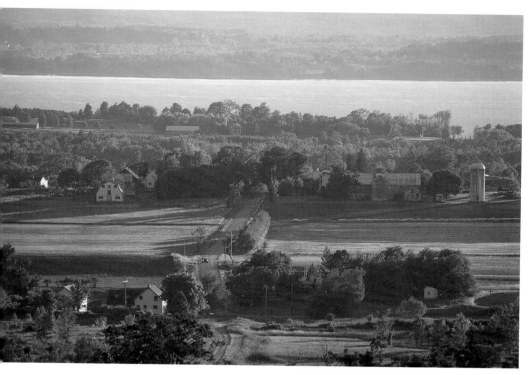

Charlotte, VT countryside.
Photo by: Paul Boisvert

Vermont gardeners feel lucky to have four frost-free months. And some gardeners' favorites, such as Salvia horminum, withstand the first cold days.
Photo by: Cheryl Dorschner

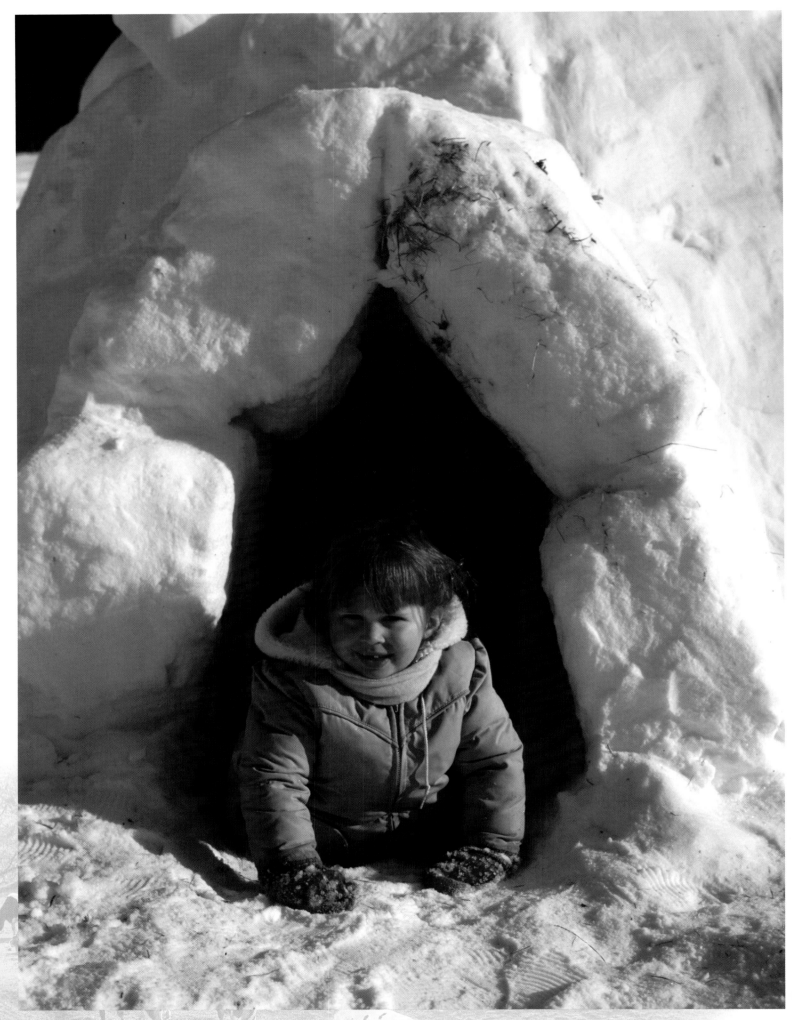

Child playing in a demonstration igloo at the Green Mountain Audubon Center, Huntington, Vermont. Photo by: Tom Way

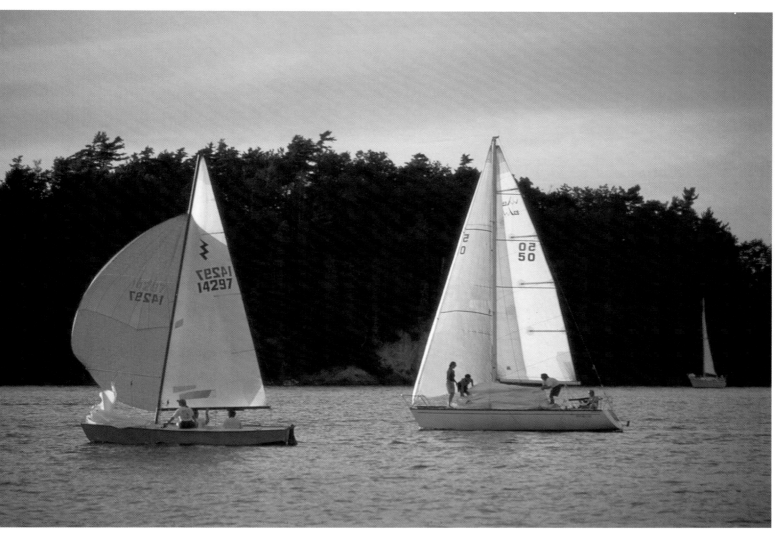

Malletts Bay Thursday night sailboat race VT. Photo by: Paul Boisvert

Green Mountain Heritage

Since the beginning, Burlington has welcomed hardworking pioneers who have etched the cityís name into the history books through their achievements.

Burlington has become a thriving urban center, yet the city remains grounded in its Green Mountain heritage. Itís an exquisite blend. And knowing Burlington and its people as I do, I believe it always will be.

Senator Patrick Leahy

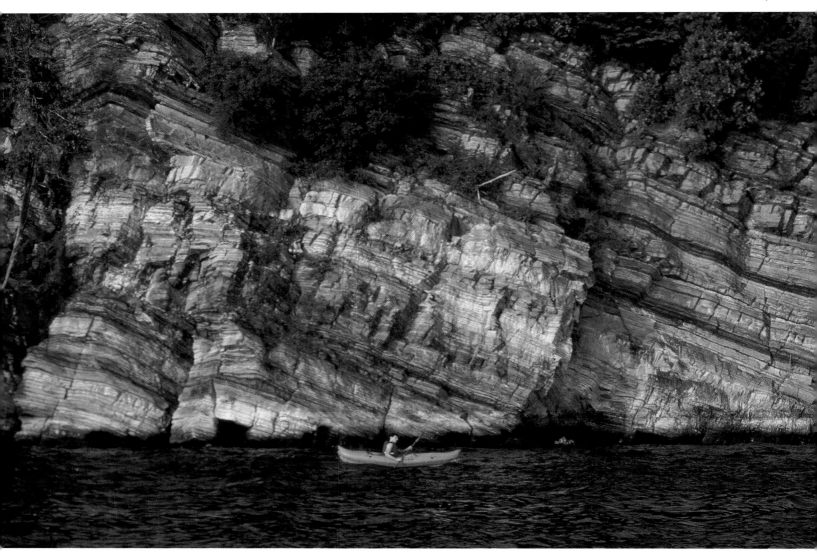

Red Rocks Park South Burlington, VT. Photo by: Paul Boisvert

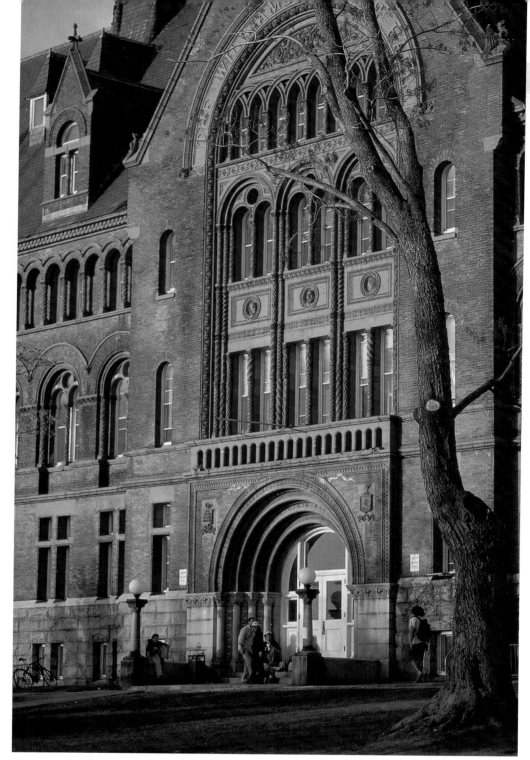

Steve Taubman, hypnotist and magician has his offices in Burlington, often performing at colleges and events state-wide. Photo by: Andy Duback

"Steve Taubman, hypnotist and magician has his of-fices in Burlington, often performing at colleges and events state-wide." Photo by: Andy Duback

Photo by: David Seaver

The Shell Colonial Mart can be found on Shelburne Road in South Burlington.
Photo by: Andy Duback

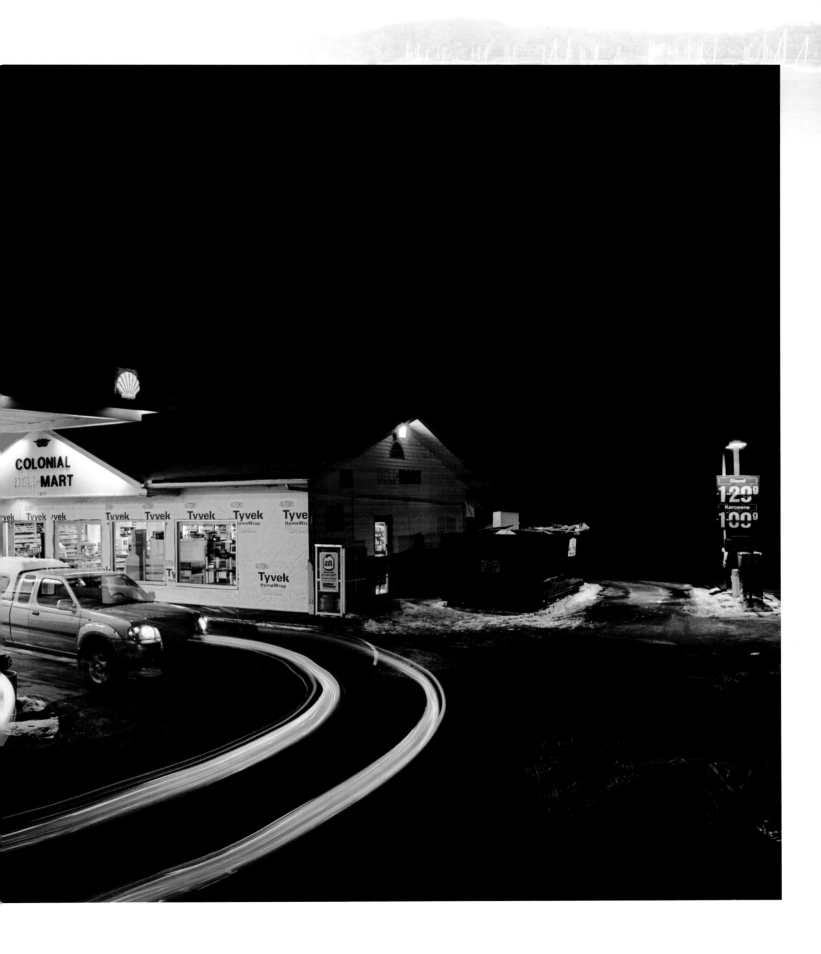

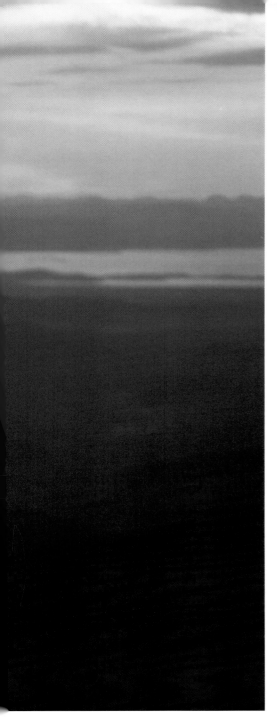

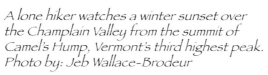

A lone hiker watches a winter sunset over the Champlain Valley from the summit of Camel's Hump, Vermont's third highest peak.
Photo by: Jeb Wallace-Brodeur

Sailing Wednesday night race Shelburne Bay, VT. Photo by: Paul Boisvert

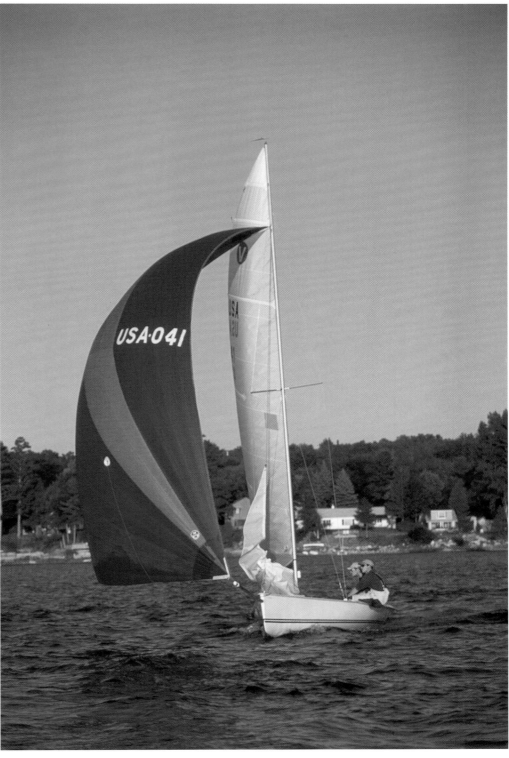

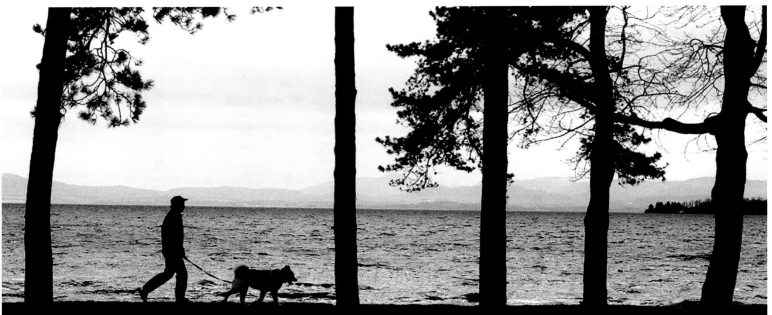

North Beach in Burlington, Vermont is a popular place year-round for dog walking and all kinds of activities.
Photo by: Adam Riesner

Photo by: David Seaver

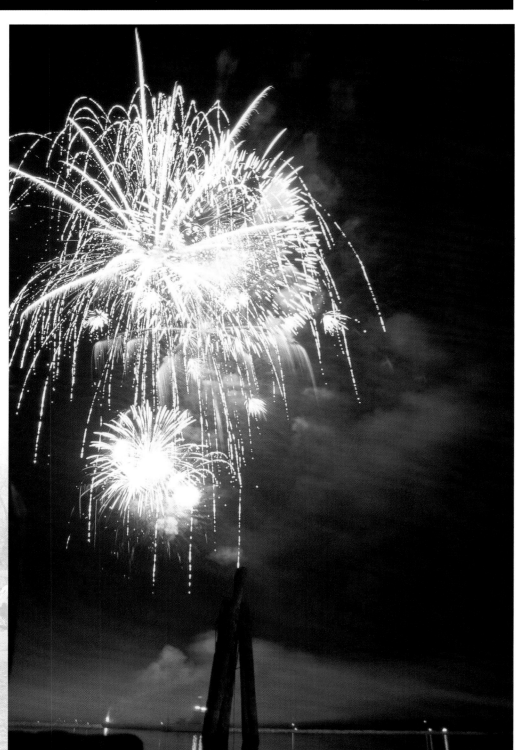

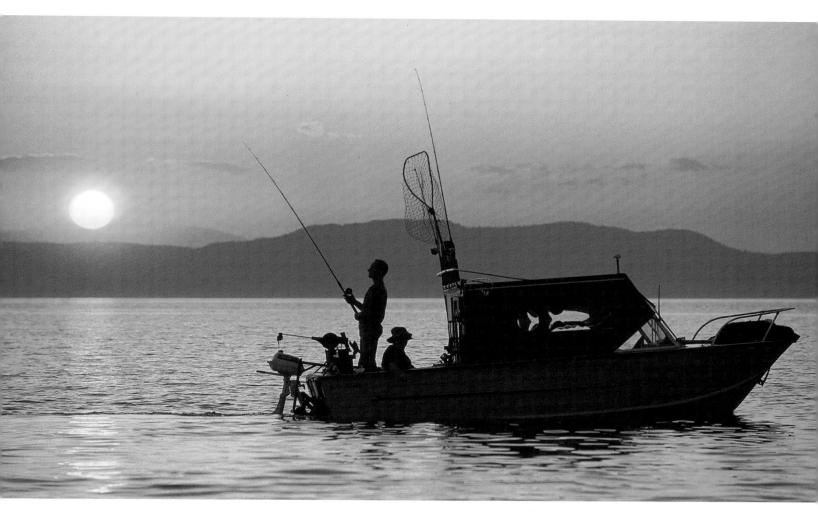

Sunset fishing on main lake. Photo by: Paul Boisvert

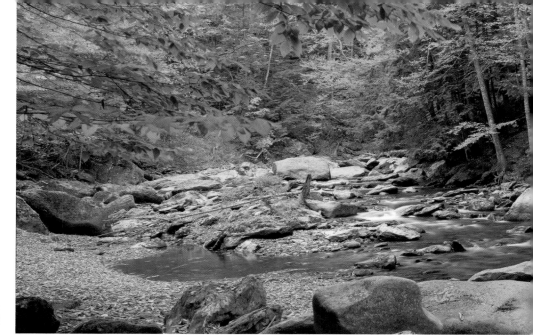

A tranquil stream near Bingham Falls, Stowe. Photo by: Jim Westphalen

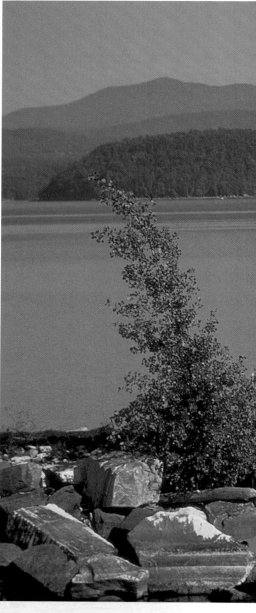

David Sleininger performs during a practice session as part of the University of Vermont's music program. Photo by: Andy Duback

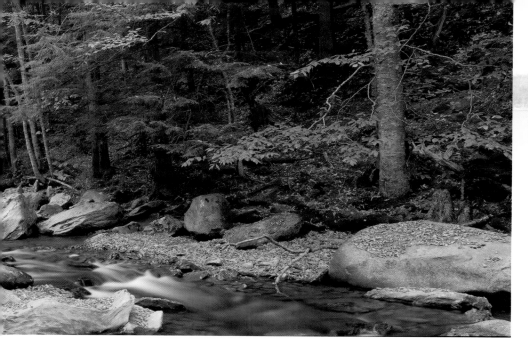

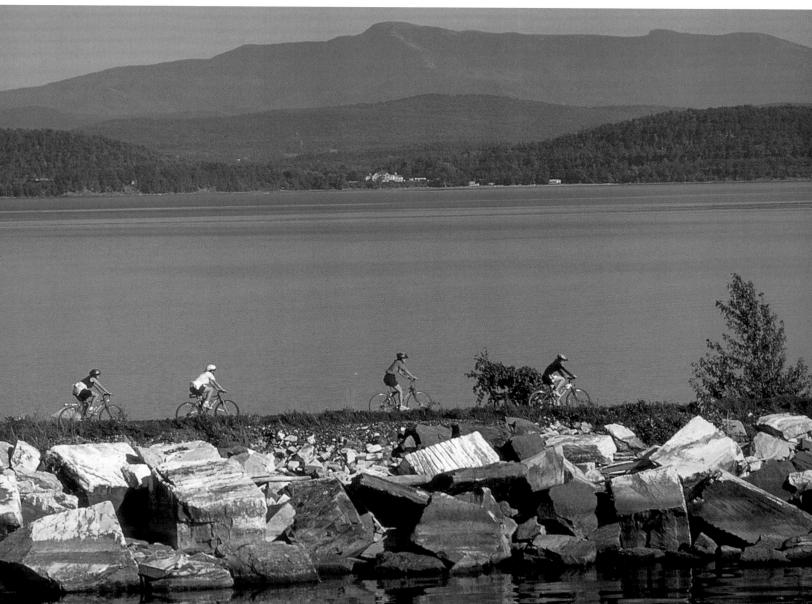

Colchester causeway bike path outer Malletts Bay, VT. Photo by: Paul Boisvert

Fabric collage and pastel artist Dianne Schullenberger working in her Jericho, Vermont studio and gallery.
Photo by: Tom Way

Photo by: David Seaver

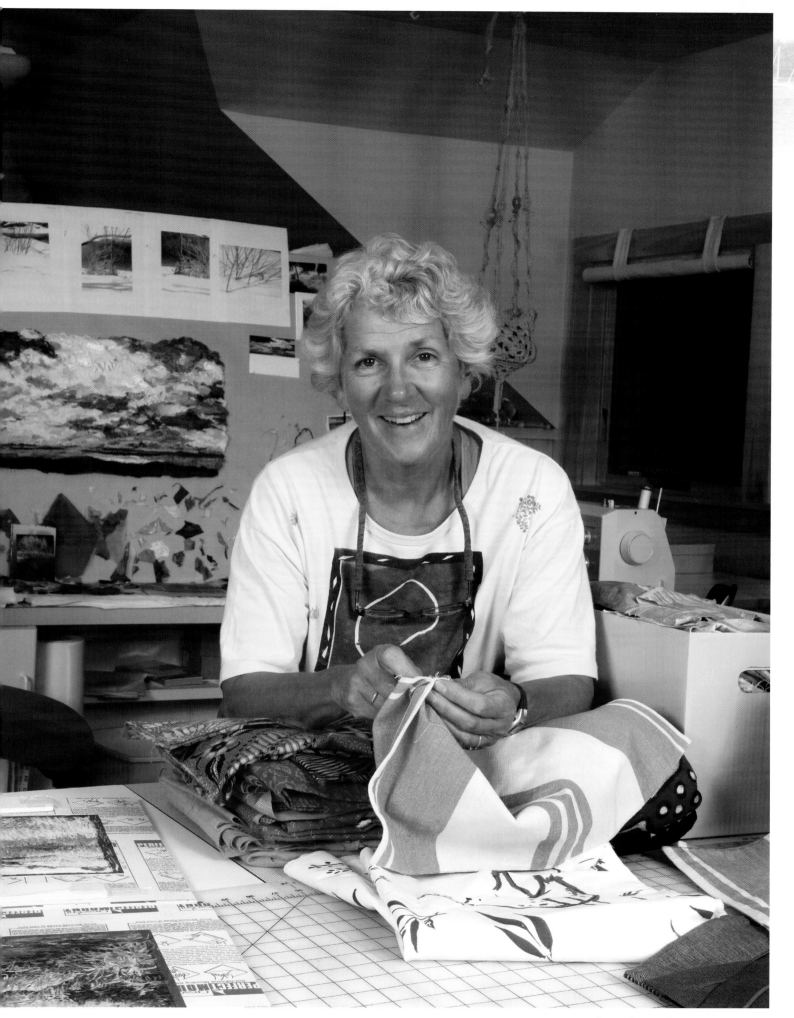

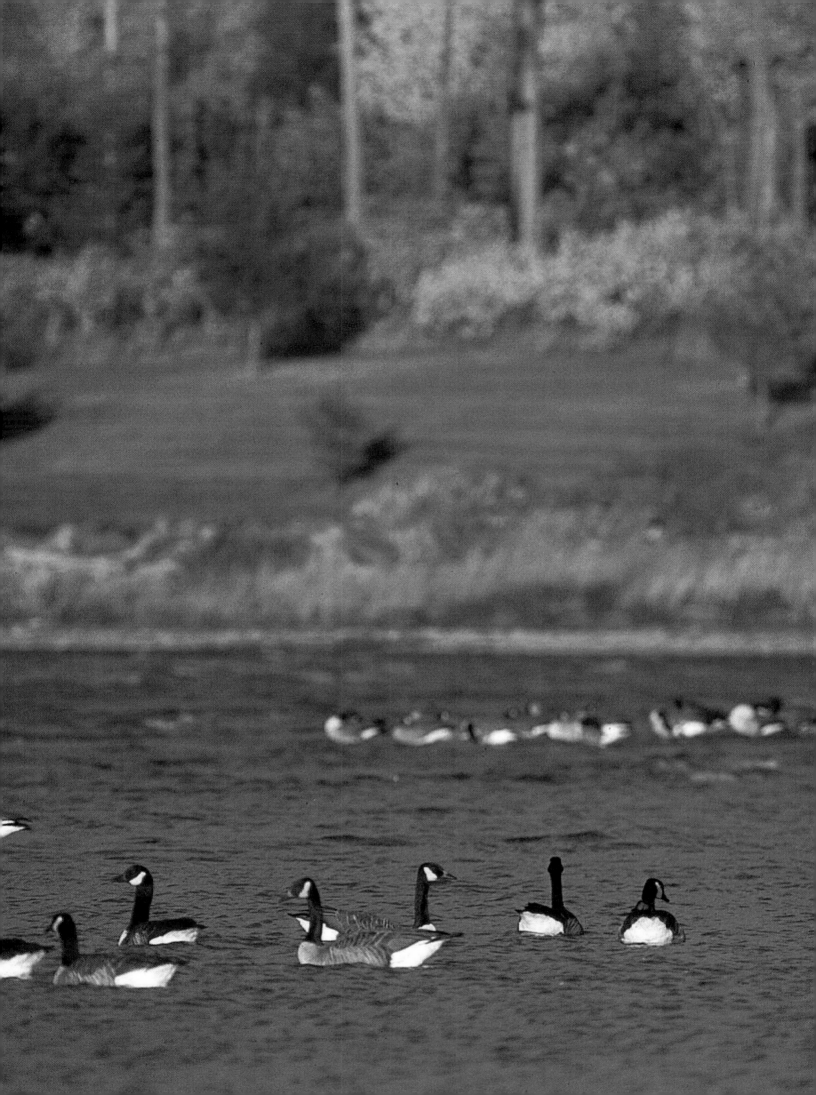

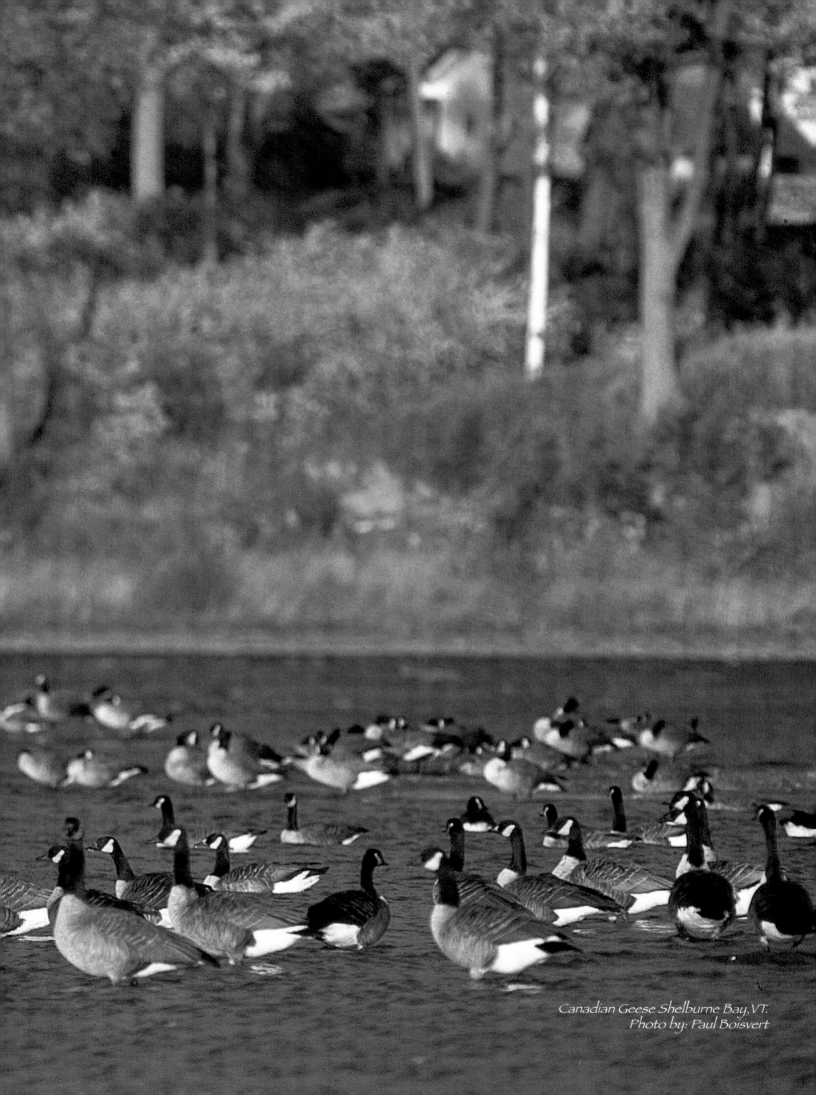

Canadian Geese Shelburne Bay, VT.
Photo by: Paul Boisvert

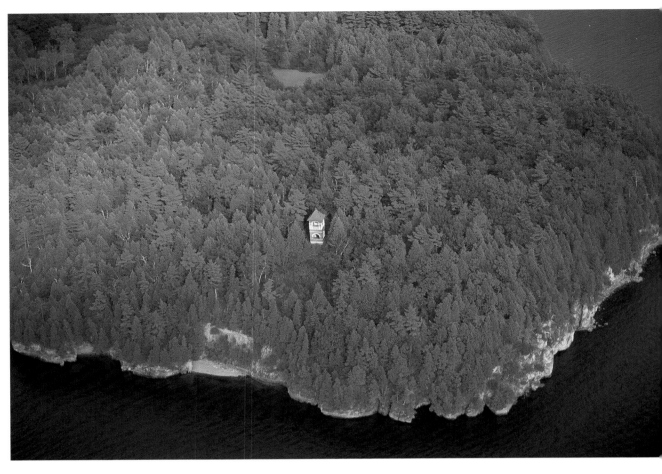

Garden Island Charlotte, VT. Photo by: Paul Boisvert

Floating champ Burlington waterfront. Photo by: Paul Boisvert

MT. Philo State Park Charlotte, VT. Photo by: Paul Boisvert

Burlington bike path. Photo by: Paul Boisvert

Burlington's Intervale area – a swath of undeveloped land along the Winooski River – is known for its rich soil and generous growing season. Here even tomatoes can dwarf a youngster. Photo by: Cheryl Dorschner

Photo by: David Seaver

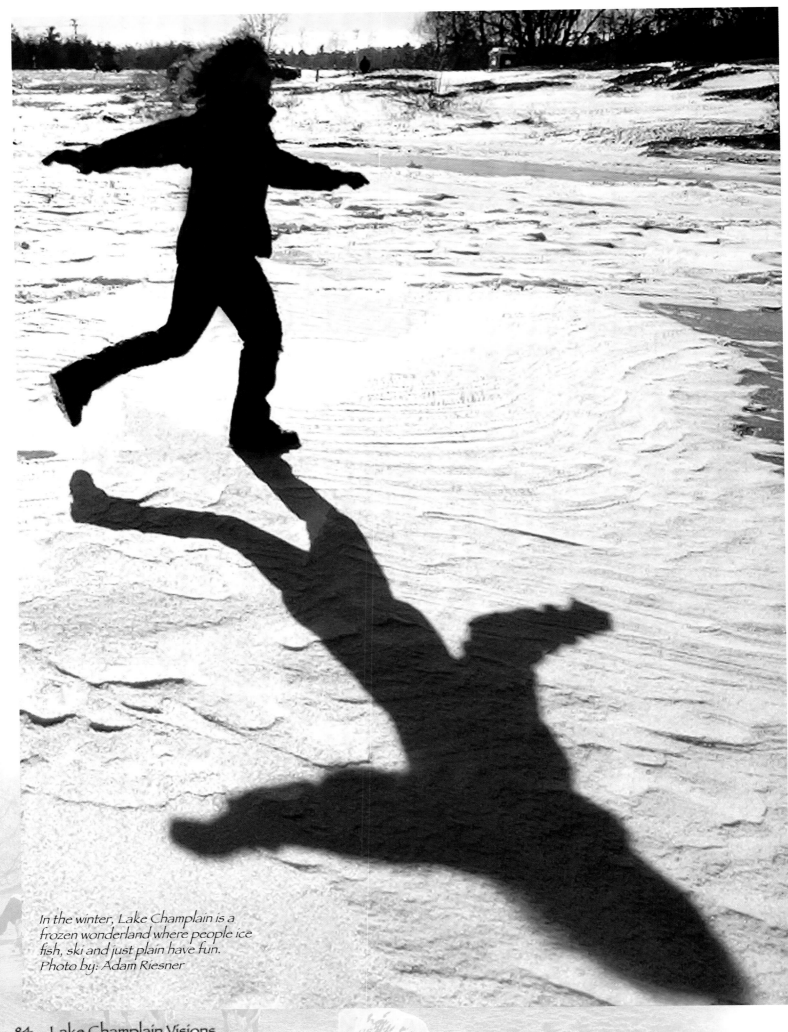

In the winter, Lake Champlain is a frozen wonderland where people ice fish, ski and just plain have fun.
Photo by: Adam Riesner

City Hall, Burlington, VT.
Photo by: Paul Boisvert

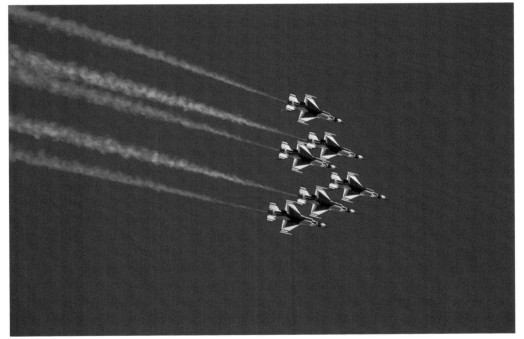

Thunderbirds at the Burlington International Charity Air Show run by Parker Air Shows. Photo by: Sandy Macy

Burlington, VT UVM green.
Photo by: Paul Boisvert

Burlington, VT bike path. Photo by: Paul Boisvert

Field and broom corn, alongside all manner of
pumpkins and squashes heralds autumn at this
1850s Vermont brick farmhouse.
Photo by: Cheryl Dorschner

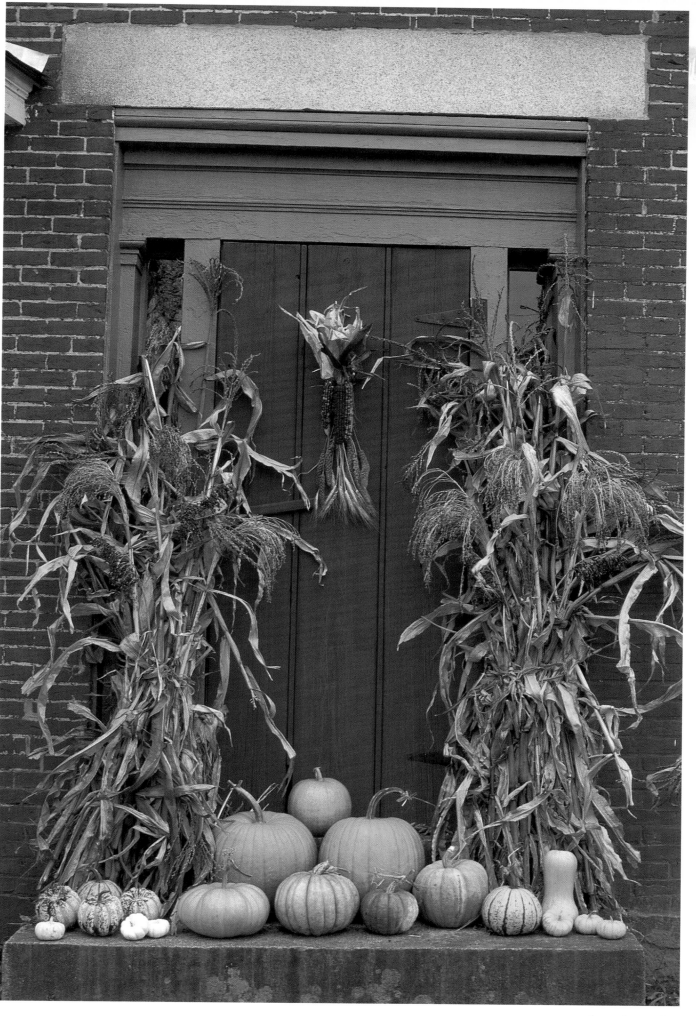

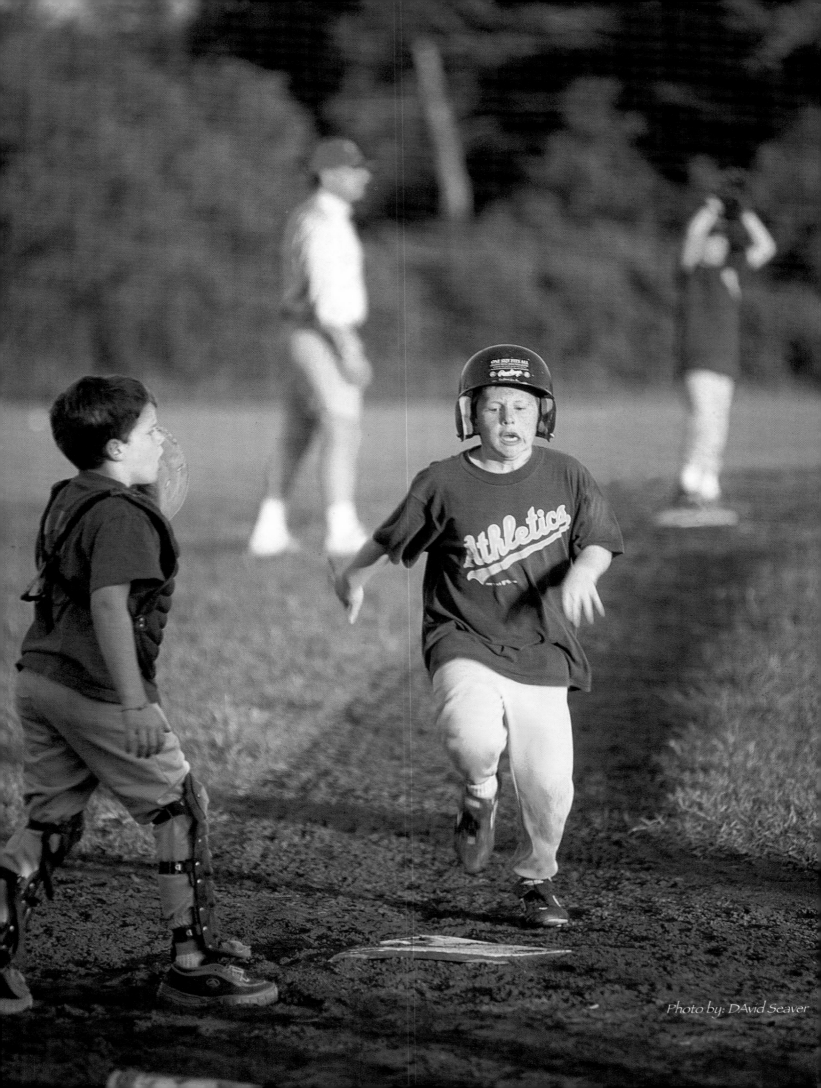

Photo by: DAvid Seaver

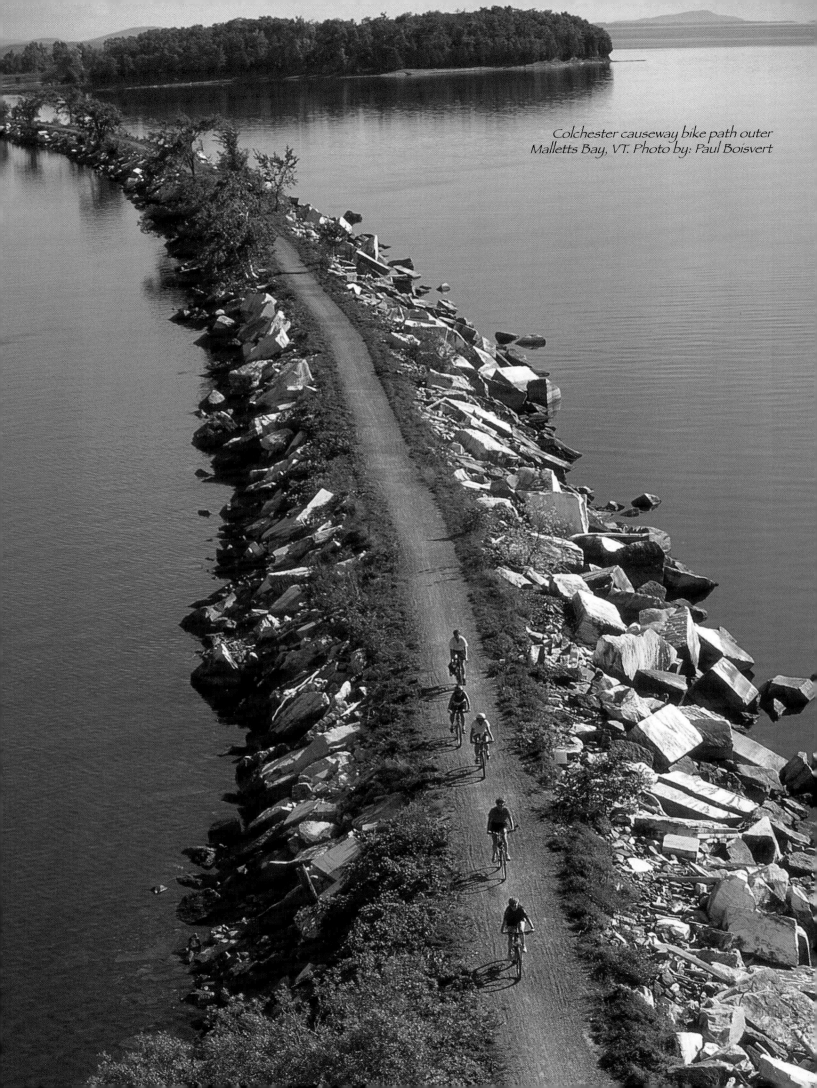

Colchester causeway bike path outer Malletts Bay, VT. Photo by: Paul Boisvert

Button Island State Park Ferrisburg, VT.
Photo by: Paul Boisvert

Testing corn for ripeness in the shade
of a garden arch is one way to while
away a bit of summer.
Photo by: Cheryl Dorschner

Window washers reflecting in the window
of a building in Burlington.
Photo by: Sandy Macy

Route 2 passes over Interstate 89 in Richmond as seen at night during a multiple, timed exposure.
Photo by: Andy Duback

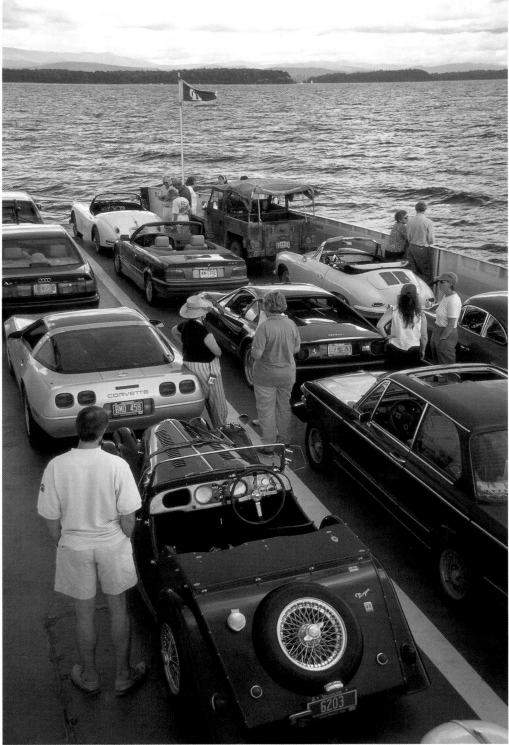

Charlotte, VT Essex N.Y. ferry crossing. Photo by: Paul Boisvert

Dance company, Moca School of New World Dance, performs the "Divine Mother Dance" at the Rose Street Gallery in Burlington. From left to right: Gina Pearce of Randolph Center, Erin Kelly of Montpelier, choreographer Monica Caldwell of Montpelier, Willow Wonder of Morgan and Lydia Trebilcock of Montpelier. Photo by: Andy Duback

University of Vermont students who are in the Jazz program there often find venues in town to perform. This scene is at Radio Bean in Burlington as part of the jazz quartet's regular Tuesday gig. Photo by: Andy Duback

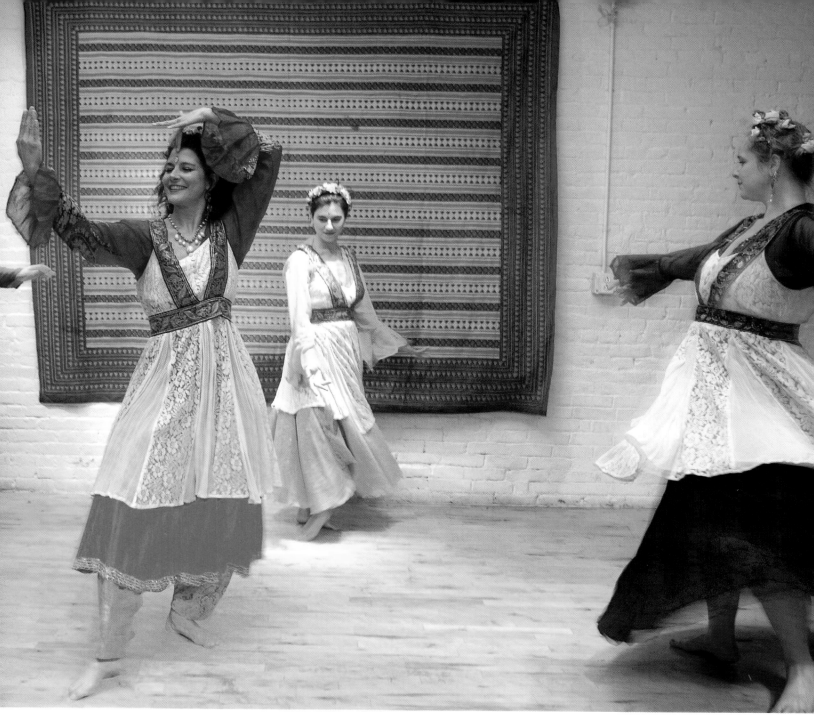

Jamie Pierson driving a powerboat on the
main lake. Photo by: Paul Boisvert

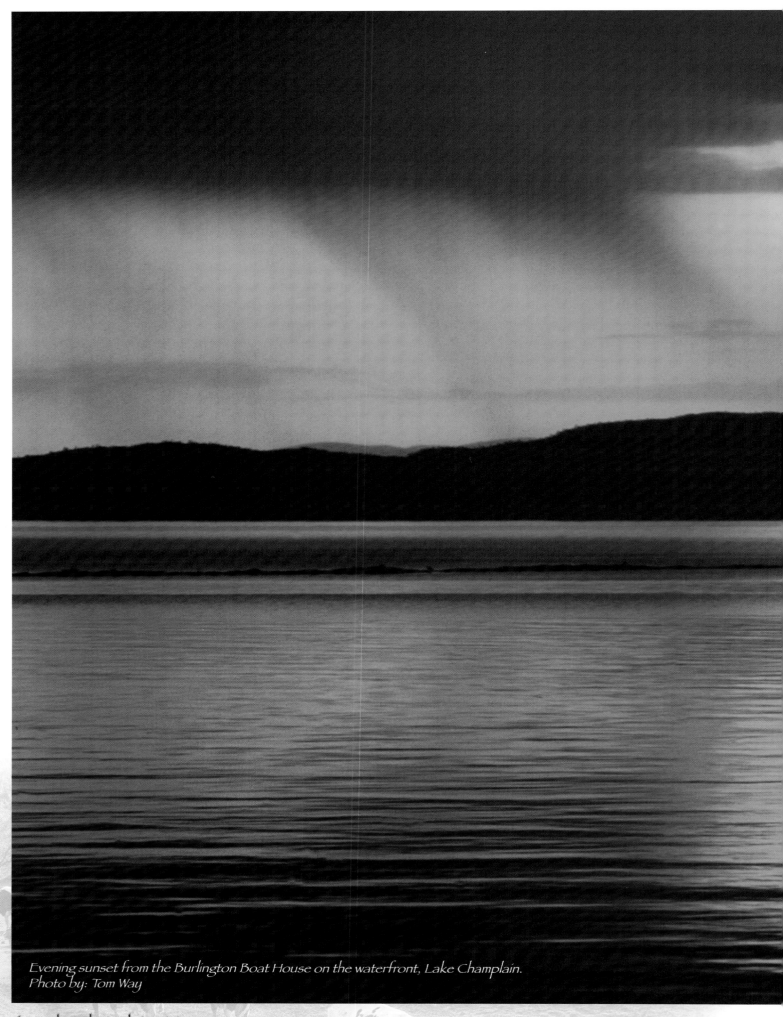

Evening sunset from the Burlington Boat House on the waterfront, Lake Champlain.
Photo by: Tom Way

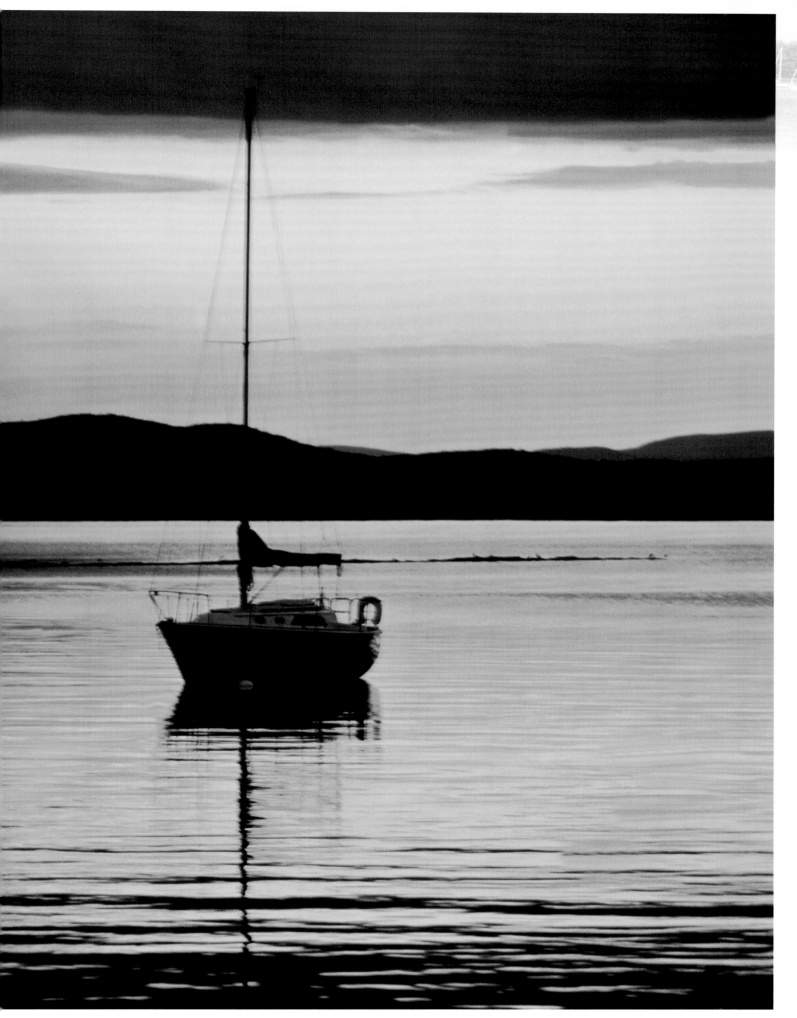

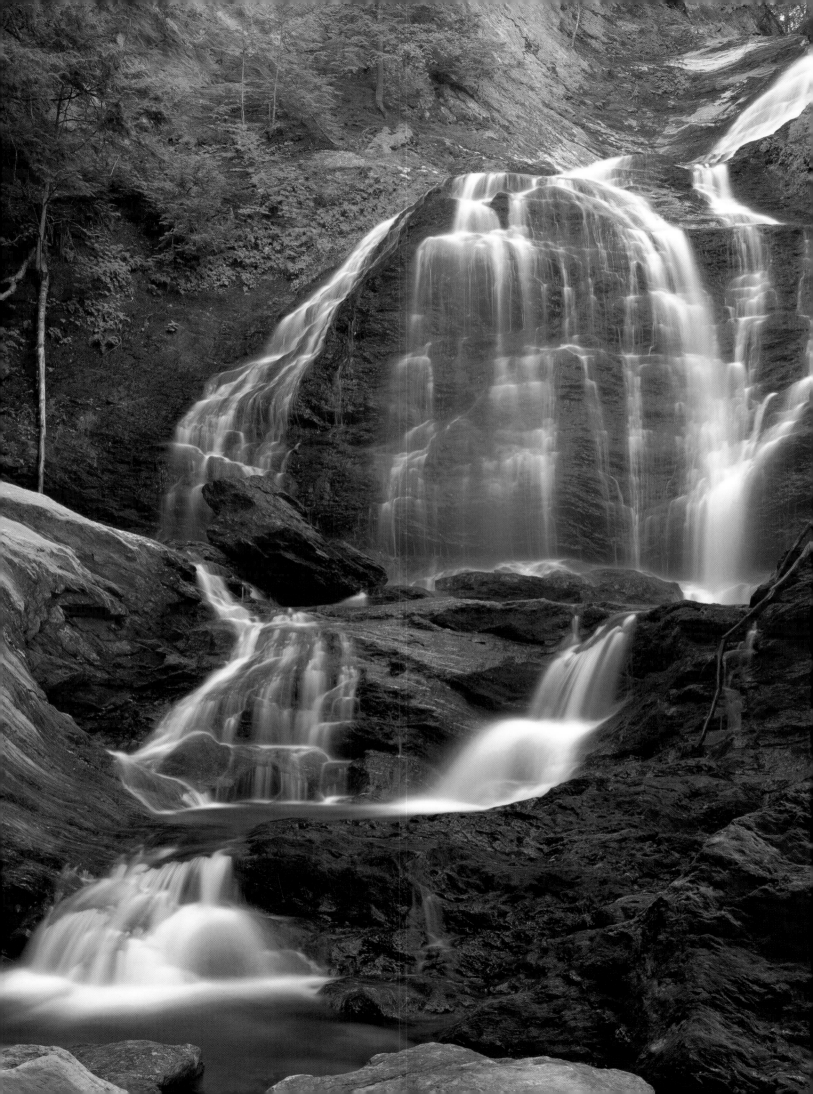

Moss Glen Falls, Stowe.
Photo by: Jim Westphalen

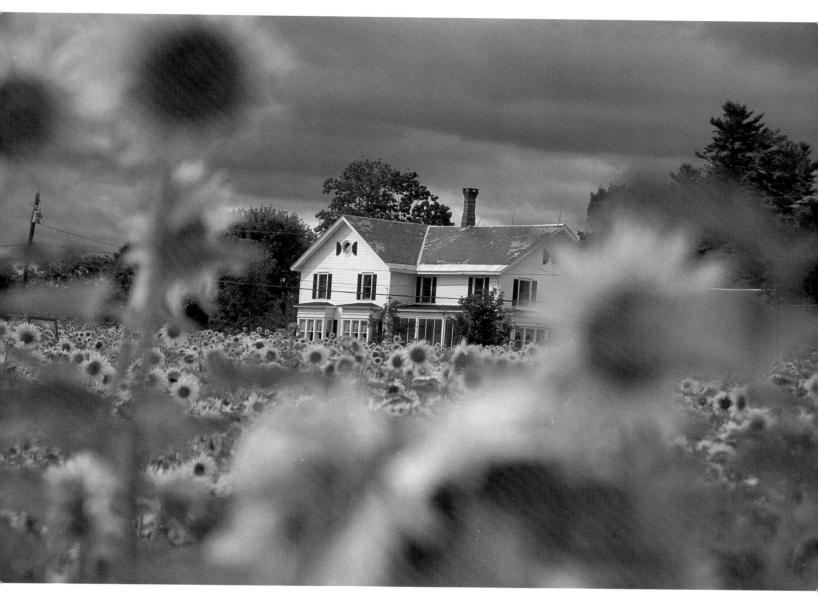

Photo by: David Seaver

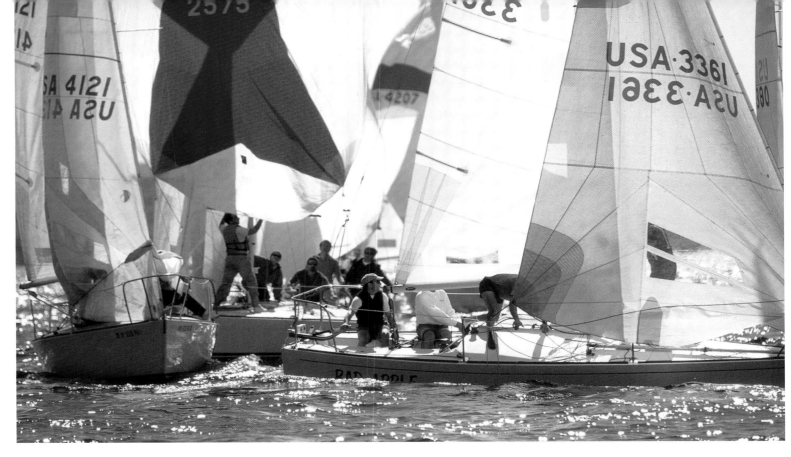

J-24 race Burlington, VT.
Photo by: Paul Boisvert

Great Blue Heron
Photo by: Paul Boisvert

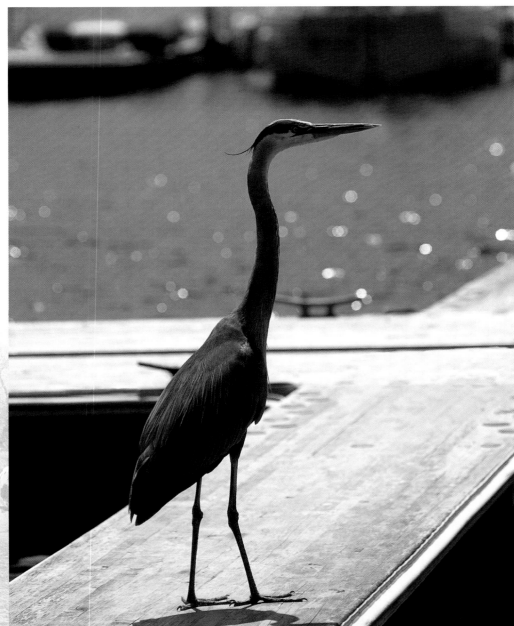

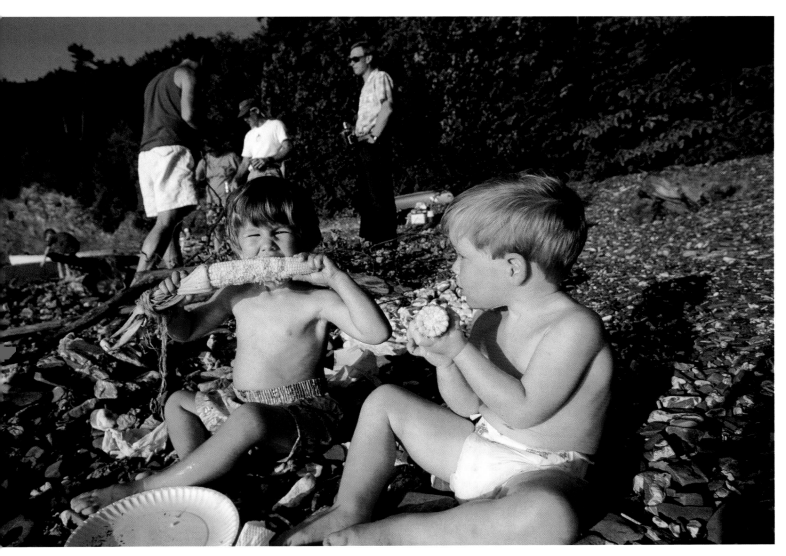

Shelburne VT beach party. Photo by: Paul Boisvert

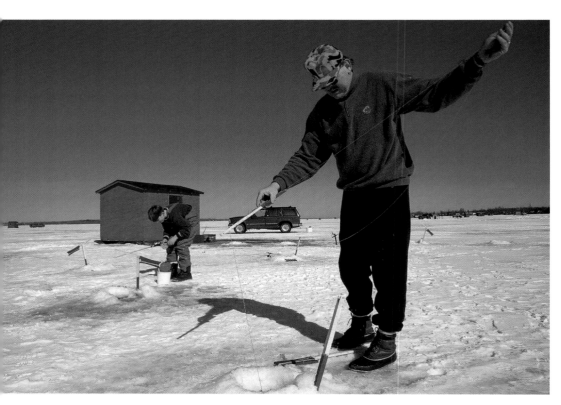

Icefishing, Swanton VT. Photo by: Paul Boisvert

Photo by: David Seaver

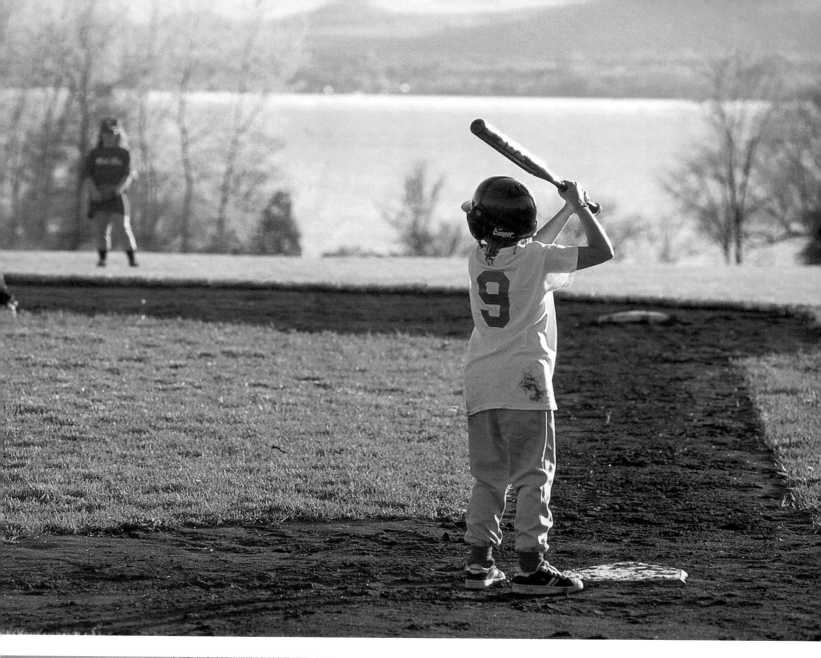

UVM green, Burlington VT.
Photo by: Paul Boisvert

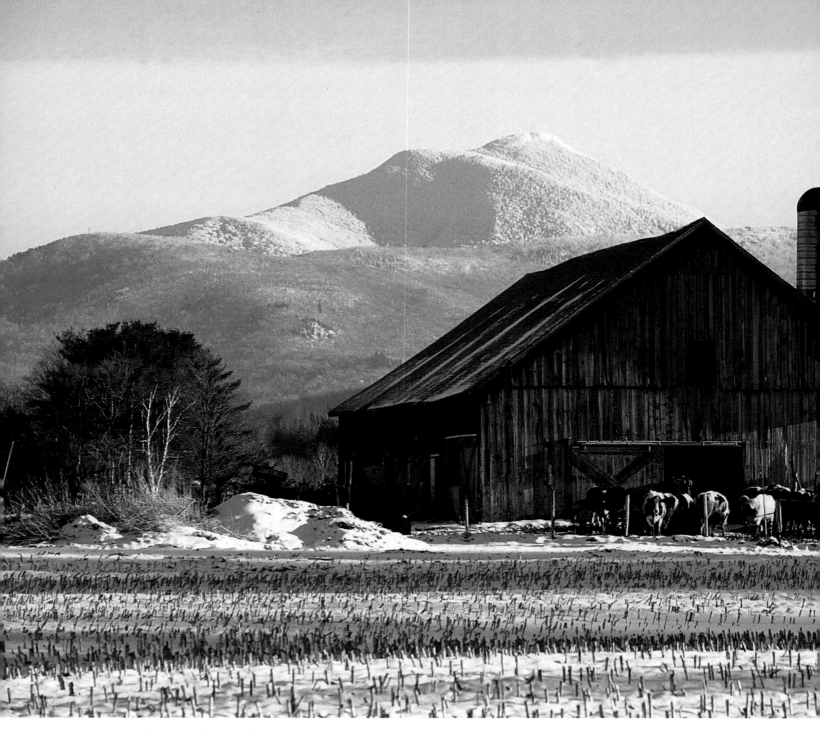

Winter time on a farm in Williston. Photo by: Sandy Macy

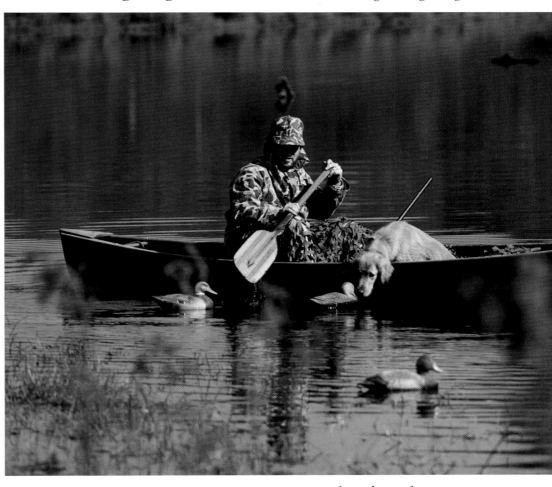

Duck hunter and dog at Wrightsville Dam in Middlesex. Photo by: Sandy Macy

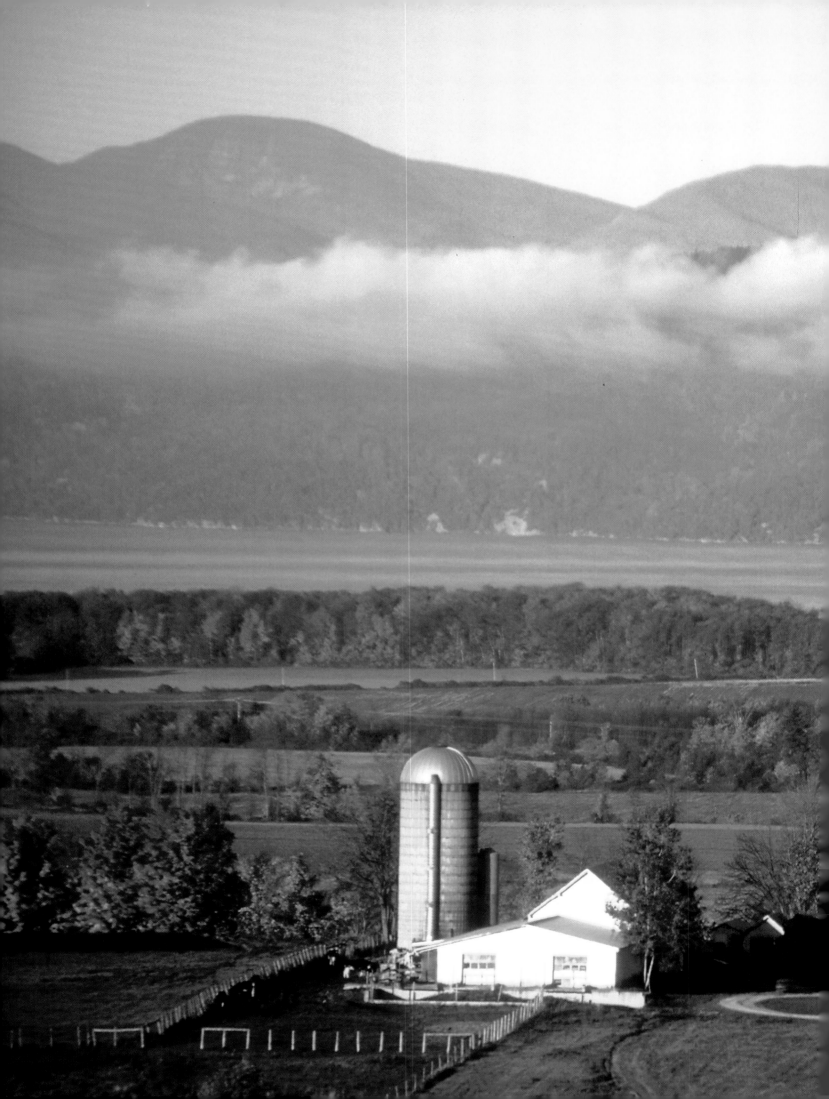

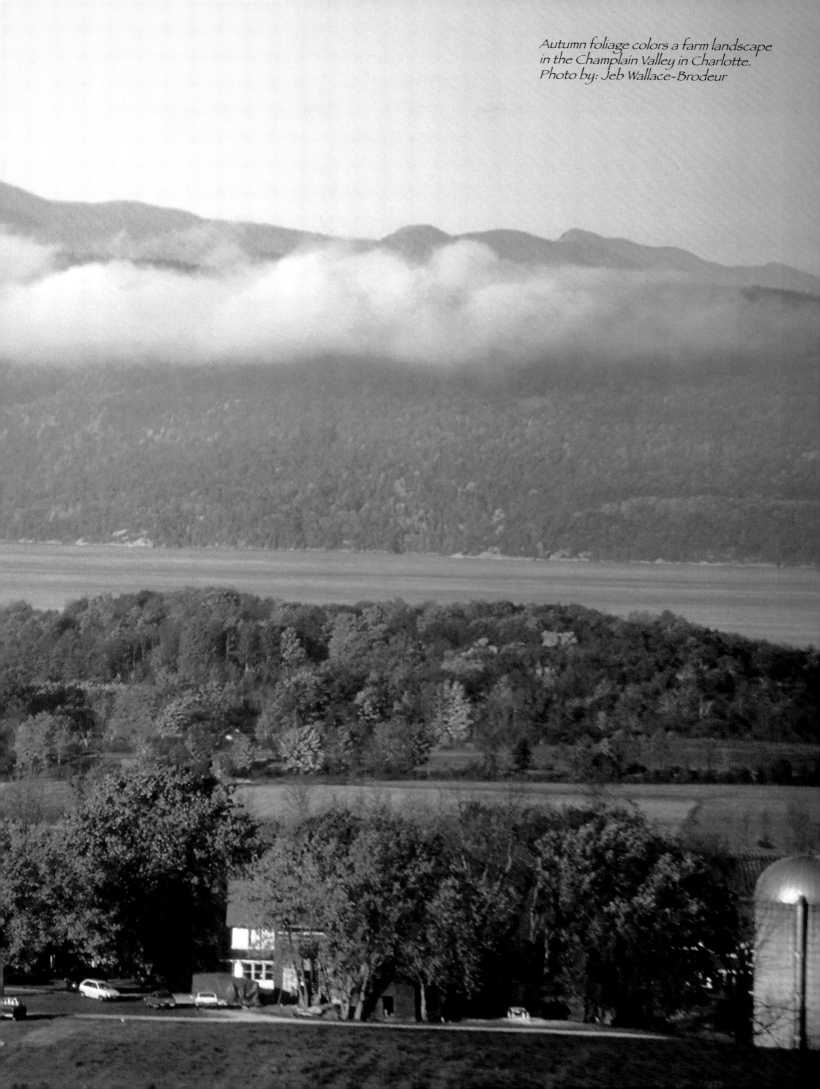

Autumn foliage colors a farm landscape in the Champlain Valley in Charlotte.
Photo by: Jeb Wallace-Brodeur

The Children's Discovery Garden at nearby Ethan Allen Homestead often holds garden contests whose winning designs are planted. One year a tribute to Vermont's own 1972 Olympic Gold Medallist in Slalom in Sapporo, Japan – Barbara Ann Cochran.
Photo by: Cheryl Dorschner

FINISH

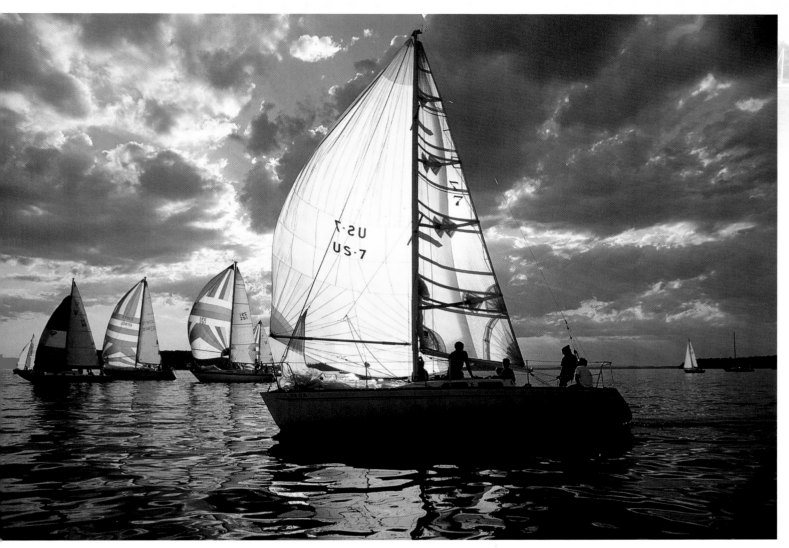

Thursday night sailing race in Malletts Bay, VT. Photo by: Paul Boisvert

Burlington, VT bike path. Photo by: Paul Boisvert

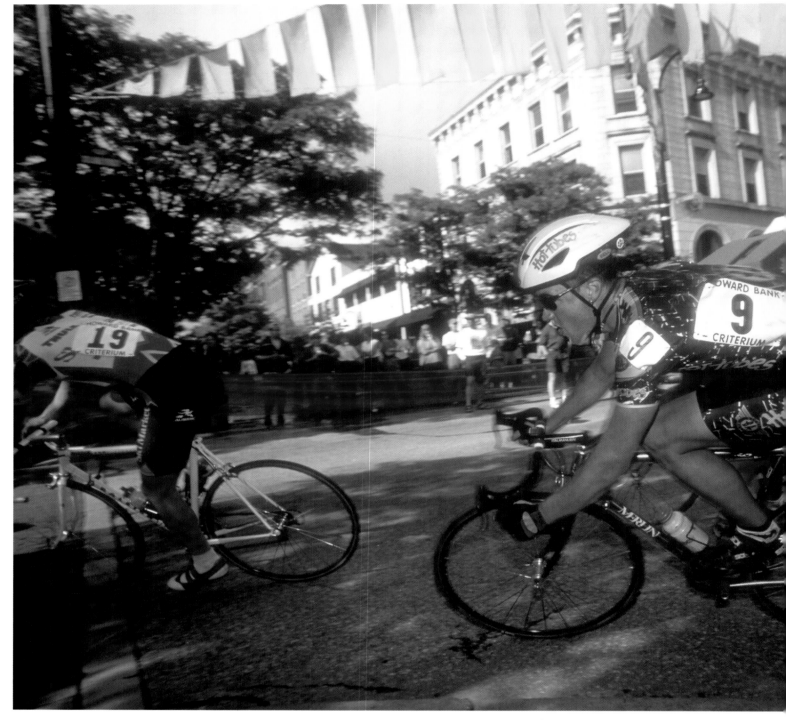

Racers speed through downtown Burlington during the annual criterium bike race held each summer on the streets of the city. Photo by: Jeb Wallace-Brodeur

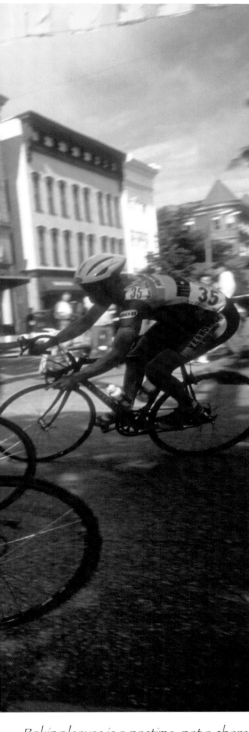

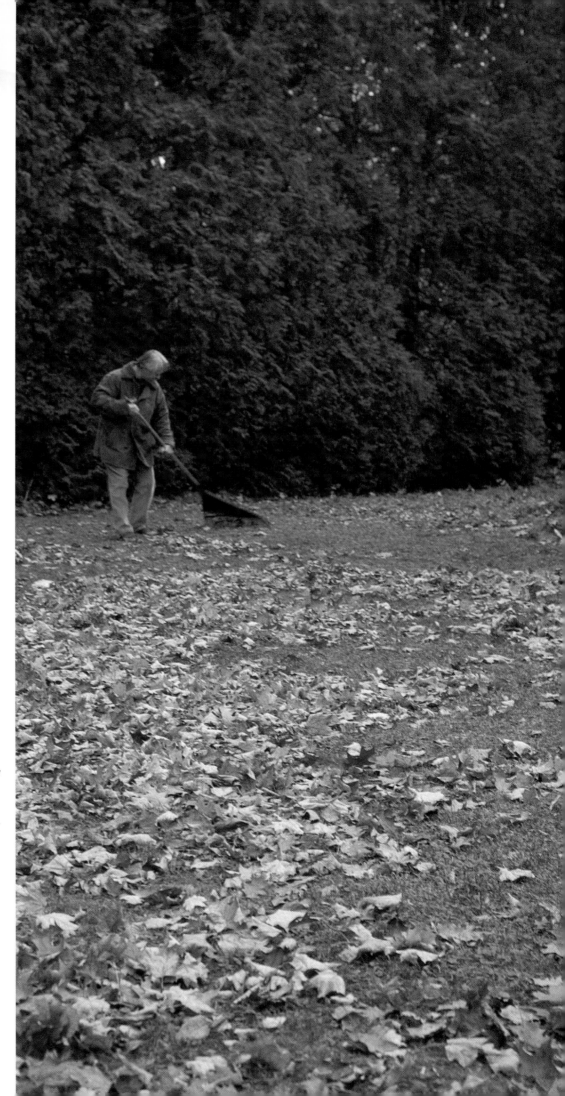

Raking leaves is a pastime, not a chore,
in the Green Mountain State. And
Burlingtonians are not exempt. The city is
noted for its many grand old trees.
Photo by: Cheryl Dorschner

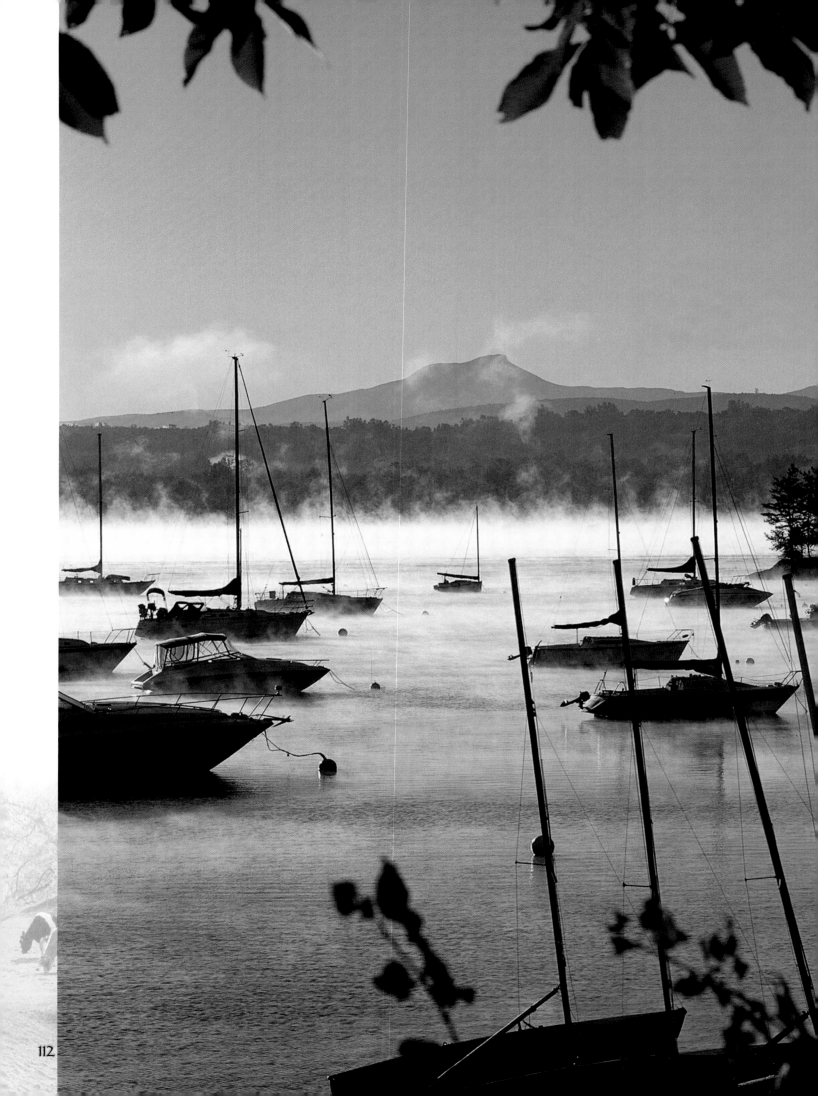

Lake Champlain Yacht Club fall sunrise
Shelburne Bay, VT. Photo by: Paul Boisvert

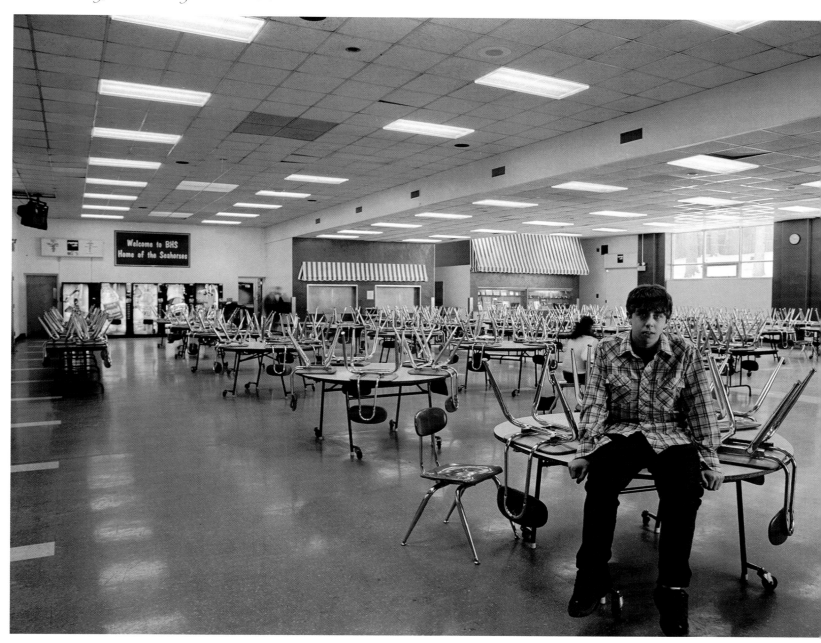

BTrevor Powers sits inside of Burlington High School after school. Photo by: Andy Duback

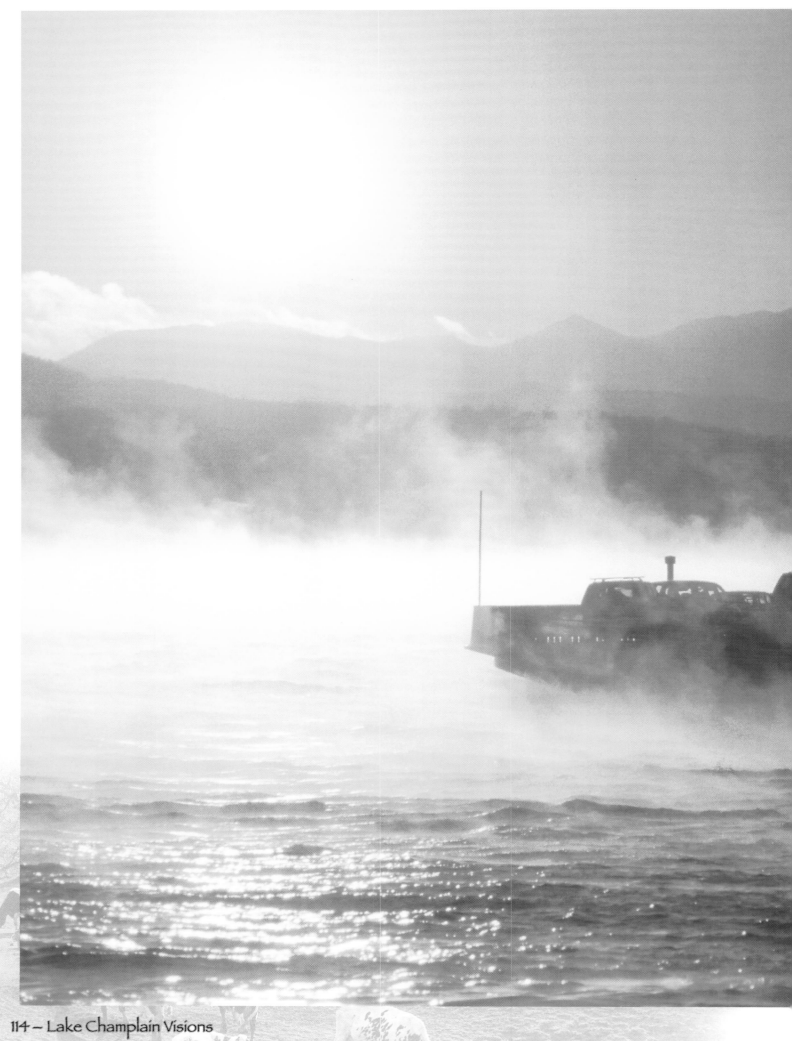

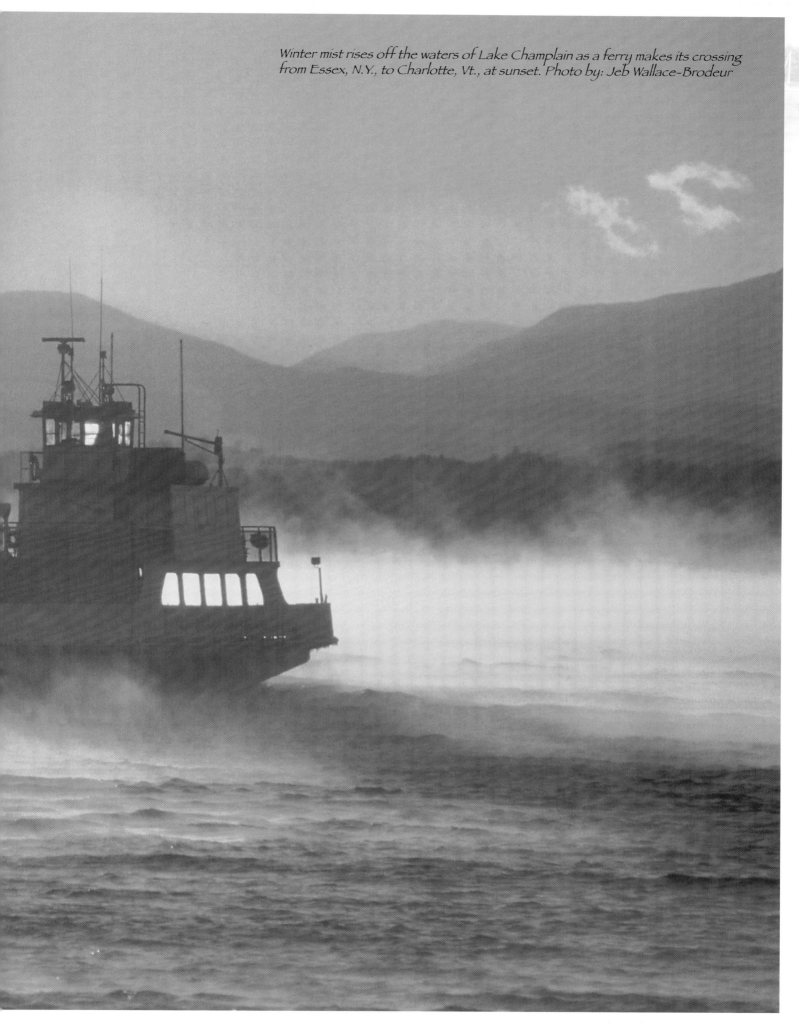

Winter mist rises off the waters of Lake Champlain as a ferry makes its crossing from Essex, N.Y., to Charlotte, Vt., at sunset. Photo by: Jeb Wallace-Brodeur

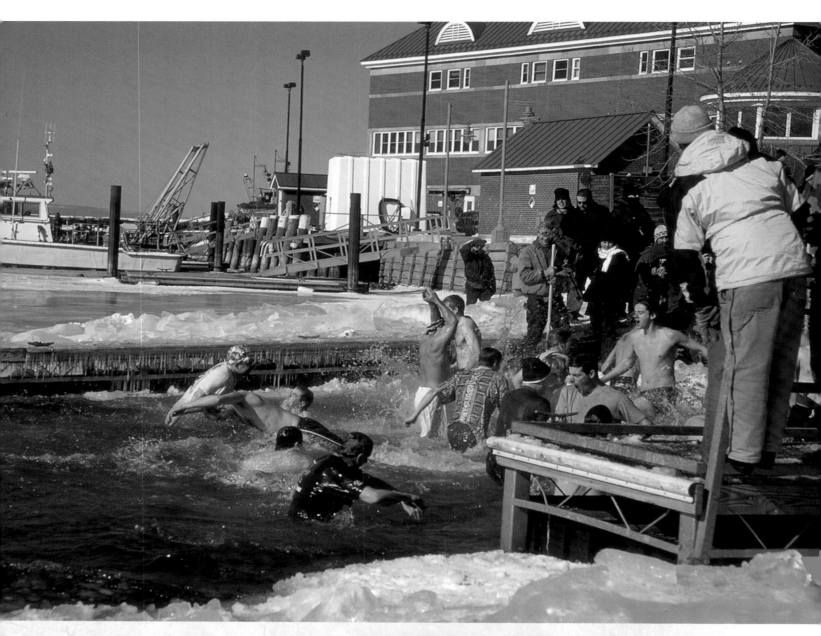

Polar Bear Plunge! January, Burlington. Photo by: Natalie Stultz

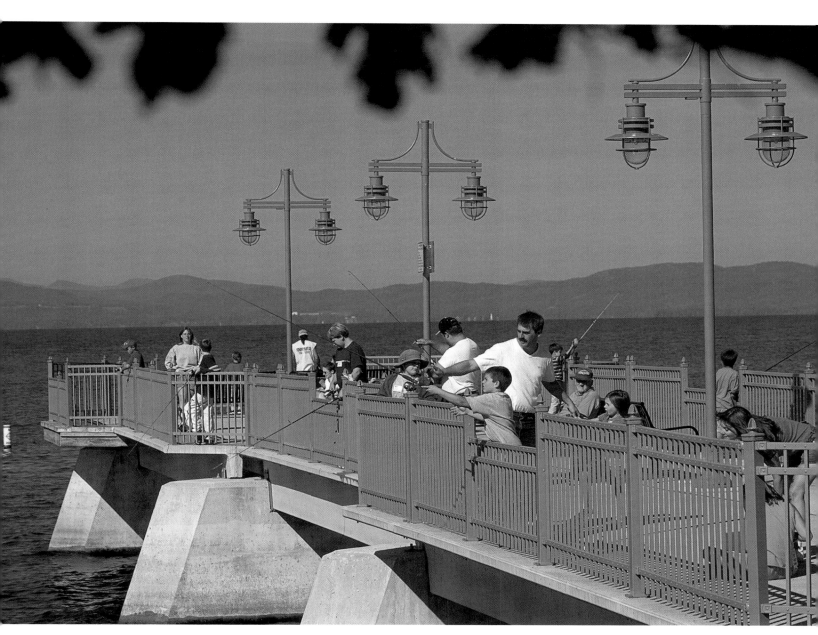

Burlington, VT fishing pier. Photo by: Paul Boisvert

Burlington, with the Waterfront in the foreground and the Green Mountains in the background looking East.
Photo by: Adam Riesner

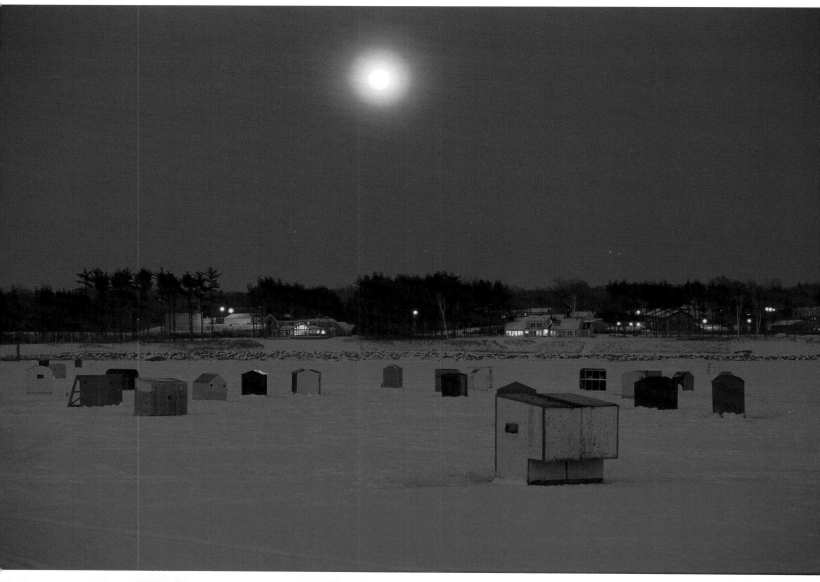

Moonrise on Shelburne Bay, VT. Photo by: Paul Boisvert

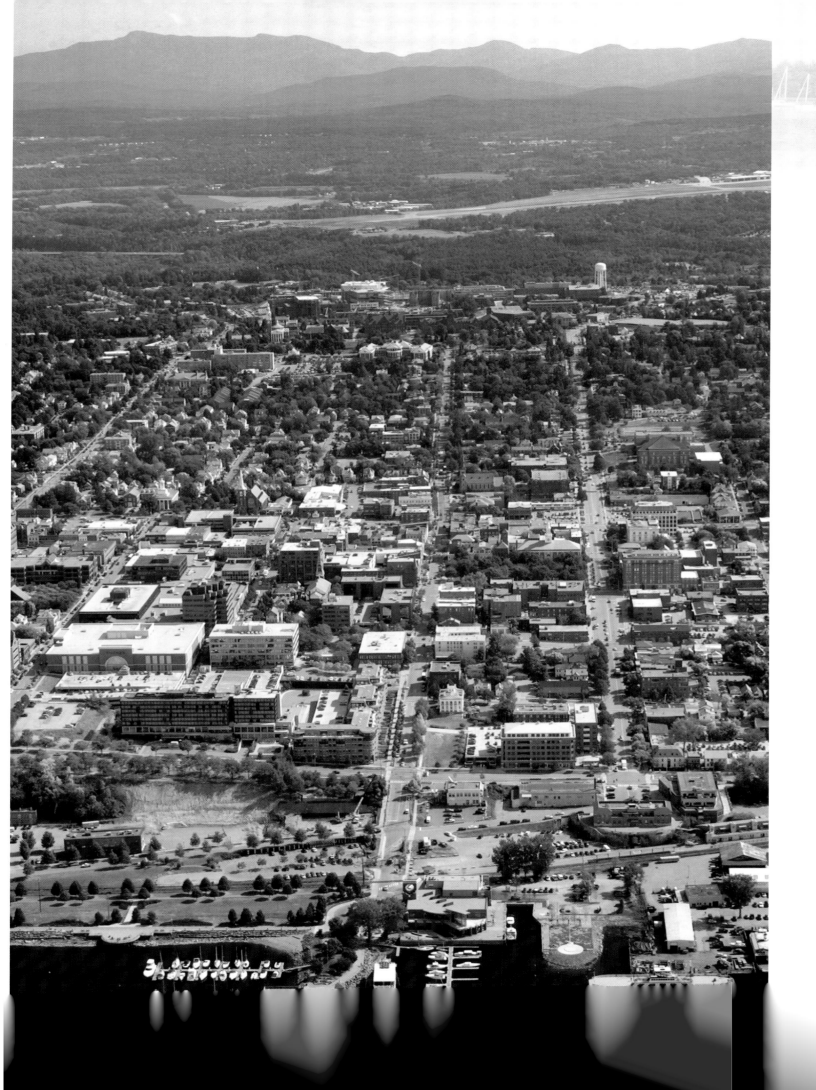

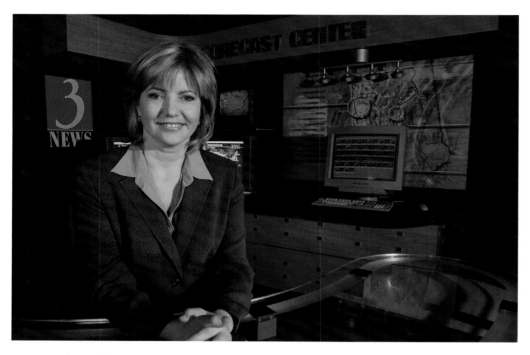

WCAX Channel 3 meteorologist, Sharon Meyer, inside of their South Burlington Studio, is a long-standing member of their award-winning news team.
Photo by: Andy Duback

The unfurling of azaleas is a well-earned sign of spring in Vermont. Gardeners grow the Vermont native, A roseum, and many cultivars such as these from one of the state's noted azalea breeders, Lou Edebohls. Photo by: Cheryl Dorschner

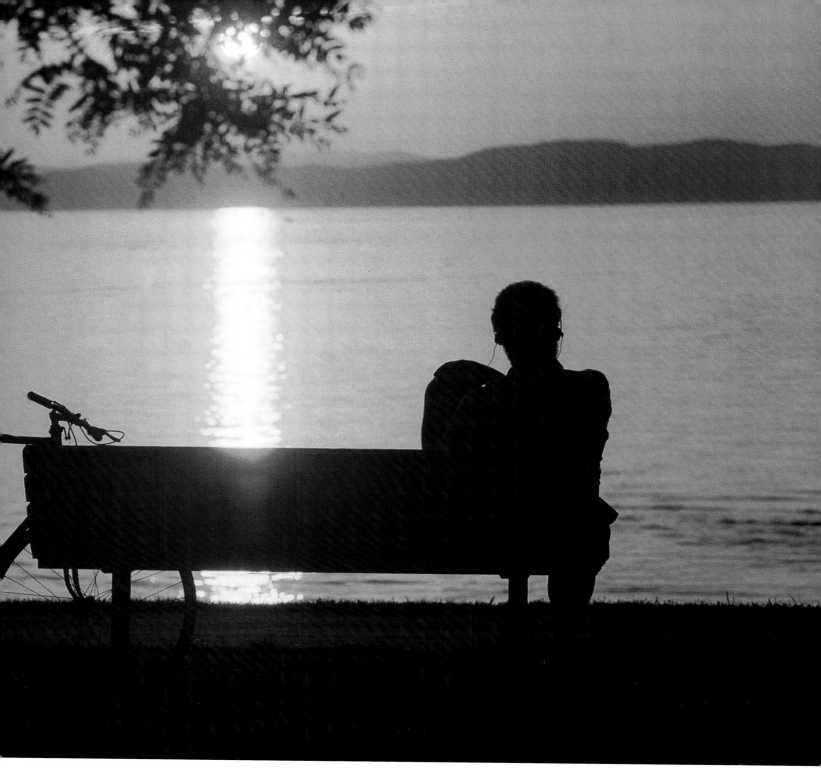

Burlington, VT bike path at sunset. Photo by: Paul Boisvert

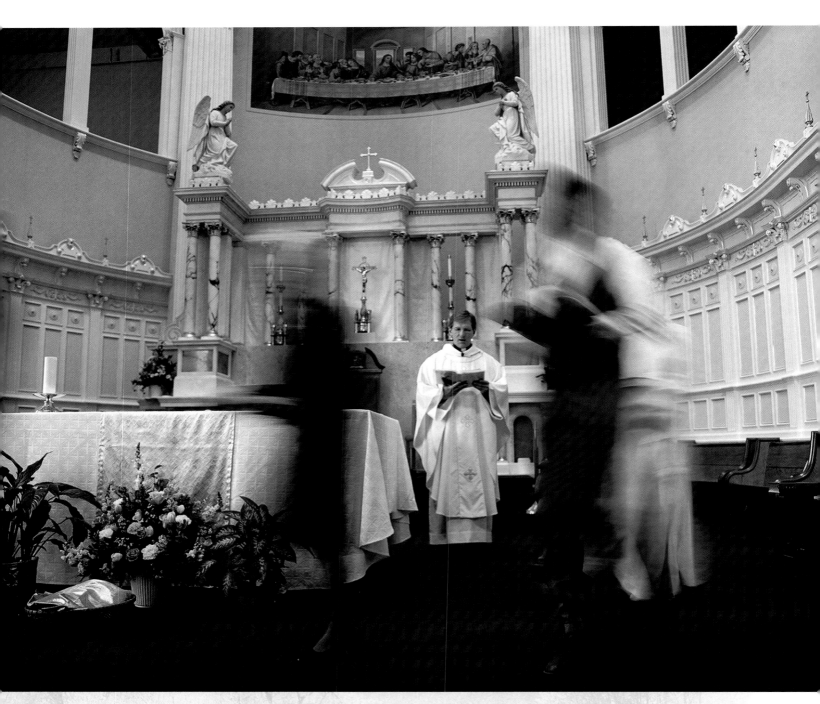

Father Steve Hornat of the Saint Joseph's Co-Cathedral in Burlington during a Sunday service. Photo by: Andy Duback

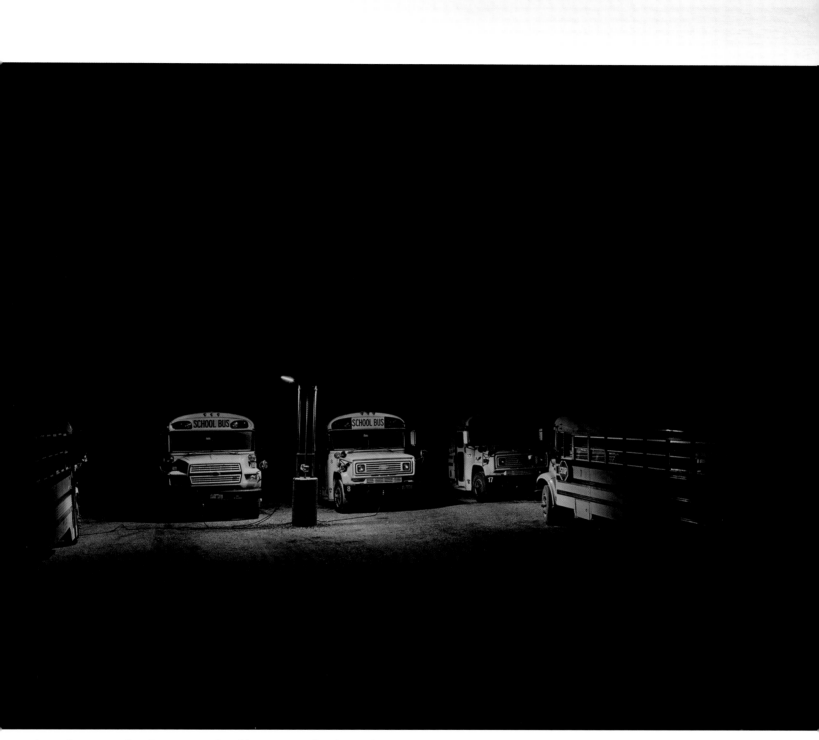

South Burlington School District school buses rest for the night.
Photo by: Andy Duback

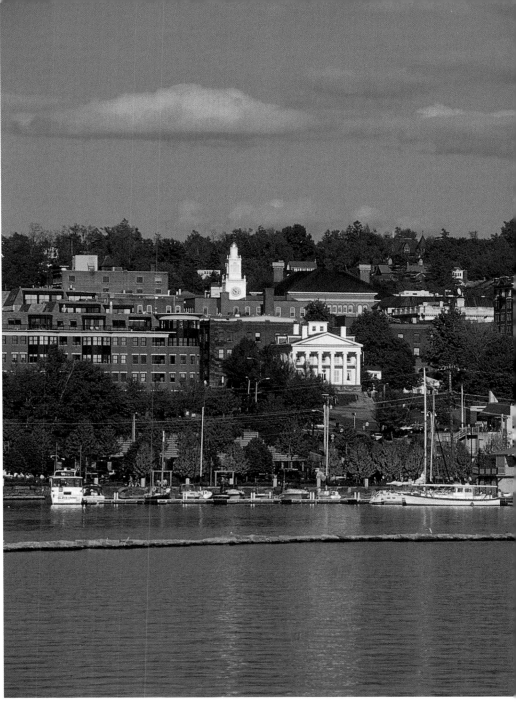

Photo by: David Seaver

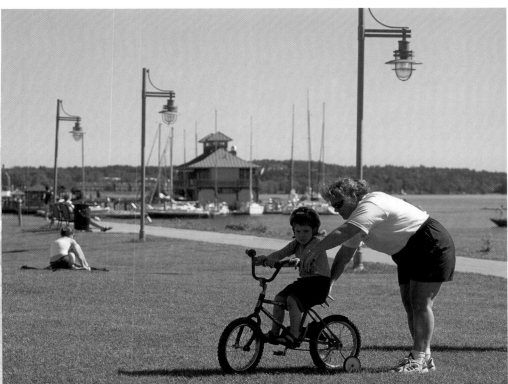

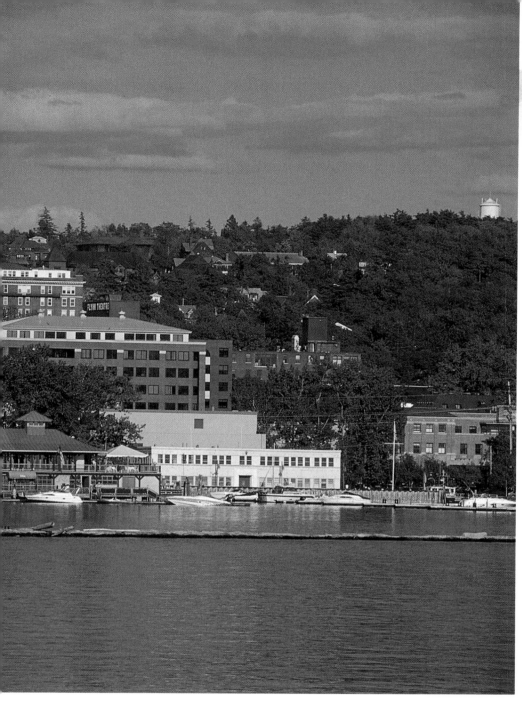

The city of Burlington and taken from a commercial boat cruise on Lake Champlain. Photo by: Sandy Macy

Ice skating off Shelburne Point, VT. Photo by: Paul Boisvert

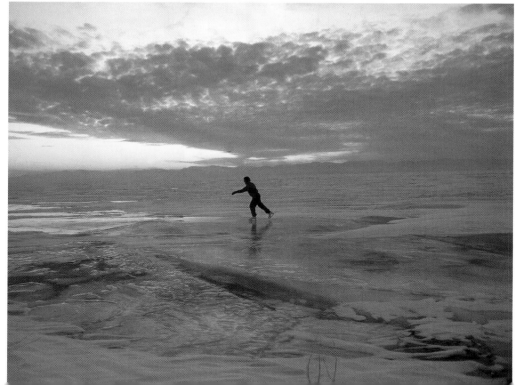

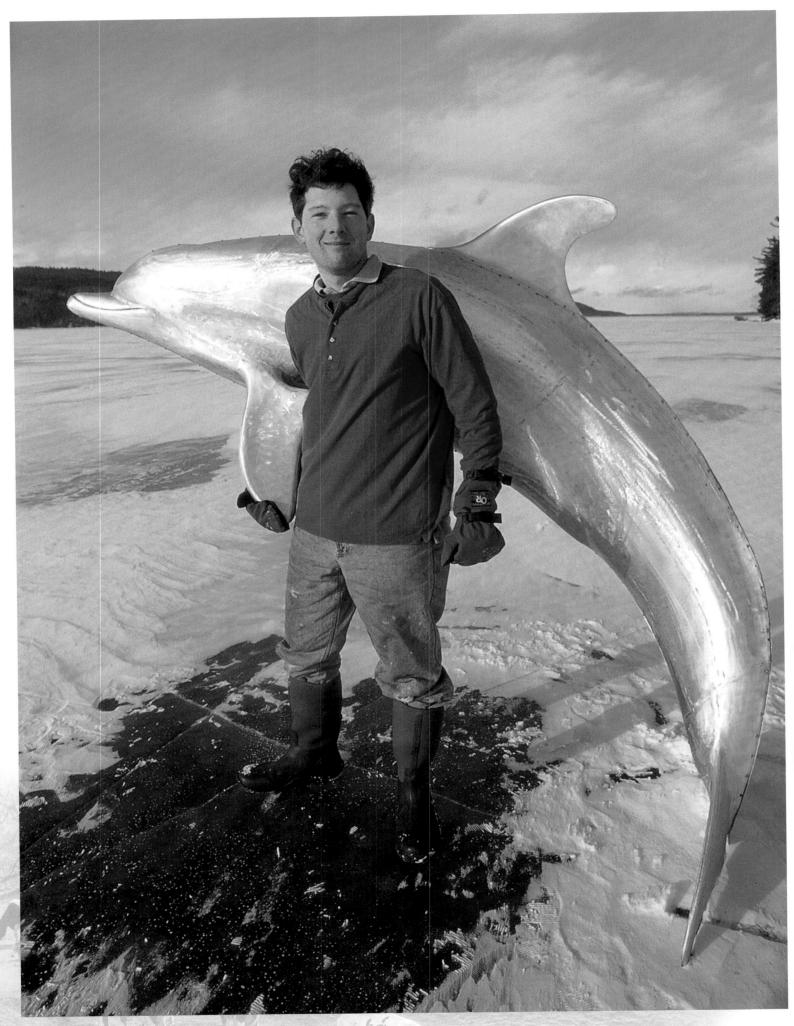

Sculptor Eben Markowski with his Dolphin on the frozen lake at Basin Harbor, Vergennes.
Photo by: Natalie Stultz

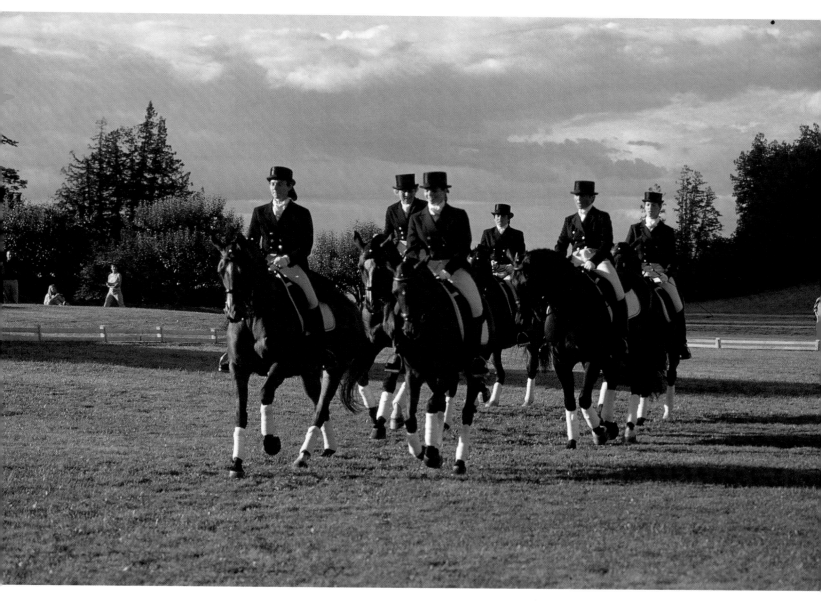

A demonstration of dressage at Shelburne Farms prior to a Mozart concert. Photo by: Sandy Macy

Photo by: David Seaver

Thursday night sailing race Malletts Bay,
VT. Photo by: Paul Boisvert

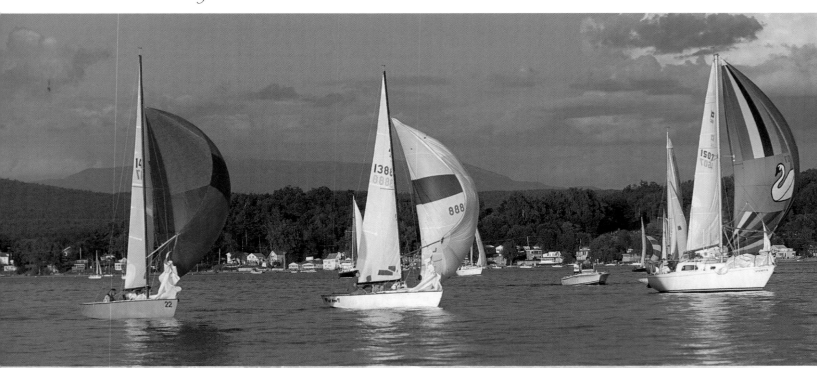

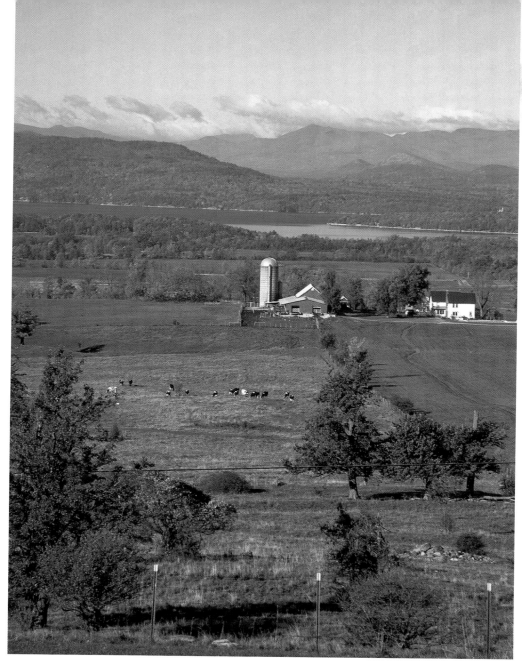

Photo by: David Seaver

Sunset on the Burlington, VT harbor.
Photo by: Paul Boisvert

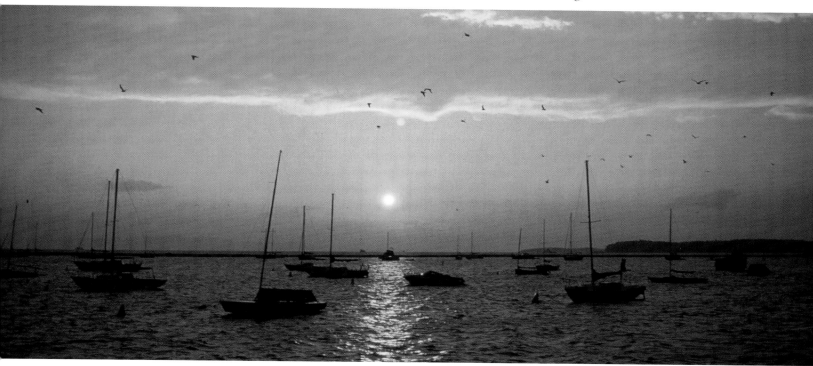

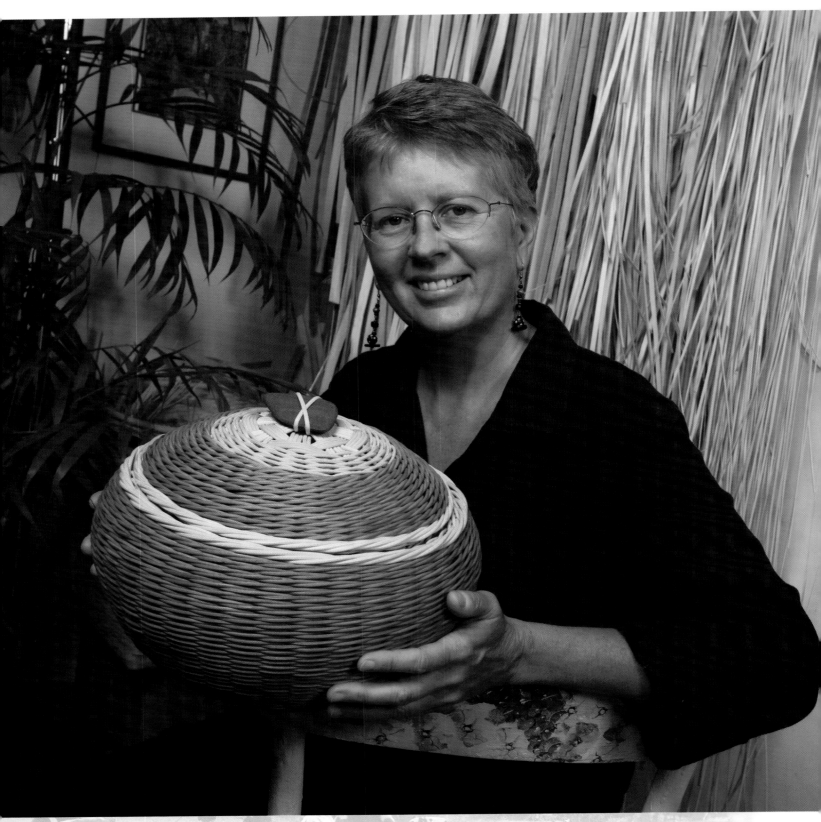

Basket maker Sandy Jefferis in her Jericho, Vermont, studio. Photo by: Tom Way

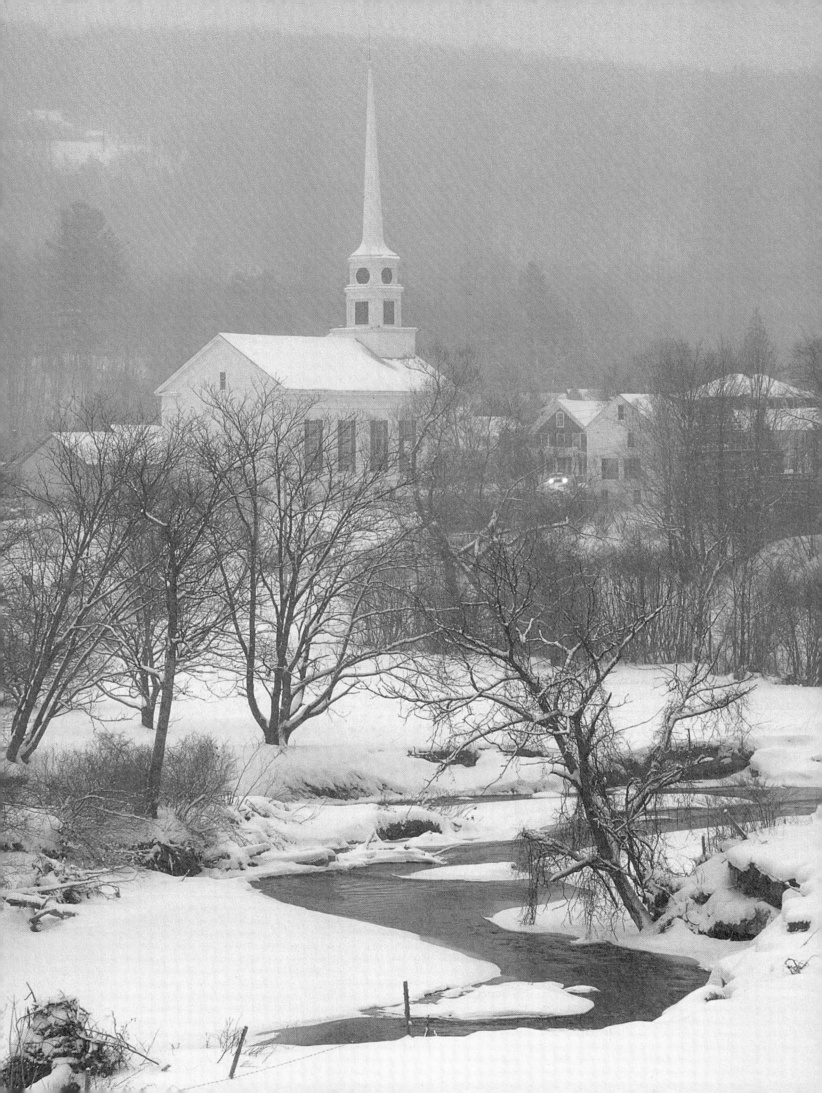

Maple sugar house in fall, Jericho, Vermont. Photo by: Tom Way

Lake Champlain Maritime Museum, Ferrisburg VT. Photo by: Paul Boisvert

Chrysanthemums and winter squash on the garden wall and dried hydrangeas on the table say autumn in this Burlington garden. Photo by: Cheryl Dorschner

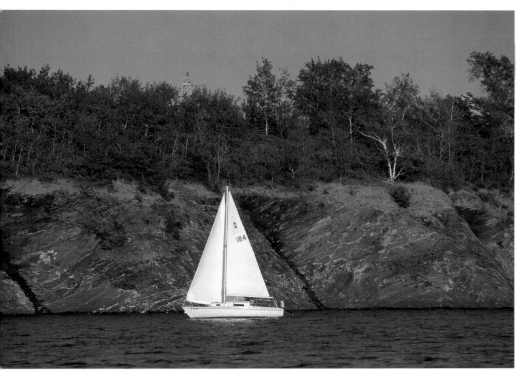

Sailing in front of Juniper Island.
Photo by: Paul Boisvert

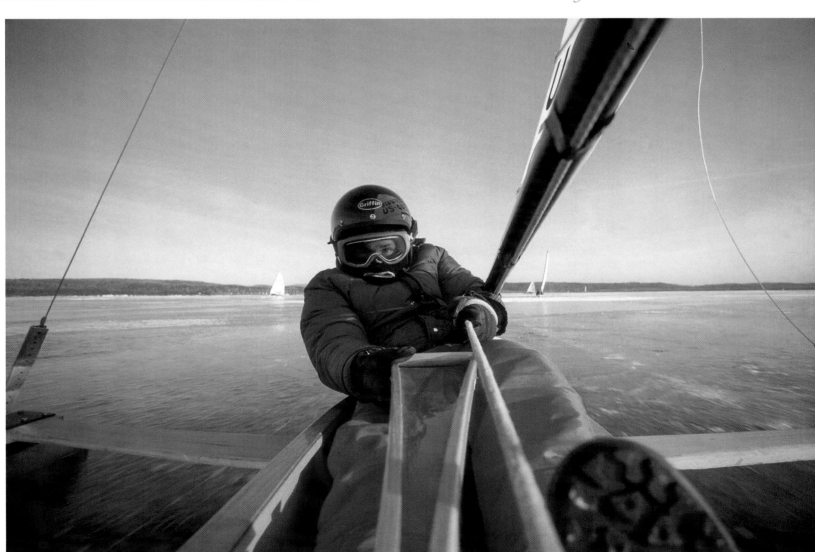

Iceboat racing at Sand Bar State Park, Milton VT. Photo by: Paul Boisvert

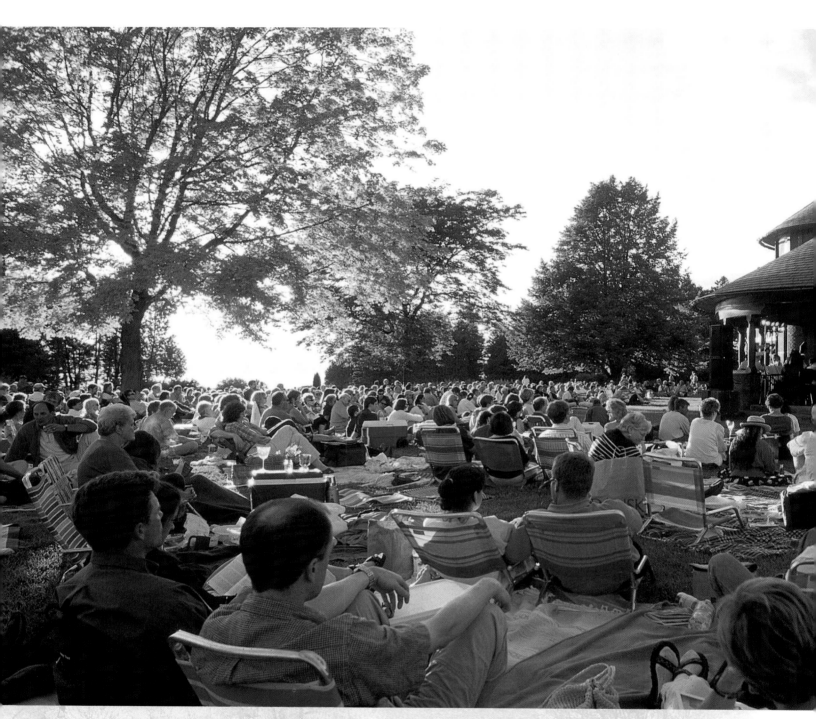

Mozart concert at Shelburne Farms. Photo by: Sandy Macy

Photo by: David Seaver

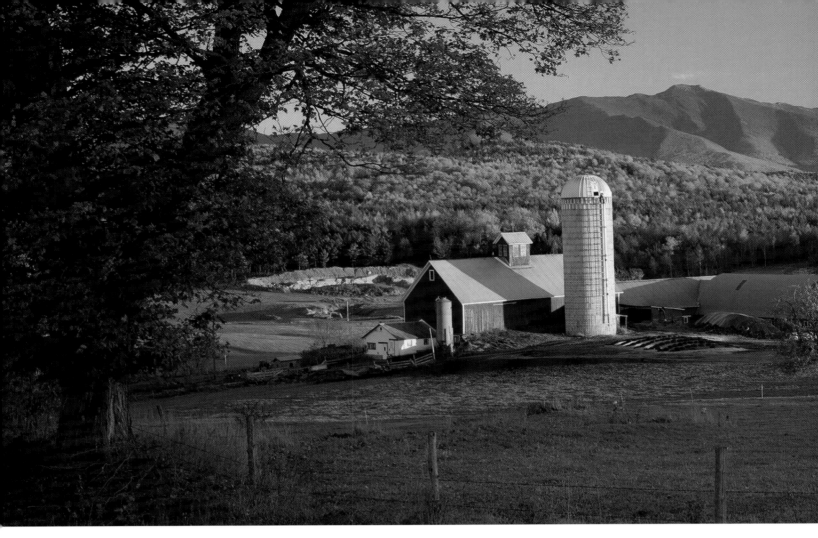

The warm light of days end on a farm near Fletcher. Photo by: Jim Westphalen

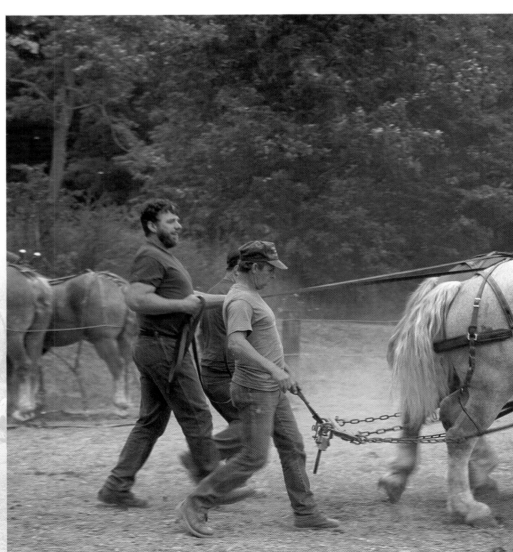

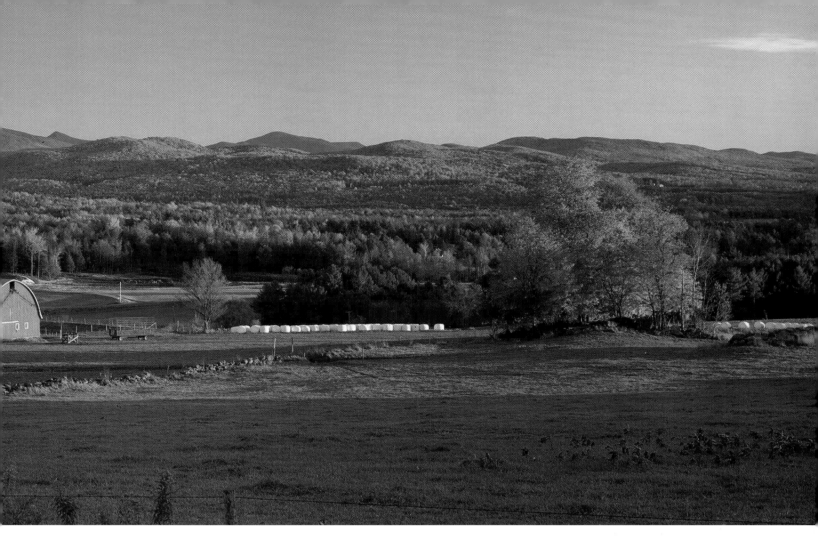

Photo by: David Seaver

*Maple sap buckets emerging from a late
winter snow storm in Jericho, Vermont.
Photo by: Tom Way*

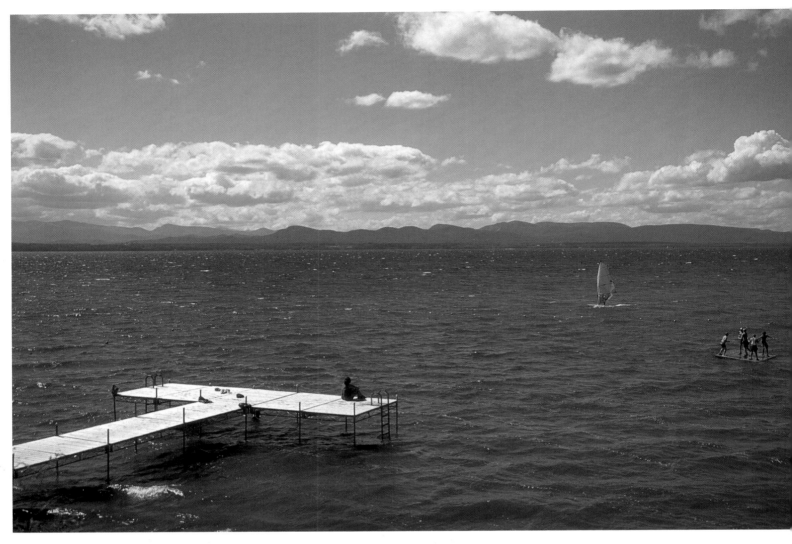

Summer pursuits in Charlotte. Photo by: Natalie Stultz

Lissy Thomas and her daughter
Katharina inside of their rental home in
South Burlington while their family builds
a new house nearby.
Photo by: Andy Duback

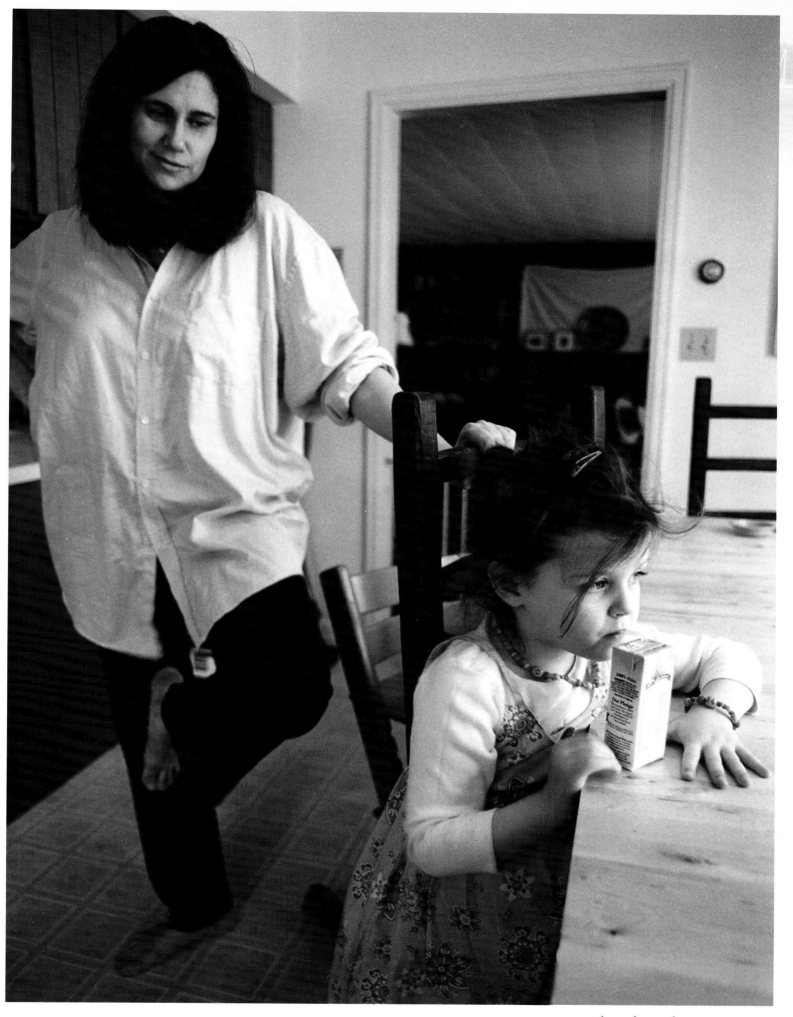

Iceboarding off South Hero, VT. Photo by: Paul Boisvert

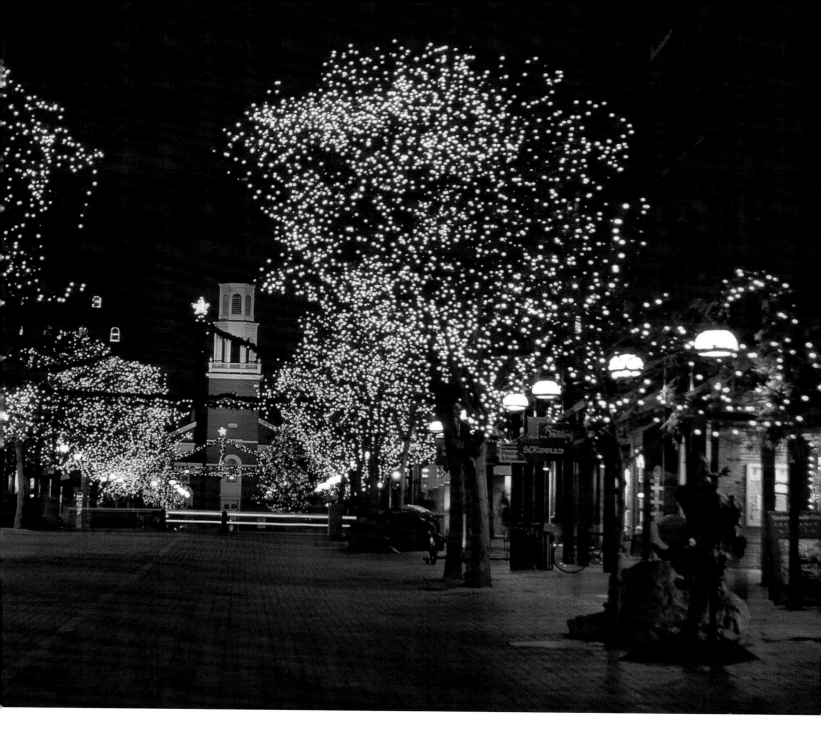

Photo by: David Seaver

Some lettuce plantings are as creative as they are delicious.
Photo by: Cheryl Dorschner

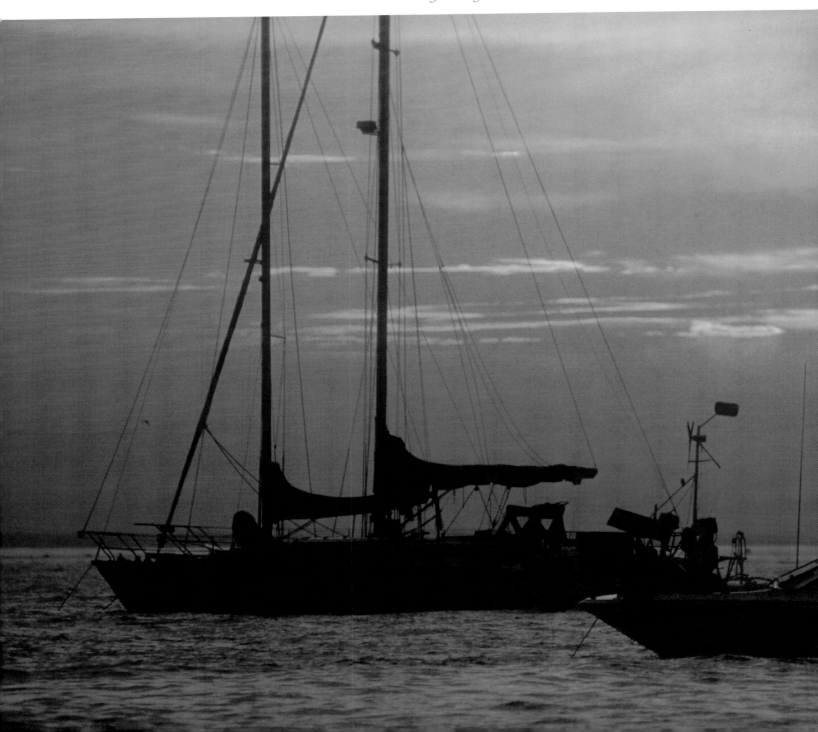

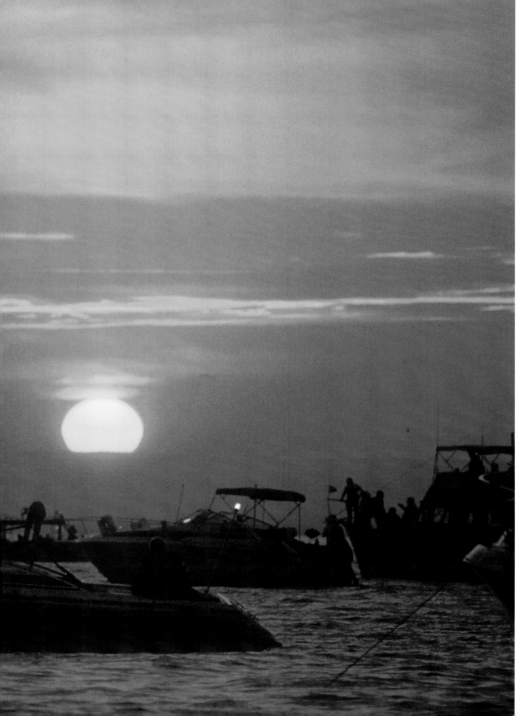

A colorful summer sun sets over boats anchored in Burlington Harbor.
Photo by: Jeb Wallace-Brodeur

Some Burlington gardens are a sophisti-
cated blend of perennials, conifers and
amenities such as the swimming pool.
Photo by: Cheryl Dorschner

Burlington, VT Winter Festival. Photo by: Paul Boisvert

Exit #14 on Interstate 89 in South Burlington is lit up on a cold winter's night. Photo by: Andy Duback

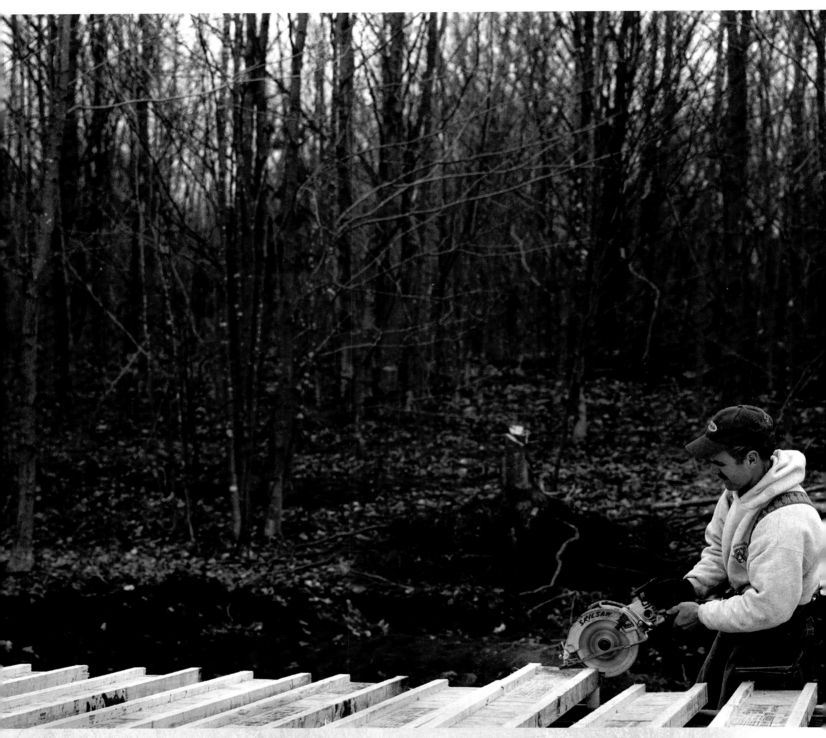

Carpenter Bob Payson sets floor joists in place for a new house in Georgia.
Photo by: Andy Duback

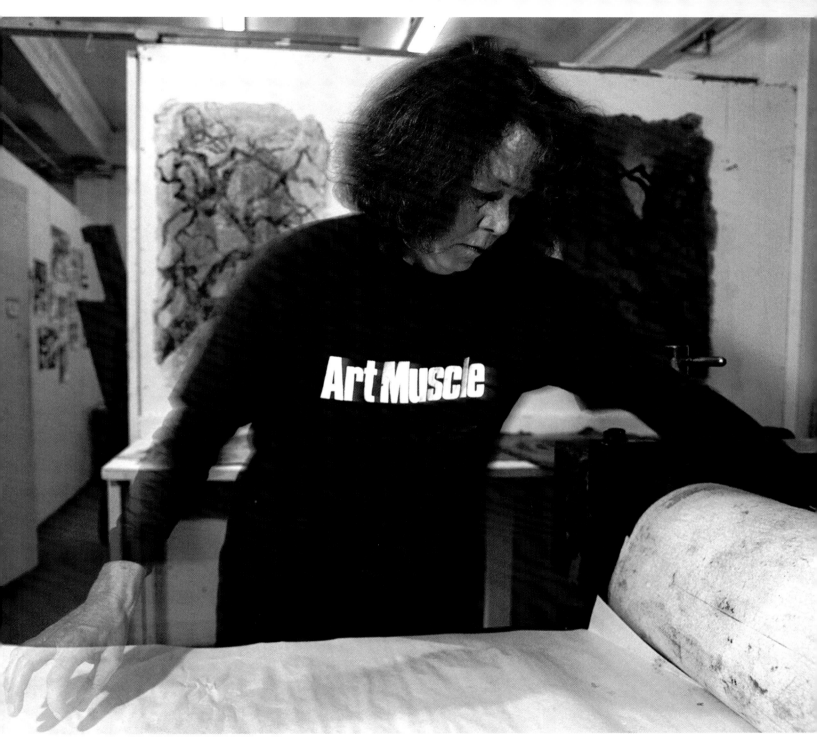

Sally Duback, an artist who lives in Wisconsin, spends one month per year at the Vermont Studio Center, which is an artist colony in Johnson. Photo by: Andy Duback

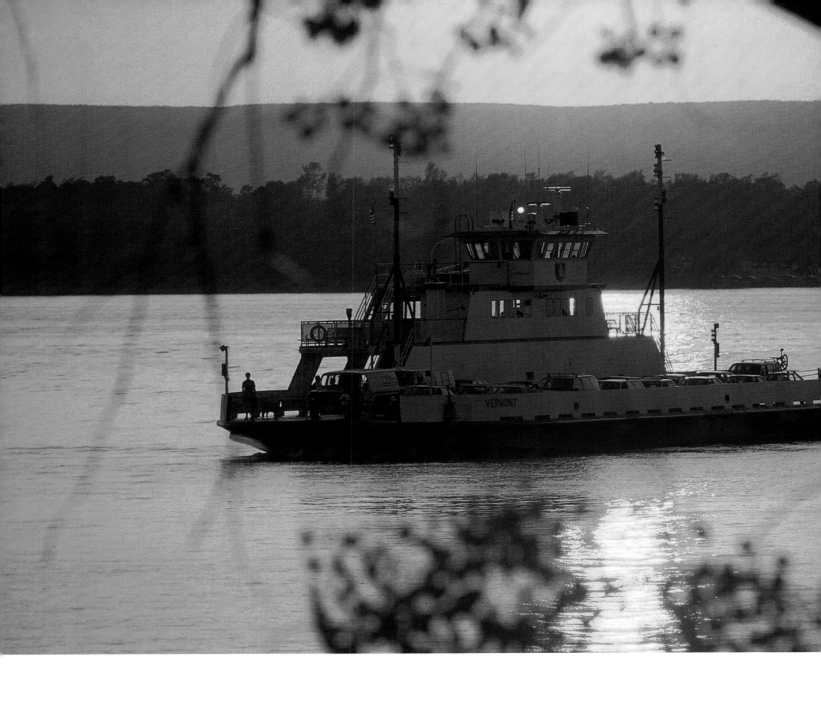

Grand Isle Ferry, South Hero VT.
Photo by: Paul Boisvert

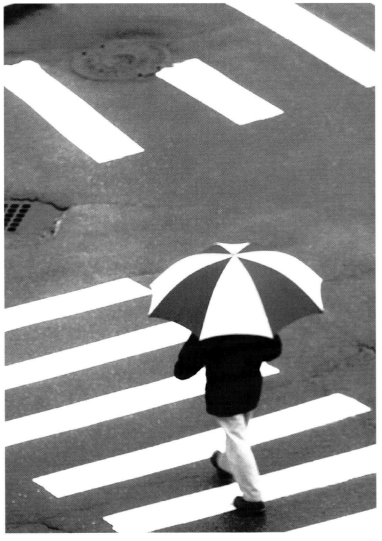

Vermonters are used to the change in weather, as this
pedestrian in Burlington, Vermont makes his way through an
intersection on Main Street. Photo by: Adam Riesner

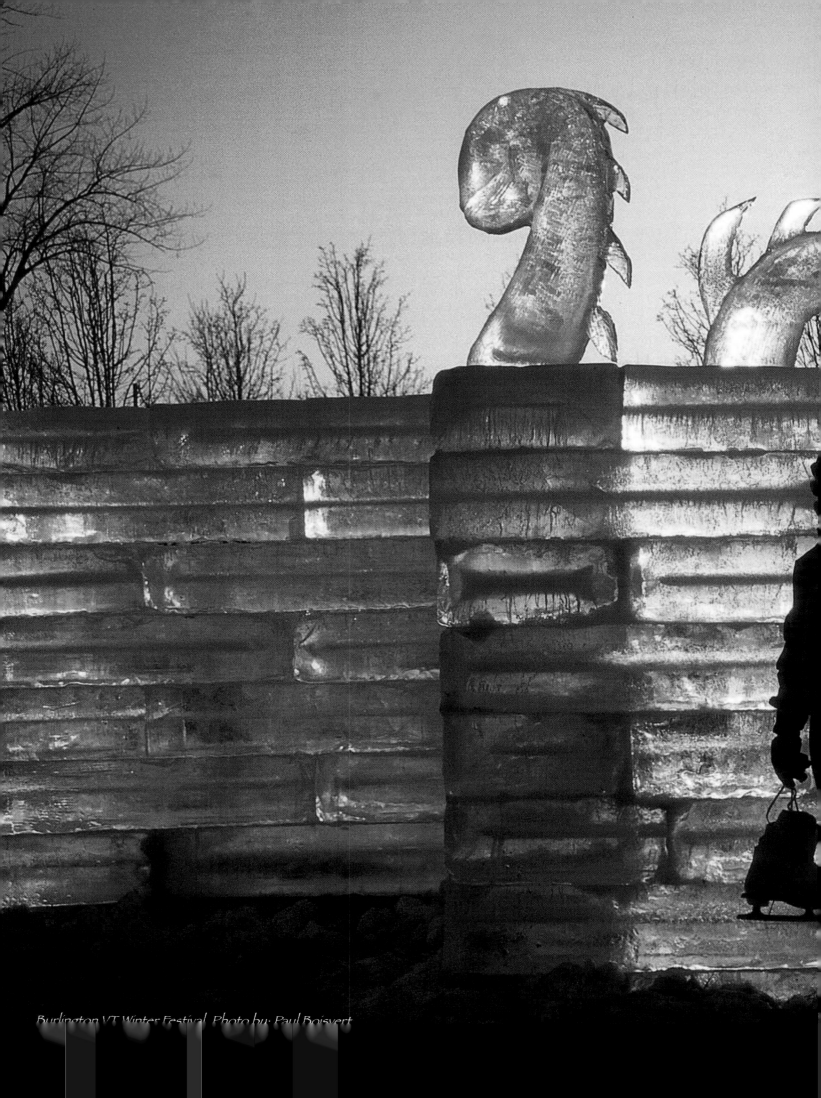

Burlington VT Winter Festival. Photo by: Paul Boisvert

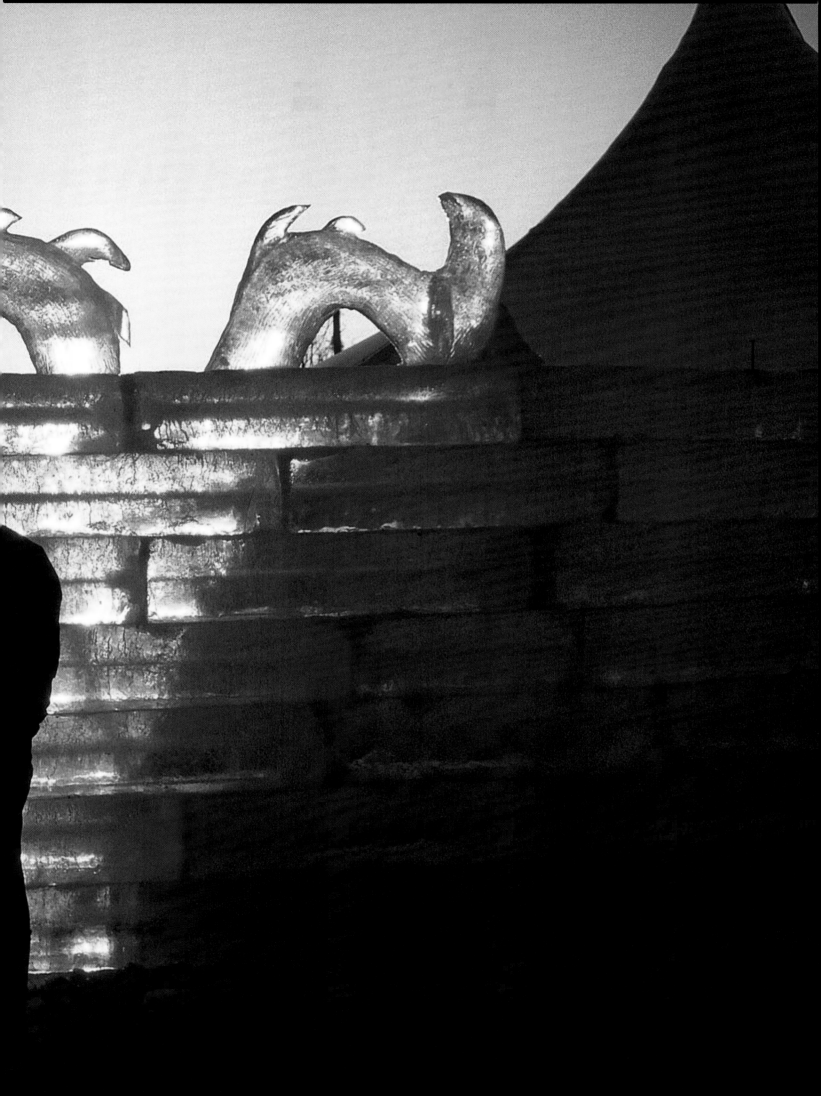

University of Vermont

The University of Vermont is the state's flagship university. And while it has a long history as the land grant state school for Vermonters, it also has the distinction of being named 'public ivy' – in league with some of the top schools in the nation.

hat public-yet-elite hallmark is manifested in UVM's large-scale research program ($117 million in grants received in 2003) plus the presence of top-caliber, motivated students and faculty working closely together – creating the atmosphere of a small liberal arts college. UVM (from the Latin Universitas Viridis Montis, University of the Green Mountains) still manages to balance its commitment to serving a wide demographic range. Recent figures show that some 40 percent of the nearly 8,000 undergraduates are Vermonters, while 60 percent come from throughout the Northeast, other regions and countries. Another thousand graduate students and nearly 400 medical students study at UVM.

Nature's classroom

In addition to UVM's outstanding academic programs, the lure of Burlington – Vermont's Queen City – and the landscape of the Green Mountain State bring many students knocking at UVM admissions' doors. (UVM and Burlington, in fact, enjoy a unique reciprocal relationship. The University's faculty and staff, students and cultural offerings enrich the community. In turn, the vitality and charm of the city are important features of UVM's character.) Teens and twentysomethings, along with everyone else, take to the streets, trails, slopes, the lake and its tributaries year round. UVM uses this self-described 'active landscape' as a hands-on classroom and laboratory. Students can study at the university's nine ecologically diverse natural areas – from pine forests to sphagnum bogs – and uncover the mysteries of the natural landscape all over the state.

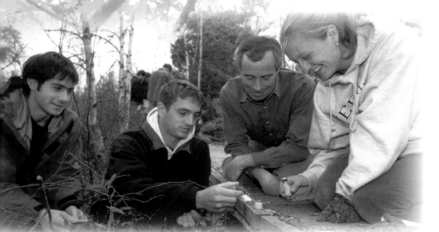

Not surprisingly, UVM has a reputation as one of the premier environmental schools in the country. The University's Rubenstein School of Environment and Natural Resources and the Rubenstein Ecosystem Science Laboratory on the shore of Lake Champlain are headquarters for dozens of environmental courses and research projects, and students can approach environmental study from disciplines such as engineering, medicine, business and agriculture as well.

Programs in the biological and health sciences also are among UVM's strengths. A major medical center on campus boosts learning and discovery in these areas. The UVM College of Medicine, allied with Fletcher Allen Health Care (FAHC), received more than $82 million in research grants in 2002-03 ñ an indication of the quality of faculty research and the first-rate science education students receive. The College of Medicine exerts a powerful impact on its home state: Nearly 40% of Vermont physicians either graduated from UVM or served their residency at FAHC.

With most of Vermont still punctuated by farmland and home to specialty food producers, UVM's College of Agriculture and Life Sciences is a leader in animal sciences, microbiology, nutrition and food safety. The School of Business Administration, which offers concentrations ranging from accounting to entrepreneurship to finance, is very popular among students, as are a range of offerings in the College of Mathematics and Engineering, from advanced mathematics and statistics to computer science to a variety of engineering disciplines. The College of Education and Social Services and the College of Nursing and Health Sciences also draw many UVM students – and produce graduates who serve the state, the nation and the world in many different capacities.

At the heart of undergraduate education at UVM is the College of Arts and Sciences, which draws more students than any other college or school, yet gives this major research institution the intimate human scale of a classic New England liberal arts college.

Time-honored traditions

This is a university whose history reaches back two centuries to the very origins of the state – 1791. The architectural treasures that surround the campus green are buildings named for well-known founders and alumni: Ira Allen, James Marsh, Frederick Billings, John Dewey and others. The campus is located in the city's historic 'hill section' with commanding views of the mountains and lake.

Facilities at UVM are wide ranging. Students are as likely to be viewing and discussing Andy Warhol paintings in the marble court of the Fleming Museum as listening to Vermont poet Galway Kinnell in the warm light of stained glass in the John Dewey Lounge or unraveling molecular genetics conundrums in high-tech Stafford Hall. Campus culture is shaped by longstanding, far-reaching student organizations like VIA (Volunteers in Action), the UVM Outing Club and the nationally ranked Lawrence Debate Union – among more than 100 other student groups. Concerts, plays, films, exhibits and speakers series fill the campus calendar and reflect UVM's commitment to promoting a culturally diverse, global-minded community.

UVM students share a passion for sports – in the bleachers as well as on the field. Hockey and basketball games spread green and gold fever at Gutterson Field House and Patrick Gymnasium, where packed crowds cheer on the Catamounts. At any time of year, seasoned competitors as well as occasional athletes test their mettle with Vermont's NCAA Division I teams (9 men's, 11 women's), competitive club sports (from sailing to cycling, dance to dressage) and a popular intramural program.

Looking toward the future

When Daniel Mark Fogel became UVM's 25th president in 2002 he set the University of Vermont's course for the next era. In the first year under his direction UVM acquired the adjacent former Trinity College campus, launched an honors college, increased size and academic standing of classes and drew up plans for expanded housing, academic and athletic facilities. In putting forth a vision for the University of Vermont's future, President Fogel acknowledged UVM's distinctions, saying, "We are determined to think big but remain small, preserving and strengthening UVM's special qualities of community, collegiality and common-sense resourcefulness."

Banknorth Vermont

After almost 200 years and an industry-leading merger, Banknorth Vermont takes pride in remaining a vital force in the local communities it serves.

The American Revolution had been fought and won. In 1791, Vermont joined the Union, the first state to be admitted after the adoption of the Constitution by the thirteen original states. In the same year, the Bank of the United States received its charter from the United States Congress. Modeled on the Bank of England and bearing President George Washington's signature, the charter had been designed by Treasury Secretary Alexander Hamilton.

Just fifteen years later, the Woodstock State Bank opened for business, a milestone that marked the beginning of stable, orderly and safe banking in the Green Mountain State. As Vermont's population and economy burgeoned along with the nineteenth century, Woodstock became a national bank, one of the most substantial and prosperous financial institutions in the Green Mountain state.

Rooted in its 200-year-old history, today Woodstock National Bank is stronger than ever. In its latest incarnation as Banknorth Vermont, it is successfully meeting the complex needs of the 21st century.

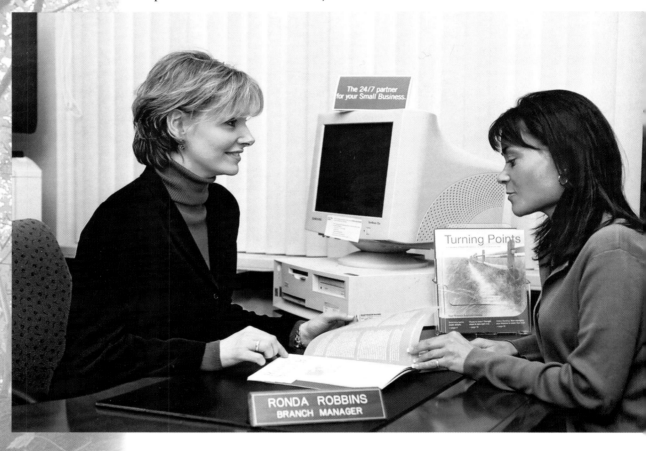

Ronda Robbins (left), branch manager, of the Burlington Banknorth Vermont office speaks to a customer about the latest bank products and services.

Strength in numbers

Banknorth Vermont, a division of Banknorth Group, N.A., has its headquarters on Main Street in Burlington. It was formed on January 2, 2002 from the consolidation of three community banks from around the state: Howard Bank, Franklin Lamoille Bank, and First Vermont Bank.

Banknorth Vermont holds the Green Mountain state's second largest market share, with over $2 billion in assets. Some 36 branches, nine in Chittenden County alone, and over 60 ATMs serve its customers across the state.

Community banking in action

According to president Philip R. Daniels, one big reason has to do with the 650 people of Banknorth Vermont. "As a full-service community banker, we take time to get to know our customers and their financial needs personally," she explains. "That way, we can provide the most efficient and cost-effective solutions."

In years past, Howard Bank, Franklin Lamoille Bank and First Vermont Bank helped Vermonters with purchasing a home or expanding a business. Today, Vermonters enjoy banking from anywhere in Vermont or across the world. In today's fast-paced world, customers can reach their hometown bank, anytime, anywhere.

"As Vermont's statewide community bank," says Daniels, "we're committed to knowing you and your business, we make quick decisions, we know the local market, we offer a broad range of products and services and most important, we believe in personal service."

Making a difference

Banknorth Vermont's employees spend over 20,000 hours each year of their personal time enthusiastically supporting local programs and activities. They serve on boards, work with neighborhood groups and provide voluntary help to numerous civic and volunteer organizations.

They're also encouraged to identify ways the bank can strengthen the communities where it does business, through financial support, sponsorships, community development and service programs. Banknorth Vermont regularly sponsors many community efforts, including playing a major underwriting role in the American Cancer Society Relay for Life Walk, Recycle North programs, as well as the University of Vermont athletic program, making Banknorth the official bank sponsor of Vermont Catamount Athletics. Banknorth is also a prominent investor in affordable housing projects throughout the state.

Each year, the bank establishes goals for meeting the financial needs of low- and moderate-income families, small businesses and deserving not-for-profit organizations. The bank helps low-income families buy homes, provide small businesses the support they need, and strengthens the quality of life statewide by focusing on education, community development and civic leadership.

As a member of the prestigious Forbes "Best Managed Companies in America" list, Banknorth, N. A. was recently named the Best Managed Bank over some of the top banks in the country. The nation may be sitting up and taking notice now, but Banknorth's customers aren't surprised – they knew it all along.

The assets of Banknorth Vermont's parent company make it one of the biggest New England-headquartered banks. To thousands of its long-time Vermont customers, 'their' hometown bank feels just as comfortable as ever.

Banknorth Vermont Burlington branch, 111 Main Street

Lake Champlain Transportation Company

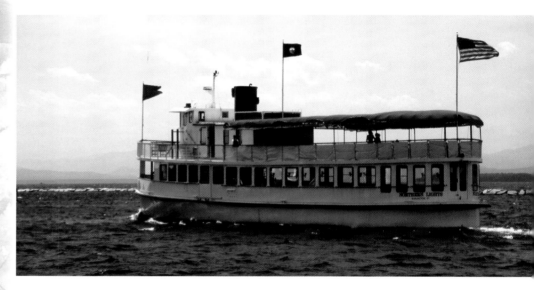

Hundreds of thousands of people cross Lake Champlain each year by ferryboat. Celebrated as one of the most scenic ferry crossings in North America, the trip offers travelers sweeping vistas of land and water, with the lofty peaks of the Adirondacks to the west and the gentler Green Mountains to the east forming panoramic backdrops for this great inland sea.

Today, Lake Champlain is best known as a watery playground for pleasure seekers. But more than a century ago, it was a workplace. The Lake Champlain Transportation Company is a tangible connection to the bygone days when wooden ships and working waterfronts defined our region.

Meeting the challenge

The Champlain Transportation Company, parent of the Lake Champlain Transportation Company, was incorporated in 1826. It quickly emerged as the lake's dominant steamboat operation. In the mid 19th century, the establishment of the region's first railroads spurred the Champlain Transportation Company to adapt their operations. Successfully meeting this challenge, the company was able to establish and maintain an important niche in the evolving transportation system.

After World War I, another challenge arose: the automobile was emerging as a significant new means of transportation. Champlain Transportation Company's old steamboats, designed to move only passengers and freight, could not compete. The new, wheeled vehicles threatened the very existence of the company.

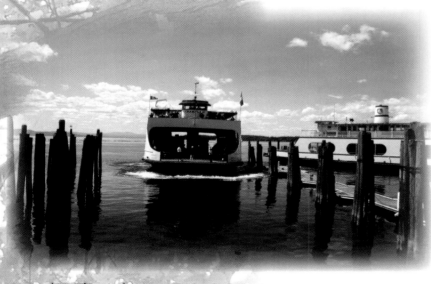

Instead of succumbing to disaster, the Champlain Transportation Company once again adapted. The company built new diesel-powered ferries designed to carry vehicles on their deck. The public's immediate acceptance of this strategy marked the beginning of decades of steady growth.

Today Lake Champlain Transportation Company is an indispensable link in the regional transportation system. The Lake Champlain Transportation Company has evolved to become one of the most successful private ferry companies in the United States. With headquarters on Burlington's historic King Street Dock and marine railway facilities located at the venerable Shelburne Shipyard, Lake Champlain Transportation Company continues its operations at three historic ferry crossings between Vermont and New York State.

Crossings

The 30-minute Charlotte to Essex, New York 'Southern Crossing' is now operated year-round. Essex, a hamlet filled with charming examples of 18th century village architecture, is popular with day-trippers and cyclists.

The seasonal Burlington to Port Kent 'Scenic Line' crossing is an invigorating hour-long lake excursion. Once at Port Kent, travelers can catch an Amtrak train that runs daily between Montreal and Manhattan.

The busiest crossing has developed at the company's northern ferry between

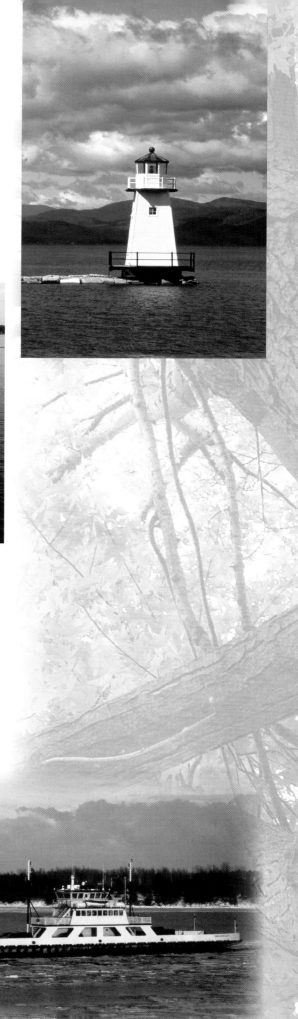

Grand Isle and Cumberland Head, rich in history. During the War of 1812, the British naval fleet attempted to take the town of nearby Plattsburgh. They were met by Commodore Thomas McDonough and an American fleet (built in Vergennes). This battle, fought in September of 1814, ended with a decisive victory for the ill-trained, ragtag Americans. Upon hearing of the defeat, the weary British retreated into Canada and so ended the war.

In 1976, the company experimented with winter operations at Grand Isle. Currently, Lake Champlain Transportation Company has expanded service at this crossing to 'round the clock, all year long. At all three crossings, the company's captains, engineers, deck hands and managers safely move more than a million vehicles yearly across the majestic Lake Champlain.

From its origin in 1826, the Lake Champlain Transportation Company has survived wind, flood, ice and the often-changing transportation technology. Today, the company, under the stewardship of the Pecor family, has invested and maintains a fleet of first-class ferryboats and the new Burlington-based cruise boat Northern Lights. The Breakwater Cafe and Grill serves up nautically-inspired sandwiches, drinks and live entertainment at water's edge from May through September.

The company's assets – nine ferries, a cruise boat, six docks, including the bustling King Street dock, a dry dock in Shelburne shipyard and a restaurant – are impressive. But its greatest asset has always been its people. The Lake Champlain Transportation Company is now home to more than 200 dedicated employees who exude pride and professionalism, the fine traditions that have always defined the Lake Champlain mariner.

Merchants Bank

Merchants Bank has played a vital role in the community development of Burlington and the Champlain Valley for more than 155 years. From the recently renovated downtown Burlington offices to the high-tech computerized headquarters located in South Burlington, Merchants Bank sets the standard for financial services and community leadership.

The bank opened in 1849 with offices on what is now known as Battery Street, just steps away from the bustling commercial waterfront and rail center of the Queen City of Burlington. As businesses grew and shifted up the hill, Merchants Bank followed and in 1896 built what was then considered 'a state of the art' banking center in the emerging downtown business district of Burlington.

Merchants Bank 164 College Street, Burlington, VT. Teller line. Photo by: Paul O. Boisvert

The elegant, four-story, granite bank building at 164 College Street overlooks Burlington's City Hall Park. Today, that same building gives first-time bank visitors a glimpse into what banking was like back then through a rich display in the lobby of banking memorabilia and the mahogany bookcases filled with historic journals and ledgers from the 1800s. The bank's original chrome-steel vault door—now a part of the bank lobby's decor—reflects the ongoing feeling of security and stability Merchants Bank has offered customers for a century and a half.

As early as 1896, Merchants Bank was on the cusp of providing innovative financial services geared toward the customer, when it offered 'lady depositors' their own teller windows for 'more convenient paying of bills by check.'

Today, still a leader in local, customer-focused banking, Merchants offers a streamlined package of banking options ranging from Free Checking for Life® and MoneyLYNX® a savings and money market account; to competitive mortgage and home-equity products to commercial accounts, loans and cash management solutions. Merchants' customers can access their account information 24-hours a day using on-line banking at www.mbvt.com, or via the phone. A network of conveniently located automated teller machines and branch offices crisscrosses the state.

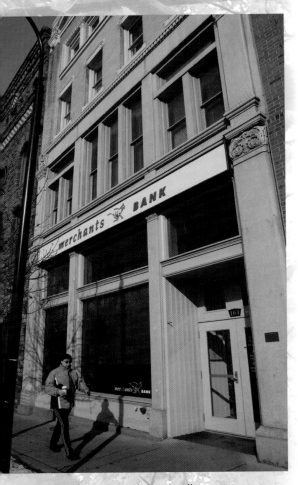

Merchants Bank 164 College Street, Burlington, VT. Photo by: Paul O. Boisvert

Merchants Bank 164 College Street, Burlington, VT. August 22, 2002 Grand opening celebration ribbon cutting ceremony with $500 donation to benefit King Street Area Youth Center. Photo by: PostScript, Inc.

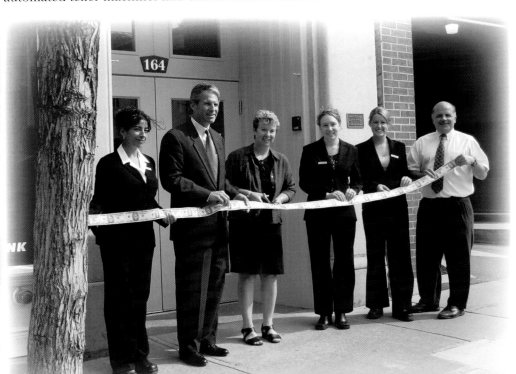

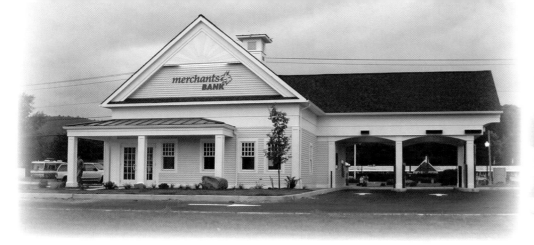

White River Junction Branch office, September, 2003. This is the prototype of the branch design for new Merchants Bank offices. St. Albans was completed in January, 2004, and Middlebury is in the planning stages.
Photo by: Postcript, Inc.

Merchants Bank has more than 35 branch offices throughout Vermont with additional sites in Middlebury and other locations in the development stages. The bank's operations center moved to 275 Kennedy Drive in South Burlington in 1994. The original downtown offices were completely renovated in 2002 along with a drive-up and ATM located right next door.

Bank President Henry P. Hickok, who served from 1854 to 1888, espoused the goal of making his bank "a model of its kind, combining strength and safety with beauty and providing every modern convenience for the rapid and inexpensive transaction of all branches of banking." It is a clear philosophy that has guided Merchants Bank presidents and boards of directors through wars, the depression and a shifting financial climate in Vermont and across the nation.

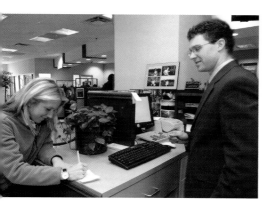

Merchants Bank 164 College Street, Burlington, VT. Customer Erin Pond with Customer Service Representative Tyler Weeks.
Photo by: Paul O. Boisvert

Joseph Boutin, the bank's eleventh president and current CEO, describes his plans to keep Merchants' people-oriented, neighborhood roots alive in the face of bank deregulation and giant banking operations. "We decided to be the equivalent of a convenience store rather than a supermarket. We'll go to the extreme to position ourselves as the opposite of the big organizations."

In the mid-1990s, focus groups and market studies helped Merchants hone in on its customer base and how banking fit into their lives. That's when the image of the wild mountain lynx became the bank's symbol and the basis for the LYNX line of banking services.

Merchants Bank 164 College Street, Burlington, VT. Branch President Heather Cruickshank.
Photo by: Paul O. Boisvert

Merchants Bank is also committed to supporting the entrepreneurial spirit of Vermonters. The bank proudly cites its role in helping such corporate giants as IDX and Ben & Jerry's Homemade Ice Cream get their businesses started in Chittenden County. Commercial banking, supplemented by a strong leadership role in the business community, remains a key component of Merchants' banking strategies.

Merchants Bank and its employees also play a critical role in supporting community non-profit organizations ranging from local school groups to United Way to arts and performing groups.

It's the on-going commitment to a hands-on approach to decision-making; careful staff development and routinely asking customers what they want, that continues to drive the bank's growth. A formal seven-step customer service pledge is engrained in every Merchants' employee from the day they begin work. It's a philosophy that applies right up the line from tellers to bank presidents, says Thomas Leavitt, a senior vice president. "We live by these standards. We train our staff and we measure their performance. Whenever there is a 'wrong,' our goal is turn it into a 'right'– for our customers. It's a Vermont common-sense rule for doing business," he said.

Vermont Catholic Charities

Bound by a strong belief in Christian compassion, Vermont Catholic Charities offer a wide range of human services to uphold the dignity of human life.

Most Reverend Kenneth A. Angell, Bishop of the Roman Catholic Diocese of Burlington, routinely visits seniors at VCC residential homes and Vermont parishes.

A busy Camp Tara camper perfects his arts and craft project. Camp Tara which merged with Camp Holy Cross this season is located on beautiful Malletts Bay.

The word 'catholic' means universal, and it is with this frame of mind that Vermont Catholic Charities sets out to help people in Vermont's communities. Although affiliated with the Roman Catholic Diocese of Burlington, the agency offers a wide variety of services and counseling to any Vermont citizen who is in need of kindness, regardless of religion or faith. Adults, children, families, and individuals can all benefit from the various human services the hardworking staff offers. Although these services may vary in their objectives, the common thread of all the services is a deep respect for human life.

No one is alone

Project Rachel is one of the key programs at the heart of Vermont Catholic Charities. Named after Rachel in the Old Testament, who was inconsolable in her mourning for the loss of her children, *Project Rachel* offers both counseling and reconciliation for those suffering the aftermath of an abortion. *Project Rachel* is clear evidence of the Church's compassionate outreach to those traumatized by abortion. Professional counseling is offered in a confidential and sensitive manner to ensure a good start on the road to healing and forgiveness.

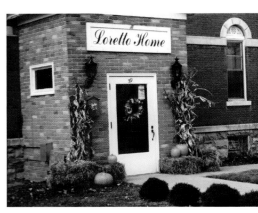

The Loretto Home in Rutland is one of four Vermont Catholic Charities facilities which offer loving residential care to the elderly.

Rainbows is another example of how Vermont Catholic Charities is committed to providing solace and hope for those who need it. Those individuals and families who might be grieving due to the death of a loved one, divorce or separation, or a change in life's circumstances will find the support of the various *Rainbows* curricula to be effective in the healing process. *Rainbows* is an international non-profit agency that has a chapter in the Office of Family Life in the Burlington diocese, which offers the appropriate support to individuals and families based on their age and situation.

A fun exploration of the Catholic faith

Camp Tara-Holy Cross, a day and residential camp nestled on the picturesque shores of Lake Champlain, offers boys and girls ages 7-15 all the traditional aspects of a summer camp adventure with a strong foundation in Catholicism. Campers experience the summer as something much more than a time for recreation and relaxation; they explore their faith in a comfortable atmosphere that also helps them to grow into mature young Catholic men and women. The camp's Catholic identity is solidified by compassionate counselors, a number of whom are seminarians, as well as a daily celebration of Mass, which helps the campers understand the Eucharist as part of their daily lives.

A celebration of life

Compassion is one of the foremost attributes to living the Catholic faith, and Vermont Catholic Charities exemplifies this compassion through the maintenance of various residences that offer older adults a chance to live independent lifestyles with the support of a trained staff. The Loretto Home and St. Joseph's Kervick Residence in Rutland, the Michaud Memorial Manor in Derby Line, and St. Joseph's Home in Burlington all provide beautiful housing to its residents. The staff not only offers general supervision and medical care, but it also helps to facilitate an atmosphere that respects each resident and supports their efforts to live fulfilling lives.

Photo by: Steve Mease

Champlain College

Online, overseas and on campus in Burlington—Champlain has been recognized as a leader in career-oriented education.

In 2003, Champlain College was named the "Business of the Year" by the Lake Champlain Regional Chamber of Commerce. The award, bestowed during the college's 125th anniversary, singled out Champlain as a "forward-thinking, entrepreneurial denizen, quick to respond to changing business, professional and community needs."

This was one of many public acknowledgments of the institution's strong business-community support and how innovative teaching methods have cemented Champlain College's entrepreneurial reputation.

Adding to that reputation is Champlain College's consistently high job-placement rate for graduates. Champlain's Career Planning Office is an on-going partner with students, guiding them toward a successful educational and post-educational experience.

Cultivating a love for learning.

Small class sizes, an attractive New England college setting and educational offerings befitting a much larger institution help make Champlain College the first choice for many high school graduates as well as professionals looking to build solid job skills.

With 1,600 full-time students, Champlain College is able to keep class size small - an average of only 18 students per class - while providing studies in 26 fields of business, technology and human service. Faculty with real-world experience work closely with their students.

A current parent expressed her daughter's enthusiasm for the faculty, "She has experienced a close relationship with her teachers, who have continued to cultivate her love for learning."

Professionals who wish to earn degrees while still working find that the flexibility of Champlain's extensive nighttime and online degree programs makes it easy to further their careers through education.

A high-tech education

Corporations have also made use of the College's expertise in online learning as they address their training needs. Champlain also works with the business community through the Vermont Information Technology Center and the Vermont Telecom Advancement Center – both reside on campus.

Champlain's proven willingness to adapt to business climate shifts is reflected in the fact that more than 50 percent of today's Champlain students are in majors that did not exist in the early 1990s, according to Roger Perry, President of Champlain College. "In today's global, high-tech economy, staying current with the demands of the marketplace is more important than ever. That's why Champlain is always on the move – to ensure our students have the professional and intellectual skills they need to succeed," Perry said.

Champlain's educational successes extend well past Burlington and even Vermont. Students from about 20 countries join students from nearly 30 states to pursue their studies in Burlington. An international perspective is fostered in the classroom with an eye to global developments. Champlain's popular International Student Exchange project offers students the chance to experience a semester in England, France, Sweden or Switzerland. Champlain also offers full degree programs on-site in countries such as United Arab Emirates and India.

Champlain College began in downtown Burlington in 1878 as the Burlington Commercial School. In the 1950s, it was renamed Champlain College and moved into its first building, a former University of Vermont dormitory in the historic Hill Section. Today, its handsome academic buildings, dormitories and offices help define Burlington's hillside neighborhood. The campus boasts a mix of Victorian-era buildings and high-tech facilities with million-dollar views of the Adirondacks and Lake Champlain.

"The dorms here are absolutely amazing," said a student from New Jersey. "This is a once-in-a-lifetime opportunity to live in a beautiful Victorian mansion with kids your own age where there are tons of social activities."

State-of-the-art expansion

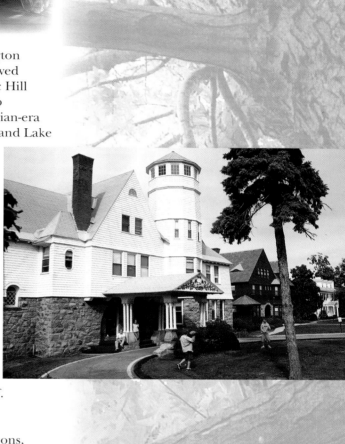

Never one to rest on its laurels, Champlain College launched The Power of Three capital campaign in 2002 to continue its tradition of excellence. The campaign funds three initiatives totaling $31 million, which are central to the college's mission and future:

- The Main Street Suites and Conference Center, a suite-style residence hall with summer conference facilities.
- The Center for Global Business and Technology, a state-of-the-art facility that houses multimedia and business resources under one roof.
- The Student Life Complex, a 42,000-square-foot student center with recreation, fitness and dining facilities.

Those new facilities join the award-winning Miller Information Commons, built in 1998 as a prototype library of the future offering video-conferencing facilities, multimedia labs and online workstations along with traditional library offerings.

The student experience at Champlain extends well beyond the traditional classroom, with work-study, internships and other hands-on training opportunities in profit and non-profit settings. Community service is emphasized for both students and faculty as a way to develop skills and professional connections, and to lend a hand to those in need.

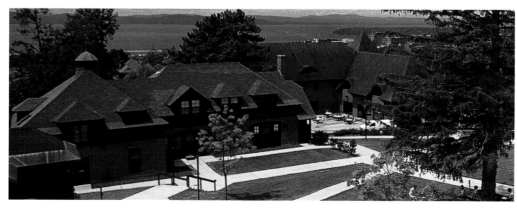

Saint Michael's College

Saint Michael's College in Colchester ranks among America's best Catholic colleges of liberal arts – academically rigorous and with strong values influenced by humanitarian ideals.

The College's founders, a handful of pioneering priests from the Society of Saint Edmund who fled religious persecution in France 100 years ago and settled in Vermont, were known for their scholarship, compassion, justice and hospitality. All of those qualities came together in 1904 when Saint Michael's College was founded in the Champlain Valley. The Edmundites' passion for community service and social justice continues to set the tone for this contemporary learning community as it moves into its second century.

"Saint Michael's is not a place of anonymity, rather it is for the student who wants to contribute to the institution, the community and the world," says Dr. Marc vanderHeyden, president of Saint Michael's College.

Some 1,900 men and women from 28 states and 20 countries attend Saint Michael's. The College's liberal arts core curriculum means that the 29 majors and 30 minors prepare graduates for life in today's complex world.

Overall, there is one Saint Michael's professor for every 12 students, a ratio that reflects the College's commitment to providing every student with a personalized education. Of the 144 faculty members, 81 percent have earned their PhD or highest appropriate degree from some of the world's finest universities. By engaging students inside and outside the classroom, Saint Michael's faculty exhibit a firm commitment to teaching, as evidenced by the fact that a member of the faculty has been named Vermont Professor of the Year for three of the past four years.

Embarking on the next century

Saint Michael's faculty was invited to establish a Phi Beta Kappa chapter on campus in 2003 just as the institution begins its second century. Phi Beta Kappa is regarded as the pre-eminent academic honors society with 270 chapters nationwide. Only two other Vermont institutions, the University of Vermont and Middlebury College, have chapters. It was another of the many milestones recognizing Saint Michael's achievements in its first 100 years. Routinely cited as one of 'America's Best Colleges' by U.S. News & World Report, Saint Michael's was recently called a "Hidden Treasure among small schools that deserve more national recognition" by Newsweek.

In 2003, just before the College's 18-month centennial celebration began, Saint Michael's received a $5 million pledge from an anonymous donor to build a library to house the books and papers of renowned literary critic and scholar, Dr. Harold Bloom.

Saint Michael's commitment to a residential learning experience is evident in both the active student life atmosphere and campus facilities. Nine out of 10 students live on the 440-acre campus in modern residence halls and apartments within walking distance of classrooms, research labs and libraries equipped with the latest technology.

Since 2000, Saint Michael's has experienced a building boom. The new Hoehl Welcome Center, funded in part by a $2.1 million gift from Saint Michael's alumni Robert and Cynthia Hoehl, provides a warm reception for students and families whose first stop is the College's admissions center.

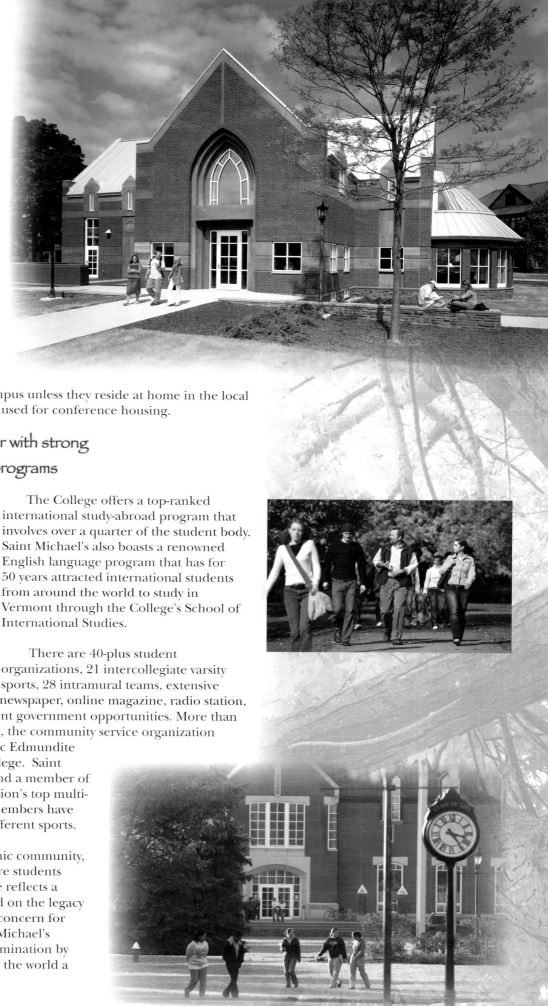

Cashman Hall, a living/learning residence with 124 private bedrooms in four- and eight-room suites that opened in fall 2002, is a model for two additional residence halls opening in 2004-05. At that time all undergraduates will live on campus unless they reside at home in the local area. In the summer, these buildings will be used for conference housing.

Promoting learning both near and far with strong extra-curricular and study abroad programs

The College offers a top-ranked international study-abroad program that involves over a quarter of the student body. Saint Michael's also boasts a renowned English language program that has for 50 years attracted international students from around the world to study in Vermont through the College's School of International Studies.

There are 40-plus student organizations, 21 intercollegiate varsity sports, 28 intramural teams, extensive recreational and music programs, a student newspaper, online magazine, radio station, and numerous community service and student government opportunities. More than seven out of ten students take part in MOVE, the community service organization that is a reflection of Saint Michael's Catholic Edmundite heritage and a hallmark program of the College. Saint Michael's is a NCAA Division II institution and a member of the Northeast-10 Conference, one of the nation's top multi-sports leagues – in the last 25 years, NE-10 members have won twenty NCAA national titles in seven different sports.

Saint Michael's today is a vibrant academic community, well-known as a warm, welcoming place where students make friendships for a lifetime. The College reflects a century of growth and development founded on the legacy of its pioneering priests – their scholarship, concern for others, and moral and spiritual focus. Saint Michael's College continues that tradition in the determination by students, administration and faculty to make the world a better, safer, more humane place.

Burlington Electric

As Burlington continues to prosper with a strong economy and a commitment to environmental protection, the Burlington Electric Department is doing its part by supplying residents and business owners with reliable, clean energy, and a variety of energy efficiency programs, which have caused Burlington as a whole to use 2 percent less electricity in 2003 than it did in 1989 while still experiencing growth, a claim few others can make.

At the turn of the last century, the city fathers were frustrated. The privately owned Burlington Power and Light Company was charging the city $80 per year for each street light – about $1,500 in today's dollars. Residential customers were paying $.14 per kilowatt-hour for electricity, the equivalent of $2.79 today. City officials proposed a solution: the formation of a municipally owned electric utility.

This bright idea became reality. On April 29, 1905, Burlington Electric Department began powering city streetlights. Homes and businesses were added a few months later. Street lighting costs dropped by $72 annually for each lamp. Residential and commercial rates fell to 10 cents per kilowatt-hour. The newly formed Board of Electric Light Commissioners were so pleased with the new rates that they approved a policy to replace, at no cost, customers' burned out light bulbs!

Thus began a tradition of saving both electricity and customers' costs—one that is still alive and well today.

Saving graces

In 1983, voters approved more than $3 million to initiate a conservation program and to insulate every hot water heater in the city. In 1990, Burlington voters approved an $11.3 million bond to fund a variety of energy efficiency programs for both homes and businesses in which all customers could participate. The resulting savings have greatly reduced the cost of contracting for new electric power, in effect helping the local economy. Energy efficiency is also helping to protect the environment. And it is doing wonders for the bottom line.

McNeil – The McNeil wood chip plant, located in Burlington's Intervale, provides 50 megawatts of power for the New England grid. When it came on line in 1984, it was the largest wood chip plant in the world. The fuel comes from sustainably harvested cuts and waste wood that would otherwise be put in a landfill.

Hundreds of businesses have significantly lowered their energy costs with the help of BED's Commercial Energy Services.

The Chief Engineer at the upscale Burlington Wyndham Hotel (formerly the Burlington Radisson) had his success story recounted in a recent issue of "Currents," the newsletter sent quarterly to BED's commercial customers. The hotel has used the BED program several times. The last was a comparatively small program that will still save the hotel more than $12,000 a year in electric costs. The engineer commented that while he knew that energy efficiency saves money, he often would get caught up in his day-to-day work. "It's nice to get a gentle nudge from the energy staff at BED," he added, "I need that."

Solar-champ – BED's 'Solar on Schools' program, funded through grants and donations, is providing the public schools in Burlington with solar panels and the teachers with curriculum on renewable energy. Here, solar panels are shown on the Champlain Elementary School in Burlington's South End.

Gregory Supply, a regional building materials supplier based in Burlington's South End, had taken advantage of BED's energy efficiency programs a few years earlier. The owner wasn't sure if additional efforts would be productive but decided to try. With the help of both BED's professionals and an outside consultant, Gregory Supply significantly reduced its utility costs. After the work was finished, the average monthly savings on the company's electric bill compared to the previous year was 35 percent.

Each issue of 'Currents' is well-stocked with tips and advice about how to make each electron work harder in office, showroom or factory, dramatized by a customer profile. A phone call is all it takes for any customer – commercial or residential – to start the efficiency ball rolling.

Low bills, high stability

BED serves about 16,000 residential customers and more than 3,600 commercial ones. Its mandate is to use fair business practices, prudent power purchases and efficiency programs to keep rates low and bills affordable for all.

The department's proven record of stable rates has earned national attention. In February 2004, BED initiated a rate increase to meet increased energy costs. This was the first hike in a decade; the previous adjustment, in 1997, was a 5 percent decrease. These stable rates are matched by a reliable power supply.

As a rule, power is something we take for granted…until it's interrupted by equipment failures, contact with animals or trees, or weather conditions. BED has a good track record regarding outages, a record that will improve as work on the underground and aerial lines is completed.

BED is converting several old circuits and replacing old equipment. New aerial lines are reducing outages due to animal contacts. BED will continue to replace its underground network with rugged new cables and equipment. The result: maintenance costs will decline and reliability will increase.

Back to the future.

During the 1970s, the rising demand for electricity prompted BED to look for ways to generate additional power to feed the city's growing appetite for electricity. Researchers looked for a fuel source that was locally available, reliable, cost-effective, non-polluting, renewable, and publicly acceptable. Wood – the fuel of choice for many Vermonters since the days of Ethan Allen – scored high on all counts.

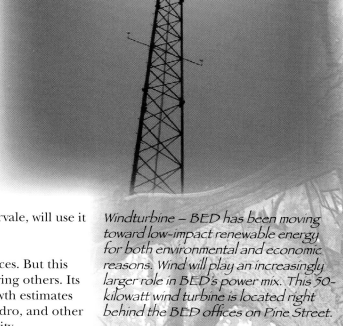

Seventy percent of the wood chips that fuel the McNeil Station come from low-quality trees and harvest residues. The Station's chip suppliers are required to conduct their harvesting activities in accordance with strict standards to protect the environment. To ensure compliance, one of BED's foresters monitors each harvest operation.

In the best tradition of Vermont thriftiness, the excess heat from McNeil won't go to waste. The Intervale Food Center, a sustainable business and agricultural park planned for Burlington's Intervale, will use it for heating and cooling.

Windturbine – BED has been moving toward low-impact renewable energy for both environmental and economic reasons. Wind will play an increasingly larger role in BED's power mix. This 50-kilowatt wind turbine is located right behind the BED offices on Pine Street.

In 2003, 40% of BED's power generation came from renewable sources. But this high percentage of renewable energy sources doesn't stop it from exploring others. Its Energy Resource Report emphasizes that BED's goal is to meet load growth estimates with renewable supplies of energy. BED is looking at wind, small-scale hydro, and other renewables to keep Burlington a vibrant, prosperous and clean community.

Burlington Electric Department has faced many challenges since its creation. It's sure to face new ones as the electric utility industry changes. What will never change at BED is its commitment to providing its customers–both residential and commercial–with low-cost, reliable electric service. And because the customers are the owners, they'll continue to have a direct voice in expressing their goals and priorities for the community and its electric utility.

Dinse, Knapp & McAndrews

Founded by our first U.N. Ambassador, counsel to clients around the world, high achievement is just one of DKM's traditions

The law firm of Dinse, Knapp & McAndrew is one of the oldest and largest law firms serving Vermont and the Adirondack Region of upstate New York. Since its inception it has specialized in business representation and general litigation, supporting clients with a client-centered mixture of responsiveness, skill and integrity.

The firm's practice areas are varied and specialized. During its 80 years of existence, its litigators have handled many of Vermont's largest and most noteworthy civil cases and its business lawyers have been involved in some of Vermont's most significant commercial transactions.

The firm is the only Vermont firm to be selected as a member of the Employment Law Alliance. Through ELA's international network of employment law firms, the firm provides its clients with effective representation around the nation and the globe.

Austin and apples

The firm holds a novel place in the history of the city, the state and the nation. Warren Robinson Austin, a native Vermonter, founded the firm with partner Bill Edmunds in 1917. Austin, a prominent trial lawyer, later pursed a career in politics and government.

As a U.S. Senator, Warren Austin participated in the creation of the United Nations at the end of World War II. In 1947, President Harry S. Truman made Austin the first U.S. Ambassador to the United Nations.

A man with deep roots in his community, Ambassador Austin maintained an office and a secretary in the firm's office in Burlington. He regularly made the 350-mile journey to his home on Williams Street, where he maintained an apple orchard; he often shipped those apples to himself in New York City.

Warren Austin is just one of the firm's former attorneys who went on to illustrious careers in public service. Fred Allen joined the firm in 1951, right out of law school. He remained a partner in the firm until he was appointed to the Vermont Supreme Court, where he served as Chief Justice from 1984 until his retirement in 1997. He served on the Supreme Court with two others, John Dooley and James Morse, who had also been employed by the firm.

Hilton Wick was already an experienced attorney when he joined Austin & Edmunds in 1950, along with John M. Dinse, a newly-minted lawyer. Mr. Wick, now retired, was for many years a partner in the firm before leaving to serve as President of Chittenden Bank. John Dinse was Managing Partner for 25 years. He retired from practice in 1993, but remains active as Counsel to the firm.

Since 1993, Spencer R. Knapp has served as President and Managing Partner. Early in 2004, former U.S. Airways CEO and Burlington native Edwin Colodny joined the firm as Counsel following service as interim President of the University of Vermont and interim CEO at Fletcher Allen Heath Care.

Chambers and Partners

High achievement is a DKM tradition that is still very much alive. In 2003, the firm was ranked number one in the prestigious Chambers & Partners USA 2003-2004 Guide to America's Leading Business Lawyers. The firm was recognized for its expertise in all four business-related categories: corporate, employment and labor, litigation, and real estate. Partner Karen McAndrew was the only Vermont lawyer selected as a leader in two practice areas: litigation and employment defense. Other members of the firm were recognized as leading attorneys in the areas of employment law, litigation, corporate law and real estate.

The recent appointment of Managing Partner Spencer Knapp as General Counsel to Fletcher Allen Health Care reflects the firm's long history of representing Vermont hospitals and major physician practice groups.

Practice makes perfect

Several of DKM's major clients have been "on board" since Warren Austin was running the show. These strong client relationships, forged over decades, are evidence of the importance the firm has always placed on client service.

Although DKM's core practice hasn't changed dramatically since its inception, the firm continues to add new practice areas: intellectual property, software licensing, and "cross-border" issues, involving representation of Canadian and other international clients doing business in the United States.

Teamwork

DKM has an affirmative corporate culture. It is no coincidence that the firm's lawyers and staff work effectively together in teams – it has always been known for its camaraderie. The firm's lawyers and many staff members share more than just their work. They're likely to jog together at lunch or bike in groups on weekends before returning to work on a complicated case. From its founding to the present, collegiality has been one of the firm's enduring strengths.

It's a win-win situation – for Dinse, Knapp & McAndrew <u>and</u> their clients.

The Old Stone Store.

The firm maintained offices at two locations on College Street for decades. In 1981, DKM moved to its present quarters at 209 Battery Street: a neo-classical limestone block building, known as the Old Stone Store.

University of Vermont researchers have discovered that the building was actually constructed in two stages, the north half in 1827-28 and the south half in 1841, and served as warehouse and outlet for the mercantile firm of Mayo, Follett & Company. The Stone Store was at the heart of the bustling Battery Street district on the waterfront. Freight arriving in Burlington via Lake Champlain had to be stored or transferred. Mayo, Follett teams were able to pull in behind the store to unload merchandise into the cellar before turning out again for another load. The company prospered as six- and eight-horse "land-ships" were continuously dispatched, carrying goods to towns in the interior of the State. This use of the building continued into the 1920's, after which the store was occupied by a number of businesses until its extensive renovation in 1979.

Burlington International Airport

Thanks to a clear vision, smart planning and a dash of luck, this city-owned airport is flying high.

The city-owned Burlington International Airport may actually be located in neighboring South Burlington, but nobody except the property tax collectors seem to care. The fact is that the airport is a money magnet for both municipalities, and well beyond.

"The latest figures indicate that the airport alone makes a $300 million contribution to the economy of the State of Vermont, both directly and indirectly," says John "J.J." Hamilton, Burlington International Airport's Director of Aviation since 1989. "Just imagine the travelers who arrive here needing a rental car, a place to stay–all those tourism dollars," he says. And don't forget the people employed at the airport, currently about 30,000. About half are air military personnel. The other half is represented by tenants, airline employees, governmental agencies like the National Weather Service, air cargo companies, gift shops and more.

Keeping it all running smoothly is no easy job. Even harder is anticipating future needs and planning to meet them. Besides planes, J.J. Hamilton keeps a lot of balls in the air – so far he's doing it with flying colors.

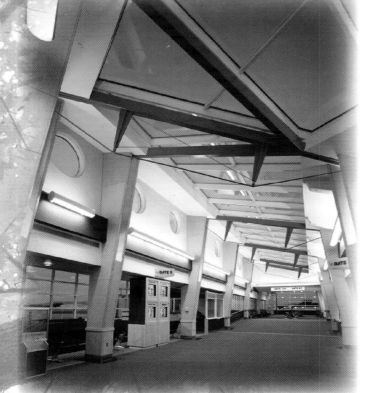

Up, up and away

In the last ten years, growth at the airport has been dramatic: more and different airlines, more passengers and a renewed and expanded facility developed to serve them. The growth spurt began after Hamilton hired a new staff member in 1995.

Robert McEwing had been a planner with the Federal Aviation Administration. "I hired him to be the airport engineer," says Hamilton. "Bob was very experienced in planning, so I changed his title to Director of Planning and Development." Hamilton knew the airport needed major attention. McEwing had come along at the right time. The two men began to meet informally, kicking ideas around, and Hamilton made the decision to upgrade the airport.

Cheap seats

In 1999 Jet Blue was so new they didn't yet have airplanes or pilots, or even a name. They knew Vermont was hungry for a low cost carrier. But before they could serve Burlington and other, similar airports in upstate New York, the airline needed to secure hard-to-get landing slots at JFK, their choice for a hub in the New York City area

"With a little political pressure applied in the right places, Jet Blue received the slots it needed," says Hamilton. "Then we had to scramble to adjust the design of the concourse to handle their airbuses." Jet Blue began service out of Burlington in 2000.

The best laid plans

The disastrous attacks on the World Trade Towers delayed construction at the airport by a year. Burlington was one of just a few airports that rebounded quickly. The turnaround began just two months after 9/11. "We've exceeded our benchmark for last year in numbers of passengers," says Hamilton. By the end of the second quarter of 2004, boardings were over 14 percent ahead of 2003, heading to a record 600,000 for the year. These numbers make it clear why the expansion program was so necessary.

Since it began as the Burlington Community Chest in 1942, United Way of Chittenden County has worked side-by-side with its member agencies to ensure basic services remain available and affordable for everyone. Since the beginning, the American Red Cross, YMCA, Howard Community Services, The Boys & Girls Club and Visiting Nurse Association have been among United Way's longtime partners in making life better in Chittenden County.

Looking back on 60-plus years of serving the community, United Way's annual community appeal has raised $85-plus million and leveraged countless millions for local non-profit organizations. In 2003, more than 16,000 donors and hundreds of businesses and organizations set a new fund-raising record when they pledged $3.8 million to United Way's Community Campaign.

Providing assistance for worthy causes.

Annual program funding requests are carefully reviewed by teams of volunteers who visit the sites and look for measurable outcomes and results. Programs that receive funding are those that make a difference for young children in daycare; for students trying to learn and stay in school; for working families struggling to make ends meet; for people with substance abuse or mental health problems; and for seniors who want to live independently in their homes.

In addition, United Way's Volunteer Center matches young and old volunteers with a range of needs at more than 400 non-profit organizations in the Champlain Valley region. United Way trains non-profit agencies on how to best utilize the time, skills and enthusiasm of their volunteers. The importance of this is clear when you start adding up the numbers over the course of a year. The estimated annual value of the time and expertise of 2,000 volunteers to the community is $1.8 million. A county-wide celebration of volunteers is held in September at the Hometown Heroes Awards, sponsored by United Way and the Argosy Foundation.

Creating partnerships, helping communities.

Still, no one organization can do it alone. That's why United Way emphasizes the need for non-profits to form lasting and effective partnerships with government agencies, foundations, businesses, schools, the justice system and other advocacy groups to see positive change. "Only then," Morse said, "will you see dramatic results, like cutting the school truancy and drop-out rate by 50% in four years the way the Burlington Truancy Task Force did." The community drive toward reducing truancy earned United Way of Chittenden County national recognition and is being used as a model for innovative partnerships at other United Ways across the country. United Way has also organized action and study groups on racism, drug and alcohol abuse, school truancy, refugee resettlement and the impact non-profits have on the region's economy.

United Way

In Chittenden County, a vital network of services, programs and partnerships are strengthened year-round thanks to volunteers and donors who believe United Way is the best way to change lives and shape communities.

United Way works throughout the community to bring people together. Here, the visiting Oscar Myer Weinermobile helped collect food for the Chittenden Food Shelf. More than 32 local non-profits partner with United Way and receive funding for more than 60 local programs.

Campaign Chair Paul Ode and his family encouraged giving back to the community during a recent United Way Community Campaign in Chittenden County.

Overhead Door Company of Burlington

It's not every day that an odd job turns into a 56-year old labor of love. But that is exactly how it happened for Donald D. Johnson, founder of the Overhead Door Company of Burlington.

Since 1948, the Overhead Door Company of Burlington has developed into what is now the largest installer of overhead garage doors in the state, as well as one of the major firms of its kind in Northern New England. With a service area that spans all of northern Vermont, the company oversees the installation of commercial and residential overhead doors, as well as loading dock equipment. This area expanded in 1982 with the opening of an office in Concord, New Hampshire, which covered the majority of the state.

About 20 years ago, in a highly successful business maneuver, Don's son and current company president, Jerry Johnson, implemented a wide range of residential and commercial windows, along with a variety of millwork products, to accompany the already superior line of overhead doors the company installed. As a result, the Johnsons' business became the top choice of contractors and homeowners who sought excellent products.

Behind every good man, there is a good woman

A successful business is not always just about numbers and bottom lines; it can also be the result of a happy coincidence. Before going off to the Marines, Don worked as a deliveryman on his family farm's milk route. It was on one of his scheduled deliveries that he met a lovely young woman by the name of Rita Kieslich. He married her in 1947.

By the time they celebrated their first anniversary, the dining room in their home that Don built at 745 North Avenue had already been put to use as the company's office. Rita worked alongside her husband to get the business up and running. She proved to be a worthy business associate, in addition to being a remarkable woman, who juggled work with maintaining their home and raising their four children.

Family matters

The Johnson's two sons, Wayne and Jerry, got into the business at an early age. Saturdays and school vacations were spent helping with door installations as well as accompanying their father on job consultations. By the time he had his driver's license, Jerry was completing jobs on his own. When he turned 18, he had his own commercial crew.

Upon Don's death in 1990, Jerry and Wayne continued the business, with Jerry becoming the company's president in 1995. Rita worked for the company until 1999.

Doors to the future

"I believe the success of this company is my employees," Jerry says. While the enduring family spirit is evident in the good fortune of the Overhead Door Company, the 45+ member staff currently employed by the company is what makes the day-to-day jobs run smoothly. While this group of loyal employees will certainly ensure a successful future for the company, Jerry Johnson admits to having high hopes with his own children.

What started as an odd job in 1948 has blossomed into the new millennium as a strong business steeped in family pride. The Overhead Door Company of Burlington promises high-quality installation that starts with stellar products. An experienced staff and the Johnson family commitment to superior customer service are what make this business a Vermont institution.

Since its founding in 1951, Pomerleau Real Estate has grown to be the largest owner/manager of commercial locations in the State of Vermont, with over 2 million square feet commercial space. In addition, Pomerleau's expertise extends to other project developments, including retail centers, Class A and medical office space, industrial and warehouse facilities, medical centers and fully-planned residential communities. Additionally, Pomerleau's full-service real estate brokerage team excels in the sale and leasing of commercial real estate and businesses through out the northeast and Canada. A third division, Pomerleau Property Management, effectively executes comprehensive property maintenance services, accounting services and financial reporting services for all their own properties, as well as third party accounts.

How long is the road from a dairy farm in Barton, Vermont to Burlington's historic Follett House? In Antonio Pomerleau's case, about 63 years and hundreds of smart business decisions that created a real estate empire and a living legend.

Tony's Burlington years have been characterized by success in both his career and his personal life. He and his wife enjoyed bringing up eight daughters and two sons here. One of whom, Ernie Pomerleau, joined his Dad in running the Pomerleau Agency full-time in 1969, after graduating from St. Michael's College. "In the 1970's we were on College Street, in a little three-room office," he remembers. "Soon after I came on board, we moved to a new facility on South Winooski Avenue. Then, in 1980, we moved again to the Follett House."

Triumph over Arson

The Follett House, a stately Greek Revival mansion overlooking Lake Champlain, has been a major Burlington landmark since 1841. Ammi Young, architect of the Vermont State Capitol, designed the building for Timothy Follett, a wealthy lawyer and judge with numerous business interests. The Follett House changed hands amongst several prominent families until 1892 and through several organizations until the 1970's, when the Veterans of Foreign Wars efforts to restore the building were thwarted by high costs. Then in 1978, the Pomerleau Agency became interested in acquiring and restoring the building for use as its offices.

By spring of 1979, when seemingly all possible acquisition issues had been overcome, an arsonist set fire to one of the massive columns on May 30th. The fire quickly spread to the third floor roof, causing extensive damage to the building's upper areas. Despite delay and increased costs, the Pomerleau Agency pressed on with the restoration. A year later, the Agency moved in. Antonio Pomerleau was 63 years old - and a world away from the old Barton farm.

Pomerleau Real Estate

One man's vision and determination created an authentic American success story -- and the real estate empire that bears the Pomerleau name.

WCAX TV

Fifty years after its test pattern signaled television's arrival in the Green Mountain state, Channel 3 remains the most watched and most respected source of local news in Vermont.

The beginnings of the Channel 3 News fleet of newsgathering vehicles.

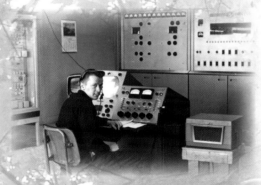

WCAX-TV engineers have always made sure the television signal made it clearly to Vermont homes.

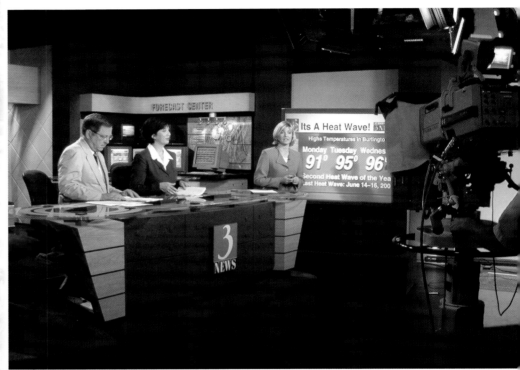

elevision arrived in Vermont on September 26, 1954, when WCAX-TV began broadcasting local programs from its first studio on Barrett Street in South Burlington. Today, WCAX-TV is located in a state-of-the-art headquarters at 30 Joy Drive in South Burlington. The transmitter remains on Mt. Mansfield, the highest mountain in Vermont, after which the station's company, Mt. Mansfield Television, is named.

Behind the scenes in-studio look at Marselis Parsons, Sera Congi, and Sharon Meyer during a live broadcast of the Channel 3 News.

The television station began life as a radio station. WCAX Radio, based at the University of Vermont, broadcast information to farmers from its Extension Service – the station's call letters are formed from the initials of 'College of Agriculture EXtension.'

WCAX Radio was owned by the Burlington Daily News, which had been acquired by local businessman CP Hasbrook in 1938. After Mr. Hasbrook sold the newspaper in the early 1950s, he began to explore ways to expand the radio station. Choosing the emerging television technology was a prescient move.

A family affair

CP Hasbrook was the father-in-law of the station's current owner, WCAX President Stuart 'Red' Martin – a 90 year-old dynamo who still comes to work every day, Saturdays and Sundays included. His son, Peter Martin, is Executive Vice-President and General Manager.

From its headquarters on Joy Drive, this CBS Network affiliate offers a mix of news and entertainment programming, with a crucial difference. Because the station has always been locally owned and operated, the connection to what happens locally, and how that affects the viewing audience, has always been strong. The local connection is a claim no other TV station in the Burlington-Plattsburgh market can make.

The station's principals and management are part of the community, sharing its goals and interests. Their historical view, ties to the area and connection to the audience simply can't be matched by stations whose owners are separated from the markets they serve.

Many of the stories the station covered in the early days were local. This has turned out to be a winning strategy. As proof, two of the original programs that first aired in 1954 are still on the air today: *You Can Quote Me*, a local news and public affairs program, and *Across the Fence*, a local farm and home program. Both are among the longest running programs of their type in the country.

Award Winning Newscasts

WCAX-TV has always made statewide news coverage a priority, with in-depth reporting on the issues Vermonters consider most important. In 1968, the station pioneered an hour-long nightly news broadcast at 6:00 PM. It remains the only TV station in Vermont to do so. Daily, total time devoted to original news coverage is close to four hours. Four news bureaus and several state-of-the-art newsgathering vehicles cover the most remote sections of its viewing area, which reaches beyond Vermont to parts of New York State and New Hampshire.

WCAX-TV's state of the art digital video production switcher.

This dedication was recognized in 2003, when the station's 6:00 PM newscast won the Edward R. Murrow Award for overall Best Small Market Broadcaster in the United States. Presented by the Radio-Television News Directors Association, the prestigious Murrow Award honors stations demonstrating the spirit of excellence the famed broadcast pioneer established for the broadcast news profession.

Channel 3 News has also received the coveted Dupont Award and the Peabody Award for excellence in news coverage – both considered to be the 'Pulitzers' of broadcast journalism. Numerous awards from the Associated Press in categories ranging from videography to editorial writing to breaking news coverage line the walls of the Channel 3 Newsroom.

Making a difference

WCAX-TV has always been involved in the community. Channel 3 sponsors numerous not-for-profit programs and organizations that serve the Greater Burlington community as well as Vermont. Among these are: the Vermont Mozart Festival, the Vermont Balloon Festival, the Vermont Historical Society, The March of Dimes, The Penguin Plunge, the Children's Miracle Network, the Vermont Lung Association, the American Red Cross and more. It donates production of the promotional video for First Night Burlington and produces many spot announcements for local nonprofits as a public service. WCAX-TV leads the nation in airtime and frequency of PSAs (public service announcements), a matter of some pride for this public-spirited company.

WCAX-TV crews man the cameras on the live, on-location broadcast of the Children's Miracle Network Telethon at the Champlain Valley Exposition in Essex Junction, Vermont.

As WCAX-TV turns 50, it finds itself in the middle of a multi-million dollar digital conversion. The station is well on its way to completing that conversion. One day, in the not too distant future, viewers will watch all of Channel 3's news and entertainment programming broadcast in high definition. Some things do change–others, like WCAX-TV's local focus, never will.

Sometimes it takes a lot of equipment to bring the story home.

Gravel and Shea

It's not easy for a small law firm to provide clients with the expertise afforded by larger, metropolitan law firms, but that's exactly what Gravel and Shea has excelled at for nearly half a century. Since 1955, the legal minds at Gravel and Shea have offered clients the support and resources of a larger firm with the personal attention of a smaller practice.

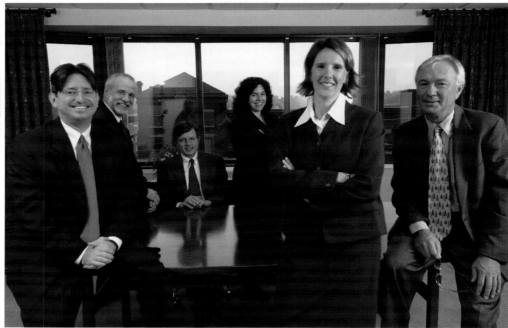

A partnership is born

After finishing his term as Chittenden County Probate Judge, Clarke Gravel began his private practice in 1955. Charles Shea arrived in 1969, and joined Gravel as partner in 1973. Together, they created a highly-respected law firm that currently has 23 practicing attorneys. With a passion for excellence and a philosophy that puts the client first, it is clear why Gravel and Shea has earned its place as a name that people can trust.

The team at Gravel and Shea has a wide practice that offers many areas of legal expertise including business and tax planning, employment law, litigation, estate planning, and real estate and development, among others. When it comes to commercial law, Gravel and Shea is often called upon as lead counsel to help with business acquisitions and mergers, in addition to debt financings, venture capital, and other equity.

An honored reputation

The firm's most recent accolade comes in the way of being rated the top-ranked business law firm in Vermont by Chambers USA, the Client's Guide, which is an independent publication that determines its rankings based on a survey of lawyers and clients. Seven of Gravel and Shea's attorneys were honored as leading Vermont business lawyers by the same publication. Additionally, six of the firm's 15 partners were listed in eight different categories in the most recent issue of Best Lawyers in America, a publication that

compiles its data based on the feedback of other attorneys.

The results of Gravel and Shea's hardworking team of lawyers go far beyond simply winning or losing a case. A law firm's current and future success is contingent upon its clients' trust, which, judging by the firm's extensive case load, is something that Gravel and Shea can certainly prove they have. The firm has maintained an impressive roster of clients that includes some of the most prominent businesses in all of Vermont. These businesses include a wide variety of professions including health care, telecommunications, commercial and investment banking, and non-profit organizations.

Big city results with small town appeal

Although Gravel and Shea maintains many high-profile clients, a great part of its workload is on the local community level. Local businesses, as well as families and individuals, have sought the respected legal advice of the Gravel and Shea team. Attorneys take on many pro bono cases to assist the various non-profit and charitable organizations in Vermont.

There's no doubt that the Burlington community is appealing—more than half of Gravel and Shea's attorneys are transplants from firms in larger cities such as Atlanta, New York, Boston, and Washington, D.C. The combination of Burlington's charm and a working environment that offers the same sophistication and challenges as any big law firm has made each lawyer quite thankful for his or her relocation.

Like many lawyers, the team at Gravel and Shea maintains hectic work schedules balanced with family and personal lives. But even after a long work day, the attorneys still make time to give even more back to the community by dedicating their time and talents to various organizations throughout Burlington. Gravel and Shea's lawyers are involved in many aspects of community life because the partners believe that community service should be meaningful to the individual, not because it raises the firm's esteem. As a result, lawyers have taught classes and led seminars at local colleges and universities, as well as volunteered their time and abilities in other areas of the community that are of personal interest to them.

Looking to the future

The attorneys at Gravel and Shea do not take their time-honored success lightly. They realize that in order to propel the firm into the next 50 years and beyond, it is essential to maintain the trust of its clients. In the words of Gravel and Shea's office manual, "'Good enough' is not good enough." The high performance expectations demand the very best of the lawyers in their research, analysis, and presentation of cases. When clients come into the offices of Gravel and Shea, they are comforted by the fact that these lawyers have done their utmost to prepare a good case. But who wouldn't feel comforted in beautiful offices offering picturesque city and mountain views of Burlington?

"Working in these surroundings gives us one more reason to look forward to coming to work each day," says Stewart McConaughy, managing director of Gravel and Shea. "We love what we do, where we do it, who we do it with, and who we do it for. And we intend to keep it that way for at least another five decades."

Vermont Rail System

What could save gallons of fuel, keep long haul trucks off route 22A and make little kids smile? The answer is simple... and it's already here.

he earliest ancestor of the Vermont Rail System was the Rutland & Burlington Railroad, chartered in 1843 by the State of Vermont to run between the two towns for which it was named. By 1867 the line was known as simply as the Rutland Railroad. Never a solid financial operation, the Rutland entered receivership in 1938. Cost cutting brought things around. But after the war ended, the decline continued, and by 1950 the end was near. The railroad closed down in 1963, and much of the right-of-way was purchased by the state.

It was the end of an era in the history of rail service in Vermont and the beginning of a new one.

Back on track

On January 6, 1964, a new short line was born from the ashes of the old one. The brainchild of New Jersey entrepreneur, Jay Wulfson, Vermont Railway became the first public/private railroad operation in the country. The company is still in the family: the current president is Jay's son David Wulfson; the Executive Vice President is Lisa Cota, Jay's daughter.

Vermont Railway was a success from day one – literally. Before the end of the first day of operations, the company was already ordering larger locomotives to haul the daily freight.

As traffic increased, dark green boxcars sporting the Vermont Railway logo were seen from coast-to-coast on all major rail carriers. Soon, the Vermont Railway name would be spotted on every major highway as well.

Serving the nation

In 1967, the Vermont Railway offered Vermont shippers the option of transporting goods via a trailer-on-flat-car system. Operating "piggyback" service in and out of Vermont, the Vermont Railway grew its intermodal trailer fleet to over 6,000 units. Vermont Railway soon became one of the largest trailer operators in the nation. It played a central role in the development of intermodal equipment as well.

With intermodal traffic increasing, Vermont Railway soon added terminals in Chicago and St. Louis to handle the high demand for the Vermont Railway trailer fleet. A terminal in Memphis was added later.

Today Vermont Rail System employs about 30 to 40 people in the Burlington area; about 120 statewide. The company also has employees in New York State, Chicago, and Memphis. All commercial functions are concentrated at the company's Burlington Headquarter; customer service, marketing, and sales, with branch operating offices in Rutland and Bellows Falls.

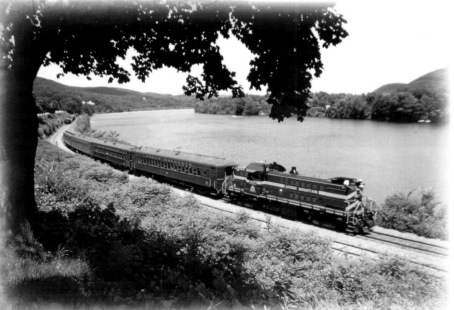

Riding the rails in Vermont

Vermont Railway was growing in the nation and at home. Starting in 1972, it began to add short lines. Its affiliations now include the Vermont Railway, the Green Mountain Railroad, the Clarendon and Pittsford Railroad, and most recently, the Washington County Railroad and the New York and Ogdensburg Railway. All have provided efficient, reliable rail freight service to a wide variety of customers for many years.

This growth has not only allowed Vermont Rail System to become a premier freight hauler, it's also created the ability to offer rail service to the general public. With daily Amtrak service, commuter rail service and tourist trains, today all types of people are discovering – and re-discovering – the utility and pleasure of a first-class rail system.

"Our primary business is moving freight," says David Wulfson, the company's President and "We also run passenger and excursion trains, to show people the beauty of Vermont."

Amtrak operates on Vermont Rail System's line from Rutland toward New York City. "Eventually we hope Amtrak will come right up to Burlington," says Wulfson. "Perhaps the rising cost of gas will encourage more people to travel by train. We'd be happy to move people, by providing passenger service, but only in situations where the economics make sense."

The fate of the short-lived Champlain Flyer provides an example. Starting in 2000, it linked Burlington with the village of Charlotte, about twelve miles away. Vermont Railway operated the Flyer with state funding. It was conceived as alternative transportation during construction work on Route 7, the main highway running south from Burlington. There were plans to extend the Flyer south to Vergennes and Middlebury and north to serve IBM with a connection to Amtrak. However, state budget problems caused the legislature to cut off funding. The service was halted in February 2003.

Freight secrets

Railroads aren't as visible as they were a century ago, when everybody took the train. But thanks mainly to freight, the industry is healthy. The US rail system is an integral part of the national economy–and the local economy as well. According to Wulfson, almost everything Vermonters buy has been touched by rail at some point. Some of his examples may come as a surprise.

"We bring in all the salt that is put on the roads in winter." Says Wulfson. "A lot of the grain and feed for Vermont's dairy cows also comes in by rail." Vermont Rail System's biggest customer, a European-based company, mines limestone in Middlebury and ships it by rail downstate to Florence, where it's processed for use in the paper, paint and plastics industries.

WJOY

At noon on September 14, 1946 chief engineer John Quill threw a switch and WJOY was off and running. It's been something of a Vermont institution ever since.

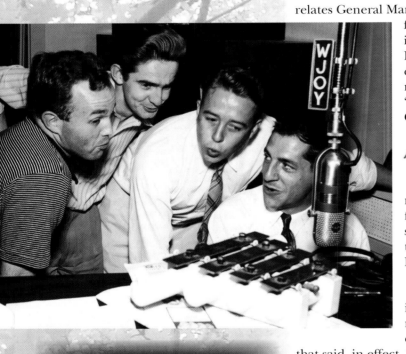

hen WJOY signed on the air in autumn of 1946, only a handful of other AM stations were operating in the Champlain Valley. Broadcasting from its newly constructed headquarters on upper Main Street, WJOY aired popular original programs like JOY a la Carter and Club 1230 that long-time local residents still remember. Local personalities on the station included Jack Barry and Val Carter, among many others.

At that time, WJOY was an affiliate of the ABC radio network. It held that affiliation into the 1960s. By then, FM radio technology was becoming prevalent. Adopting this new technology, station owner Frank Balch initiated WJOY FM. Sports and news continued to be aired on JOY AM, while FM was reserved for so-called "beautiful music."

AM to FM

"There was a reel-to-reel tape player for beautiful music that was kept in a closet," relates General Manager Dan Dubonnet. "It wasn't considered much competition for AM." But as the decade progressed, FM stations gained increasing prominence, delivering rock music to a new generation. Responding to this trend, in the early 1970s, owner Frank Balch changed the call letters to WQCR FM and dedicated it to automated rock. "There were reels and reels of tape," remembers Dubonnet. "Instead of beautiful music, now it was album rock – groups like Cream and Deep Purple."

April Fool?

"There seemed to be a giant hole in the marketplace," remembers Dubonnet. "We decided to do a research project to find out how we could better serve the market, and it came back saying Top 40 Country. So on April 1, 1990, we went from Stairway to Heaven to Hank Williams, Jr. We became WOKO FM, still at 98.9 FM."

The format changed on April Fool's Day. About three songs into the first hour, people realized that this was not a trick – country music was here to stay. The station fielded more than a few complaints before the tide changed and calls starting coming in that said, in effect, "Thank God there's a country station now." Since then, WOKO has been ranked either #1 or #2 in its market by Arbitron.

Hall Communications

"It's a family owned company," says Dubonnet, a Vice-President of Hall Communications who has been with them for more than 18 years. Most of the other General Managers are also officers of the company. The current owner, Bonnie Hall Rowbotham, is Robert Hall's daughter. A woman at the helm is rare in the radio business. "The big boys are buying up every radio station they possibly can, but we're not for sale…our owner has repeatedly said she wants to keep her father's name alive. We're small but we must be doing something right…we're actually taking those guys to the cleaners."

Tune in tomorrow

This radio group is the highest rated in the area as measured by Arbitron Rating Services. Dubonnet says they want to keep it that way. "We have a phenomenal group of people here. Many have been with us 20 years or more. Still, we are constantly looking to the future, looking for young and talented people. Our goal is to bring them along and train them, to keep freshness alive at the radio station." Now that's a pretty cool idea.

The firm's approach to every project is underscored by the understanding that it frequently requires a vast number of participants to design, permit and construct a building project. At Wiemann Lamphere it is understood that a cooperative attitude fosters a positive teaming experience.

That approach began with the company's founding in 1964 by J. Henderson Barr and Richard H. Wiemann. Their intent was to form a company that would evolve over time and grow with each change in ownership. In addition to Barr and Wiemann, principals to date have included James A. Lamphere, Dennis Webster, Gary Lavigne, and most recently, David Roy. The latter three represent the firm's current operating principals, with Lavigne acting as corporation president.

As ownership has evolved, so have project types. The approach has always been to respond to market forces and to minimize the temptation to specialize. The team building attitude allows the firm to collaborate with national and international specialty design and architectural firms in an effort to provide clients who have very specific needs with the level of expertise required for any project type. The firm has provided services to a wide variety of public and private clients in the areas of education, technology, banking and finance, business and industry, criminal justice, healthcare, resort, hospitality, and public and private housing. Among their clients are IBM, Infineon Technologies, Dartmouth College, the University of Vermont, Federal, State, and local government agencies, and a number of private regional and local organizations.

Although the firm has varied in size over the years, the current strategy is to maintain a staff of approximately twenty people. This commitment to stability has allowed the firm to retain a very high ratio of licensed architects and engineers, many of whom have decades of experience. Younger staff provides the technological expertise required to keep the firm competitive. Professional staff maintains licensed registration throughout the northeastern United States, from Maine to Michigan, and from the Canadian border to Metro New York. Leadership in Energy and Environmental Design (LEED) certification and membership in such organizations as the American Institute of Architects and the Construction Specifications Institute are critical to remaining current in the profession; while active participation on local boards and committees and pro bono efforts demonstrate the firm's commitment to the community.

Wiemann Lamphere Architects

Collaboration and teamwork: the foremost principles at the heart of Wiemann Lamphere Architects.

Wiemann Lamphere designed the first four floors of this seven-story building, which serves as a main branch for Key Bank. The design included cutting a 20 X 40 hole out of the second floor, creating this dramatic entrance and linking the two floors. The floor is mostly flamed granite, for traction, with polished granite accents. The back wall is the reverse. Photo by Gary Hall.

Sheraton Burlington

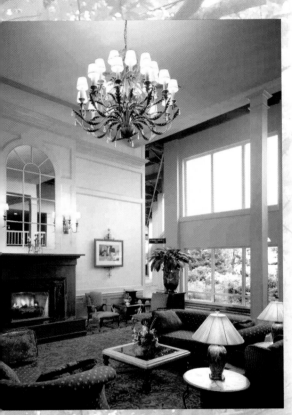

A landmark since 1840, today it's the hotel of choice for Hollywood stars, local business meetings, and just about everything in between.

It's only fitting that the Sheraton Burlington has been designated Vermont's first "green" hotel: its roots reach deep into Burlington soil, nourishing a tradition that treats its guests and the environment with equal care.

Today, the Sheraton's location marks the busy major routes linking Burlington with Vermont – and the world. But a century before the interstate and the airport, the traffic and the bustle, a farm stood here – with one feature that set it apart from its neighbors.

"Baxter's Follies"

Carlos Baxter's farm produced an abundance of livestock, milk, wool and vegetables for the Burlington area. It also produced an ambition in his wife, Elvira, who hit upon a way of broadcasting their prosperity to the world. At her request, four decorative cupolas were erected on the farm buildings – one for each of their children. The cupolas caused a sensation, with some sneering at them as "Baxter's Follies." The tallest, 26 feet high, was the first sight of Burlington for travelers coming to town in any direction. Modeled after the originals, which can still be seen in the courtyard and elsewhere, new cupolas now crown the Sheraton Hotel.

Vermont's largest

By the early 1990s, the Sheraton Burlington had become a world-class hotel and conference center, with hundreds of well-appointed rooms for guests and 30,000 sq. ft. of lavish meeting space that included an exhibition hall and a tiered amphitheater. A "summerhouse" interior courtyard now housed restaurant, lounge, pool and fitness facilities. Superseded by additional renovation, Baxter's and its connecting covered bridge were carefully dismantled in 1995 and taken away to be recycled.

"We're the largest hotel and convention center in the state of Vermont," says Alan Hebert, Director of Sales and Marketing at Sheraton Burlington, "In fact, we're the largest between Boston and Montreal. You can drive a bus right into the exhibition hall. There's an oversize garage door built right into the wall."

Hotel with a heart

"If someone is here due to an emergency, with, say, a loved one in critical shape at the hospital, they can stay here at a special low rate, for as long as they need, no questions asked," says Hebert. "We'll drive them to and from hospital if necessary; we'll do whatever we can to help."

Future plans

Hebert believes that the property's unique design and outstanding service are the reasons that guest satisfaction is so high: this hotel consistently ranks in the top percentile for guest satisfaction compared to all the Sheratons in North America. It's a rating he wants to maintain. "We'll work hard to keep everything in top shape – to keep them coming back."

ermont Business Magazine began modestly enough in 1972 as an insert in the Springfield, Vermont daily newspaper. In classic Horatio Alger style, thanks to hard work and several key strategic decisions, VBM is now widely considered the premier business publication in the state, with recognition earned both regionally and nationally.

If today VBM is the first place business people turn to for news, data, and the lists the publication is famous for, it's largely due to the efforts of two men: Publisher John Boutin and Editor Tim McQuiston. In 1992, Boutin headed a staff of five in what was then the Burlington branch of the Brattleboro-based business magazine; McQuiston was editor.

More than a decade later, Vermont Business Magazine lives up to its name with a print run of 7,500 and 6,000 subscribers and a statewide beat that puts the tabloid-format publication in a category of one. They publish fifteen issues each year: one each month plus three indispensable business guides.

Enter vermontbiz.com

Newsprint may never go out of style. But the introduction of their web site in July 2003 has gained the magazine a powerful Internet presence while speeding interactive communication with VBM's business constituency. Unlimited access to proprietary pages includes the magazine's complete archives and a list of almost 5,000 commercial, retail and manufacturing businesses – a largesse of downloadable data. Subscribers at the "Full Access" level use this information to create labels, use email and web addresses and reach key people. They can also download databases that include all the lists, directories and other publications. Subscribers receive a hard copy of VBM and can read it online as well.

Publisher John Boutin is pleased with benefits the web site is bringing to both his publication and the business community. "Our site is updated daily, in-house. Any Vermont business can submit press releases and calendar-type information. If it's considered relevant, we'll post it immediately," he says. "The searchable data base is a nice feature. If you're looking for, say, a graphic artist with five employees in Chittenden County, this is a fast way to find it."

Vermont Business Magazine

This is the magazine Vermont's smartest business leaders read—and now it's online.

What's ahead?

Vermont Business Magazine has also joined forces with The Association of Area Business Publications, which represents 67 members in the United States, Canada, Mexico, Australia and Puerto Rico and reaches some 1.1 million business professionals. As a member, VBM reaps significant benefits that include market research, regular meetings, workshops, a national advertising and public relations program, awards for editorial excellence, and an ongoing exchange of information and ideas between members. VBM was recognized in 2000 at the AABP Editorial Excellence Awards with the Best Reporter Award, Small Newspaper.

New England Air Systems, Inc.

Heating, air conditioning, ventilating, plumbing, sheet metal fabrication, duct cleaning, service and more are all in a day's work

Steve Bartlett, Owner

o the uninitiated, New England Air Systems might suggest an airline. The reality is more down-to earth. In fact, New England Air Systems is one of the region's most respected sources for designing, building, installing and servicing advanced mechanical systems.

"We serve customers all over New England," explains Heather Ferrara, the company's Executive Vice President. The systems they design manipulate air, water and other materials in various ways to customer specifications.

New England Air Systems was founded in 1972. President Steve Bartlett, the company's owner, has been on board almost as long. Steve entered the sheet metal construction field in 1967. Seven years later, he began working for New England Air Systems. "Steve started as a young man on the more simple tasks, like building locks and drives for ductwork as well as cleaning up scrap metal from behind the cutting shear," says Ferrara. "Now he owns the company."

Hardworking and resourceful, Steve Bartlett held a series of positions that took him steadily upward, from shop fabricator to field mechanic to project manager to chief officer. He bought New England Air in 1984. It's a family operation: Heather Ferrara, Steve's daughter, is Executive Vice President; his son, Bill, is Vice President of Building Services.

Building relationships

The Chittenden Bank at Taft Corners in Williston has New England Air Systems' stamp on it. So do Burton Snowboard's facility, the Husky Hot Runner Facility, the Middlebury College Library and Dining Hall, and Building 617 at IBM; other key customers are Green Mountain Coffee Roasters, Wyeth, Ben & Jerry's , Vermont Butter & Cheese, Queen City Printers, University of Vermont, Champlain College, Eveready Battery Company to mention just a few from a roster of client names, many quite large.

The company provides all services necessary to design, build, install, and service a project – a method known as 'design build.' As a specialist in mechanical systems design and fabrication, they are hired directly by a project's owner or by a general contractor.

"Say the project is a hospital or a school," says Ferrara. "The general contractor will put up the shell of the building. Then we come in and install the custom systems we've designed and built."

New England Air Systems is a full service mechanical contractor offering heating, air conditioning, refrigeration, process piping, commercial piping and medical gas piping. They have a full service department offering 24-hour HVAC and plumbing service to all of their customers along with preventative maintenance and system repair and equipment replacement. They are also the only certified mechanical duct cleaners in Vermont. Their duct cleaners are equipped to do air duct video inspection and surveys for their customers. Unlike many of their competitors New England Air Systems offers a 'single source of responsibility' approach for their customers. New England Air Systems, Inc. can design mechanical systems in-house in their engineering department,

they build the product in their custom sheet metal fabrication shop, and they have highly skilled employees to install the mechanical systems along with a full service department to service the mechanical systems. The bottom line is the outstanding customer service commitment they offer at the beginning, throughout and after the job. They believe in long-term relationships with their customers.

New England Air Systems uses advanced equipment to fabricate whatever the design calls for: ductwork, stainless steel pipe, exhaust stacks and more. Plumbing installations include substances not just found in the average bathroom, like medical gas, process chilled and hot water, pressured steam and compressed air. Building designs have called for geothermal heat pumps, wood-fired boiler plants, cooling systems, waste-heat recovery systems. New England Air Systems has seen it all, and done most of it.

On the job

New England Air Systems employs about 140 people. 110 of them are field workers responsible for providing all the services, heating and ventilating and more. Some have worked for the company for decades. "Most of our foremen have been with us for over ten years – that says a lot about our company and our employees," Ferrara comments.

Many skills are represented, with project foremen overseeing journeymen. The company also runs a full apprenticeship program for the service, plumbing and sheet metal trades. It's state-approved, one of just a handful. The apprenticeship program is open to employees of any age or sex. Admission isn't automatic, though: prospective apprentices must meet certain criteria. Once accepted into the program, participants receive both classroom and on-the-job training.

"It's a commitment to our workers," says Ferrara. "We fund the program. They have to do the class work and keep track of their hours, but every six months, as they move through the apprenticeship program, they get a raise. It's a great opportunity to better themselves."

Doing it right

Safety is extremely important to New England Air Systems' employees, from Steve Bartlett and company management right on down the line.

"Construction is a tough business." Ferrara points out. "Even in a small job, there are many obstacles that could cause injuries. We have a number of safety training programs," she says. "And we reward workers for safety-oriented habits and efforts." New England Air has earned more then a few rewards of its own for a job well done. The Lake Champlain Chamber of Commerce named them Business of the Year. Burlington Free Press Reader's Choice voted them HVAC Contractor of the Year. So did the Vermont chapter of the Associated General Contractors of America, a special honor for the company.

"Associated Builders and Contractors picked one of our projects, the Husky Hot Runner Facility building in Milton." says Ferrara. They received the ABC Specialty HVAC Project of the year award for the Husky Facility; other projects have also been chosen for recognition from the ABC over the past few years. New England Air Systems, Inc is the only local contractor that is a consistent annual recipient of the National Air Duct Cleaning Association safety award for no lost time on the job.

After over 32 years, New England Air Systems continues to be a leader in their industry and proud to be a Vermont owned company. "They rank all the U. S. companies in the industry by revenue," Ferrara explains. "Each year we are higher on the list." The company has also made the Top 600 Specialty Contractors list every year since 1994.

Champlain Water District

A single-minded focus on performance keeps Champlain Water District's operations – and its award-winning water – running smoothly.

Aerial photo of the CWD water treatment facility site.

CWD's Water Treatment Plant dedicated to Board Chairman Peter Jacob.

Where does water come from? If you live in Chittenden County, the simple answer may very well be the Champlain Water District. The Champlain Water District serves some 65,000 people around the county, ensuring a pure and reliable water supply by protecting the water source, treating and disinfecting the water to exacting standards, and sending it to taps countywide through a complex system of pipes and pumping stations.

Until the late sixties, each community in Chittenden County treated its water separately, with varying degrees of efficiency. Some were purchasing water from the city of Burlington. As growth accelerated in the county, Burlington was reluctant to meet the water needs growing beyond its boundaries. Worried officials, anticipating a water shortage, began to search for alternative solutions.

"The individual communities went to the Federal Government looking for funding," remembers Champlain Water District's Peter Jacob, Board of Water Commissioners Chairman. "The government pointed out that the communities were all in the same county, so why not work together?" Housing and Urban Development (HUD) supported the concept of a consolidated water system. Realizing the benefits, the communities agreed to act jointly.

Champlain Water District began organizational meetings in 1966 and received a grant from HUD in 1970. Chartered in 1971, Champlain Water District went on-stream (literally) in 1973. It supplies nine different communities serving twelve municipal water systems: South Burlington, Jericho Village, Williston, Shelburne, Essex Town, Essex Junction, Colchester Town, Milton, Winooski, Colchester Fire Districts #1 and #3, and the Mallets Bay Water Company.

Water journey

The source of the 10 million gallons of water Champlain Water District produces each day lies one half mile off the shore of Shelburne Bay. There, 75 feet below the surface, an intake pipe pumps water toward the Peter L. Jacob Water Treatment Facility on Queen City Park Road in South Burlington.

The rigorous series of operations performed thereafter almost compulsively honor the entity's mandate to ensure a safe and healthy water supply. "We have treatment and transmission specialists who share 24/7 duty. They continually monitor data to control overall operations," explains Champlain Water District's General Manager Jim Fay. "They'll redirect the water flow to put more or less water into certain communities, to fill storage tanks, they'll respond to fire incidents to allow more water to be directed to a certain location. If necessary they'll dispatch Champlain Water District and surrounding community water operators to emergencies. These are the folks that make certain that when you turn your faucet on, the water quality, pressure and volume are there." Other Champlain Water District technicians are busy maintaining all of the water related equipment to ensure optimal operation and performance. With an average of twelve years on the job, the plant's employees perform their tasks with swift efficiency.

This attention to detail has earned Champlain Water District one of the highest honors in the water field: the Phase IV Partnership for Safe Water-Excellence in Water Treatment Award

The best H₂O in the Business

The Partnership for Safe Water organization is a unique cooperative effort that includes the EPA and a consortium of national water industry associations. The Partnership encourages and assists United States water suppliers to voluntarily improve their water systems' performance to enhance public health protection.

In 1999, an independent team from the Partnership spent three days at Champlain Water District, evaluating fifty separate parameters in water treatment design and systems operations. Then came the exciting news. Champlain Water District had achieved the Excellence in Water Treatment Award: the first water utility in the nation to do so. Because the requirements are so challenging, Champlain Water District remained the sole recipient of this award until 2003, when a water treatment facility in Utah became the second to meet the award's high standards.

How does Champlain Water District treat its water? "Very, very carefully," says Jim Fay. "Even though we have multiple clarifiers and filters that treat the water and make it safe to drink, we don't just look at the 'combined filter effluent,' we examine each individual treatment unit. We set very strict water quality goals for each unit."

CWD's source of water is a protected deep water location in pristine Lake Champlain

CWD's Partnership for Safe Water Excellence in Water Treatment Award.

The Board

Champlain Water District has a publicly elected Board of Water Commissioners – a member and alternate from each member town – who serve three-year terms. The number of years of service averages sixteen, providing the continuity that makes for an informed and effective body. Chairman Peter Jacob's history offers an outstanding example of the commitment typical of all Board members. First elected to head the Board in the late 1960s, he's held this position ever since. Under his informed leadership, the Board very quickly comes to consensus on what needs to be done in a very proactive manner.

With the Board's support, Champlain Water District takes a long-term approach. The objective is to stay a half-decade or so ahead of regulatory schedules, proactively investing in new strategies to meet regulations that are years down the road. Following an extensive sixteen-month effort, in 2003 the Champlain Water District distributed its Twenty Year Master Plan, a comprehensive review of the treatment, storage and distribution components of the water system. A key feature of the plan is the development of a computer model with water quality modeling capabilities, based on an advanced GIS (Geographic Information System) map.

Making it work

The District's municipal charter is dedicated exclusively to supplying safe drinking water. This gives Champlain Water District an advantage over the alternate situation where water treatment is one of several city departments – perhaps run by the same manager – all competing for time, attention and funds.

"At Champlain Water District, it all comes down to water quality," says Jim Fay. "We treat our water for the intent of the law, not just the letter of the law. We do what we do, not just for today, but because it's going to work very effectively in an evolving regulatory climate years down the road."

Burton Snowboards

Jake Burton shaping boards in the early days.

The world's most successful snowboard company got tsarted as many things do in Vermont - on a farm.

Back in 1977, Jake Burton Carpenter moved to an old farmhouse in southern Vermont. Jake began shaping snowboards himself in the barn. The grassroots business soon took over every room in the house, with Jake taking orders at all hours from his bedroom phone and making deliveries out of his station wagon. From such humble beginnings sprang a company that ignited the growth of snowboarding, and leads the industry worldwide.

Today, snowboarding is a mainstream sport. But in the late 1970's and early 1980's snowboarding was an underground hobby - riders had to hike local hills and backyards to try out the sport, and snowboarders weren't allowed on resort chairlifts anywhere in the country. Jake Carpenter realized that the first thing he had to do to grow his business was to grow the sport.

Because Burton started in Vermont and is still based here today, the state has played a role in the growth of snowboarding as well. In the early 1980's, Jake lobbied hard for local Vermont ski areas to open their lifts to snowboarders. In 1982, Suicide Six Resort in Pomfret, Vermont was the first resort to allow snowboarding. Soon after, Jake succeeded in convincing Stratton Mountain to allow snowboarding, resulting in a strong lpartnership that still exists today.

Jake Burton on one of Burton's first snowboards - The Backhill.

Taking off

Once resorts began to accept snowboarding, Jake knew the next step was to support an event that showcased the sport and allowed riders to compete. To further this aim, he assumed operation of the Open Snowboarding Championships in the early 1980's, an event held at Stratton Mountain, Vermont since 1985. The Open fueled the growth of snowboarding, exposing the sport to media, spectators and the world at large. Now the longest standing snowboarding contest in history, the US Open has become the pinnacle event of the winter, attracting upwards of 35,000 spectators and the best riders on the planet.

Worldwide growth, Vermont style

As the sport grew during the 80's and 90's, Burton Snowboards also grew exponentially. The definitive leader of the snowboarding industry since its inception, Burton products are currently sold in thousands of specialty retail stores around the world. The company also sponsors the world's top pro riders including Olympic Gold Medalists and native Vermonters Kelly Clark and Ross Powers.

With headquarters and a high-tech snowboard factory located in Burlington, Vermont, the heart of Burton is still very much in the Green Mountain State. Pro riders from around the world often stop by Burton headquarters to help with the product development process, and Jake Burton is also based out of th e Vermont office. Snowboards at the Burton Manufacturing Center in South Burlington are crafted by hand, with the true attention to detail that Vermont-made products are famous for. Burton Snowboards also has a flagship store located in Burlington, Vermont, which boasts the largest selection of Burton gear in the world. With

international offices in Innsbruck, Austria and Tokyo, Japan, Burton dominates the snowboard market around the globe as well.

Growing the sport

Even though millions of people now snowboard, growing the sport is still a priority at Burton. The company started two successful programs in the late 1990's to expose the sport to more people. In 1998, Burton created the Learn to Ride (LTR) program and became the only snowboard company in the industry focusing on instruction methods and beginner-specific equipment. The goal of LTR is to give beginner snowboarders the best initial snowboarding experience possible so they return to the mountain and continue to snowboard. By using a proven instruction method and equipment created specifically for beginners, LTR helps riders enjoy their first day on a snowboard. Vermont resorts including Killington, Mt. Snow and Stowe were the first to adopt this highly successful program, which is now offered at more that 63 resorts in nine different countries.

The Chill program, also founded by Burton in the mid-90's, focuses on learning to snowboard as a means of supporting at-risk youth's self esteem and giving back to the community. Started in Burlington, Vermont, Chill is a non-profit intervention program for disadvantaged city kids who would never have the means or resources to get out of the city, enjoy an area mountain resort and learn to ride. Chill takes underprivileged and at-risk kids snowboarding once a week for six weeks and provides them with everything they need for the experience: lift tickets, instruction, bus transportation and head-to-toe gear. Every winter, Chill provides this life-changing program to 1,700 kids in nine different North American cities.

Rider-owned, rider-driven

Vermont native and Burton rider Ross Powers at the 2003 US Open. Photo by Jeff Curtes

Chill kids enjoy learning to Snowboard.

Many of the core beliefs Jake held in the beginning are still the cornerstones of Burton Snowboards today - focusing on progressing the sport and product, involving snowboarders in every aspect of the product development process, suppporting a team of the world's best snowboarders and having fun while working hard.

These principles not only make the company successful, but also make it a great place to work. Bringing your dog to the office and skipping work when it snows more than two feet (a rare phenomenon in Vermont) are two of the best benefits of working at Burton Snowboards. The dogs are some of Burton's most valued employees, and a free season's pass at Vermont-area resorts keeps Burton employees on snow all winter long.

By Abigail Young

Rossignol

Rossignol's North American corporate headquarters is located in nearby Williston, Vermont, serving a global ski and snowboard consumer base.

ts proximity is less than an hour from some of the best skiing and boarding in the East, offering Rossignol's employees, teams of competitive athletes and a growing corps of winter sports enthusiasts with the perfect terrain to field test the company's line of alpine and cross country skis, snowboards, boots, poles, bindings and outerwear.

The Williston facility serves as the international corporation's American headquarters for customer service, warranty and repair, marketing and human resources. It is also the home base for Rossignol's sales and product management who service authorized Rossignol dealers across the country. It is one of two U.S. distribution centers; the other being located in Clearfield, Utah. Rossignol received its industry's top honor when it was named Supplier of the Year in 2002 for the third year in a row by the National Ski and Snowboard Retailers Association.

The low-slung brick facility, tucked back from the road and surrounded by tall red pines, also serves as the company's key research and development site for the next generation of snow sport equipment.

A passion for snow sports

Since it began in 1907 as a French ski company, Rossignol has become the brand leader, both in the U.S. and worldwide. It is known for high performance ski products that withstand the test of time on the most challenging slopes. Rossignol remains the top supplier for the U.S. Ski Team as well as internationally known athletes looking for the competitive edge in their sport.

Photo by: Agence Zoom

A long-standing commitment to forward-thinking management and product enhancements fueled the rebirth of the alpine ski industry in the 1990s and continues to capitalize on the exploding youth and winter sports consumer market. "We have never been satisfied to rest on our laurels," explained Hugh Harley, Vice Chairman of Rossignol.

A passion for snow sports and a respect for the mountain drive the creation of such innovations as shaped skis, 'soft' boot technology and the use of new materials to increase speed, durability and reliability. The longevity of Rossignol's employees, most of whom have been with the company an average of 16 years or more, speaks volumes about high standards and commitment to quality work.

Ninety percent of the company's catalogs, advertising and marketing efforts are developed and created in Williston setting the benchmark for the look, feel and style of winter sports on an international stage. Rossignol's slogan 'Pure Mountain Company,' provides a signpost to what it has strove to be for nearly a century – a world leader in winter sports products with a respect and commitment to the environment.

Photo by: C. Hasse

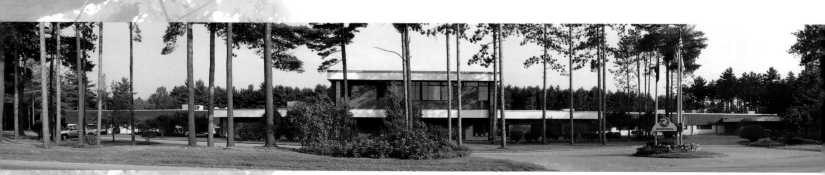

A t the University Mall in South Burlington, shoppers can choose from a selection of major department stores like Kohl's, JCPenney, Sears and The Bon-Ton, plus plenty of specialty shops featuring electronics, sporting goods, the latest fashions, housewares, and much more. Visitors can take a break in the Garden Cafe food court or enjoy a bite at Applebee's Neighborhood Bar & Grill. There's so much under one roof, with plenty of free parking.

University Mall

With over 70 stores, Vermont's largest enclosed shopping center has something for everyone!

A mall's beginnings

Managed by Finard & Company, University Mall was built in 1979 with two department stores as its 'anchors.' In 1989 it doubled in size and currently spans 608,000 square feet, making it the largest enclosed mall in Vermont.

University Mall credits a loyal shopping base with offering a variety of stores that allow shoppers the opportunity to purchase gifts, decorate their homes, and outfit the entire family – all in one shopping trip. Mall-wide gift certificates, which account for approximately $1.6 million of the mall's yearly revenue, make it even easier to shop for family members and friends during the gift-giving seasons. By visiting www.umallvt.com, shoppers are also able to purchase University Mall gift certificates online, find out about upcoming special events, and sign up for an e-newsletter that gives them the 'heads up' on sales and promotions.

More than just shopping

Since the mall first opened its doors, the Mall Walker program has been part of its identity. This popular program encourages seniors to come and exercise by walking the length of the mall before stores open for business and currently has over 500 registered walkers. From Monday through Saturday, the doors are opened at 5:00 am to allow for exercising and socializing. Mall Walker Speaker Weeks, held in February and June; are made up of experts from various health professions who speak on topics of interest to the walkers. The health benefits of mall walking are touted doctors nationwide as the flat walking surface and climate controlled environment is beneficial for people of all ages and conducive to a wide range of fitness abilities.

Giving back to the community

One of the ways University Mall is helping to build a better future for the Greater Burlington area is through its Scholarship of Excellence program. Each year, $25,000 in scholarships is awarded to area college-bound students who demonstrate excellence in academics, leadership and community service. University Mall has awarded a total of $100,000 to area youth since the program began in 2001.

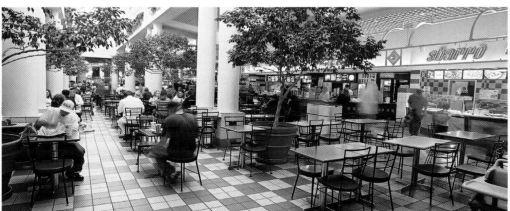

Lang Associates Realtors

This homegrown independent empowers its agents, supports dozens of charities, and outsells the competition.

The Lang family; over 75 full time Associates and 24 staff

From the outside, Lang Associates' headquarters on Hinesburg Road in South Burlington looks like the bricks and mortar of any modern upscale office building. Step inside and you are in another world, filled with collector-quality antiques and art; polished, warm and elegant. Lang people clearly have an eye for quality.

"Thanks to our associates and staff, we have led our market for over two decades," says Lang owner and President Staige Davis, who chooses people as carefully as paintings. "Their talent and dedication alone are what keep us ahead of our competitors." That is quite a tribute. Lang Associates, an independent real estate firm, competes with some heavy hitters – franchisees of giant national companies with deep pockets for advertising and marketing. Despite that, most people think of Lang Associates first when they are property shopping. Measured by dollars earned and units sold, Lang Associates is the largest real estate company in Vermont.

Foundation

In 1980, Staige Davis came to Lang for an interview with his mind already made up that he wanted to join the firm. He had interviewed at several other real estate firms. To each he asked the same question: aside from your own company, which one is the best? The answer was always Lang Associates.

Lang Associates' South Burlington office, 550 Hinesburg Road

Associates at Lang are assisted, coached, educated and supported by management, but at the end of the day, are driven only by the will to succeed. The 75 plus full-time associates enjoy being at Lang. In an industry characterized by the revolving door, most of them have stayed at Lang for more than a decade. One associate has been with the firm almost continuously since Nancy Lang founded the agency in 1969.

Changes

Lang's award-winning website, www.langrealestate.com, contains a complete database of Northwestern Vermont properties and a link to the multiple listing service detailing properties throughout Vermont and the United States. Prospective buyers who visit the site can take a virtual tour of almost all Lang's current listings. Other pages offer a wealth of information related to every aspect of buying, selling, renting, building and maintaining real estate. Approximately 30% of Lang's leads are generated via the Internet. The virtual tour feature has even sold houses, sight unseen.

elinda Moulton and Lisa Steele call themselves Sustainable Redevelopers. In the tradition of other successful Vermont entrepreneurs, from Ice cream's Ben and Jerry to snowboarding's Jake Burton, they are literally breaking new ground.

Partners in Main Street Landing Company, Moulton and Steele have been involved in environmental and socially-conscious redevelopment since the early 1980s. Together they created an innovative team approach to design, development, and construction, and used it to conceptualize an ambitious 25-year redevelopment plan for the company's holdings on Burlington's waterfront.

Front of CornerStone Building at Three Main Street. Photo by: Sandy Milens

North courtyard of the Wing building, with stairs leading to Union Station and The CornerStone Building. Photo by: Brad Pettengill

Back to the future

In July 2003, Main Street Landing began construction of the Lake & College Redevelopment Project, just north of Union Station on the Burlington Waterfront. As with Union Station, Lake and College will include performance and fine arts elements. The project enlivens the Battery Park neighborhood, offering warmth, access and visual interest, along with a range of amenities that serve and complement the public urban park.

Moulton and Steele believe strongly in pedestrian-friendly environments. This project is a case in point: mixed-use functions are leavened with plenty of public access. A pedestrian connection combines a central overlook, stairs and an elevator, allowing people to stroll through the project on their way between Battery Park and the waterfront.

Plans call for the construction of a streetscape along Lake Street that invites people into the businesses, shops, performing arts facilities, and promenades. A balanced mix of exterior designs will harmonize stylistically with the buildings already present on lower Battery Street. The focus will be on local businesses, including an independent-film cinema with two screens, each seating 140; a black-box performance theater, and a restaurant.

A potent mix of the visionary and the practical

Although it's not here yet, Melinda Moulton can see the future clearly: the pedestrian-friendly local businesses and shops with their pleasing mix of visual beauty, local character and charm–the boutiques and artists' studios–the airy second-floor offices. "You'll notice the glow of the lighted marquees on both the live theater and the cinema," says Moulton, pointing out that the performing arts features will be a Mecca for citizens and tourists alike, drawing them toward Burlington and its remarkable arts and cultural community.

Main Street Landing Company is building the Lake and College project according to principles that strongly adhere to environmental and social guidelines. Lake and College will be completed by July 2005, and ready for occupancy – retail and office space is already available – thereby giving list-makers yet another reason to include 'little' Burlington among the best places to live in the USA.

Main Street Landing

The self-styled 'redevelopers' of Main Street Landing Company believe that decisions made today should not limit the choices and opportunities of future generations. Their vision is changing the face of Burlington's waterfront.

South entrance to Wing Building. Photo by: Brad Pettengill

Union Station, One Main Street, Burlington. Built 1916. Photo by: Brad Pettengill

Green Mountain Coffee Roasters

Fueled by a passion for coffee, Green Mountain Coffee Roasters has brewed up a premium blend of the highest quality coffee and social responsibility, for economic success.

I n 1981, Bob Stiller wasn't much of a coffee drinker. He'd grown up with the dubious taste of perked and instant. As an adult he was less then impressed with the bitter, boiled potion served in diners and most restaurants. Then, in a small Waitsfield cafe, he had an epiphany. "The place roasted their coffee beans on their premises" I'd never tasted anything like it," he remembers.

Most people might have been content with ordering a refill. Bob Stiller saw an opportunity. Already a successful entrepreneur – he'd already founded and sold one profitable company – Stiller now resolved to bring this enriching experience to a world that didn't yet know what it was missing. He bought the cafe, and a different kind of coffee company was born.

Serving premium quality, freshly roasted coffee by the cup and the pound soon led to the new company's first expansion. They began supplying their products wholesale, at first to area restaurants and inns that served skiers and other visitors to the scenic Green Mountains. When these vacationers asked the company to ship the coffee to their home states, the company responded by adding a mail order operation.

By 1985 they had moved to larger quarters in Waterbury, a short distance away. There, in the late 1980s, the company's desire to operate more efficiently resulted in some delightfully unexpected consequences.

Eureka!

"We were trying to do a little better financially," remembers Stiller. "So we got all the employees together to try to figure out how we could save money, but there really wasn't much energy behind it." Then a group of employees decided they wanted to start an environmental committee.. "They'd turn the temperature down at night, and then they got enthusiastic and turned it in the day, too," says Stiller.

The lesson, says Stiller, is this: when it was just about reducing company expenses, people were neutral. Saving the planet was something else entirely. Everyone got motivated and ideas began to fly. People in the shipping area redesigned boxes, reducing the size to fit the product: the company reduced waste and reduced expenses too.

This correlation between "good for business" and "good for humans and the planet" informs every decision at Green Mountain Coffee Roasters. "We realize that without being profitable and successful we're not going to be able to do any good," says Stiller. "But what we've been striving to be is a model company that embraces sustainability and succeeds."

One way to measure success: the company had sales in excess of $116 million for the fiscal year ended September 2003, generated mostly by the company's wholesale business, which serves more than 7,000 customer accounts. But at Green Mountain Coffee Roasters, profitability is just part of the story.

Taking responsibility

Heightened environmental awareness soon led to development of Rain Forest Nut coffee. It was an elegant plan. The coffee raised awareness of the plight of the fragile rain forest, and part of the profit from sales was donated to Rain Forest Alliance and Conservation International.

"We began developing sourcing guidelines for coffee farmers – giving suppliers extra points for responsible treatment of the environment, better pay for workers and so on," Stiller says. Green Mountain Coffee Roasters bought more organic coffees as the quality improved. When Fair Trade certification came along, the company's organic coffee suppliers also qualified as Fair Trade farms for at least two reasons: they were co-ops, and the workers were earning decent money because Green Mountain Coffee Roasters was paying Fair Trade certified prices.

The certifying authority, TransFair USA, has established price guarantees to make sure that small-scale coffee farmers and processors receive fair compensation for their efforts. Fair trade practices help to avoid the sharp swings in coffee economics prevalent for decades: a boom-or-bust situation that can drive desperate coffee growers to plant other crops or abandon the land entirely. "These are wonderful people that just want to find some way to be able to live, to take care of themselves, their families, and their communities," Stiller comments. His company's practices have gone far to stabilize the lives of coffee growers in several coffee communities.

Green Mountain Coffee Roasters' Fair Trade coffees are organic (certified by Quality Assurance International) and cultivated with natural gardening techniques like composting and terracing. They are grown entirely without pesticides, herbicides, or chemical fertilizers. They are also almost always "shade grown" – interspersed with other plants – to discourage erosion and preserve vanishing wildlife habitat, including songbirds that migrate to Vermont and sing for our pleasure, perhaps while we're out on the deck enjoying a cup of coffee. During every processing step at the Waterbury plant, the certified coffees are carefully segregated to ensure their purity.

Partners in caring

Green Mountain Coffee Roasters works with Heifer International, a nonprofit world hunger organization, to raise consumer awareness about the importance of buying Fair Trade organic certified coffee, and to increase support for Heifer's mission of ending world hunger. Heifer provides cows, goats and other livestock to impoverished families. It then asks them to pass on offspring of their animals to others, lifting up whole communities. Since 1944, Heifer has helped more than 4.5 million families become self-reliant.

Other alliances to support coffee growing communities worldwide include Coffee Kids, Grounds for Health, Habitat for Humanity, and many others. The list means more when you consider what it represents: a feedback loop that connects grower to processor to user in a cycle of understanding: the result is compassion, all the way down the line.

People power

Green Mountain Coffee Roasters employs about 600 people, half in Waterbury, the rest in regional distribution centers in the eastern USA. Working for this company is something more than just a job – it approaches a way of life.

The company's CAFE (Community Action For Employees) program gives employees paid time off to volunteer in their community wherever an employee sees a need. Each year, employees spend thousands of hours volunteering at schools, fire departments, rescue squads, and numerous community organizations. Green Mountain volunteers also visit coffee growing communities in Mexico, Central America and Africa where they volunteer in projects to improve the health care and housing of coffee farmers and their families.

CVCA

Treated with care and cutting edge skill, hearts are in good hands at Champlain Valley Cardiovascular Associates.

Walter Gundel, MD, F.A.C.C

Daniel Raabe, MD, F.A.C.C

Kevin Carey, MD, F.A.C.C.

Stanley Shapiro, MD, F.A.C.C.

I n 1985 two cardiologists who were friends and colleagues had the vision that a highly personalized cardiovascular practice would benefit patients in the state of Vermont. They opened a small practice in a building of Victorian vintage in Burlington. Walter Gundel had been the Director of the Cardiac Catheterization Laboratory at the University of Vermont and Dan Raabe had been the Coronary Care Unit Director

In 1992 Kevin Carey who had recently trained at the University of Massachusetts Medical Center and Stan Shapiro who had an established cardiology practice in Middlebury, joined the group. Subsequently, a third cardiologist from Rutland, J. Christian Higgins, was enlisted thus creating a third CVCA (Champlain Valley Cardiovascular Associates) office and expanding the referral base throughout the entire state of Vermont. Following in rapid succession were Joseph Winget and Robert Battle, both with highly regarded cardiology practices at the University of Vermont. Most recently added was Steffen Hillemann. CVCA, in an effort to even better meet inpatient needs, brought Steve Crumb on board. A nurse practitioner, Steve works full-time to provide and coordinate direct hospital inpatient care.

By 2002 CVCA had moved into larger quarters on Dorset Street in South Burlington. Presided over by Karen Rounds, Chief Operating Officer, who runs the practice with boundless energy and limitless innovation. Employing more than forty individuals, CVCA is the largest private cardiology practice and medical subspecialty group in Vermont.

CVCA is proud to say that staff members, from clinical to clerical, are routinely praised by patients for the way they care for them and respond to their needs. Every day a nurse is stationed at a phone that is a direct line for patients who can call with questions, request prescription refills or share concerns with a live human being at the other end.

"We've made a commitment to continue to provide a personalized high-level service for patients," says Raabe. "As a group we really enjoy our patients," adds Gundel. "We've known a lot of these people for years and they've become very special to us-they're friends."

According to the philosophy these doctors share, a caring and friendly attitude can be downright therapeutic. "If you like and trust your physician, you're much more likely to do the things you're asked to do that will help make you healthy," Raabe comments.

Specialties

"Cardiology has many subspecialty areas and we cover them all," explains Dr. Raabe. Clinical cardiology is basic: seeing patients in the office, adjusting prescribed medications, and ordering diagnostic tests. Beyond that CVCA provides a multitude of diagnostic and treatment modalities including nuclear cardiology and nuclear stress testing, echocardiography, interventional cardiac catheterization, and electrophysiology. In fact, Walter Gundel was the first doctor in the state to perform angioplasty in 1970.

Office Visits

Patient visits range from a routine follow up of coronary disease, heart failure and hypertension to a complex evaluation of patients who have had surgically treated congenital heart disorders and who are having advanced arrhythmia problems. As always, striving to be at the forefront of exceptional patient care, CVCA recently introduced a number of new procedures. Among them is an unusual procedure called enhanced external counterpulsation (EECP). "EECP is for people with coronary artery disease who are running out of other options," says Raabe. Special air-filled cuffs are applied from ankle to upper thigh and inflated directionally toward the heart in coordination with the heart cycle. Treatments are given five days a week for seven weeks, reducing symptoms in about 85% of patients.

An anticoagulation clinic was also established for patients requiring coumadin therapy. Patients can have their blood values evaluated by fingerstick with results given at that visit. This helps to improve patient compliance and to maximize outcomes.

A heartbeat away

"Another innovative process we've just started is something called Care Link," says Gundel. "It records your heart rhythm all the time. If people with automatic defibrillators develop any problems, this is a new way to detect and stop it."

"We used to have patients come in to make sure their device was working properly and to see what kind of rhythm problems they'd been having. Now they can check in from home or practically anywhere in the world. If they can get a computer hook-up, they can get their defibrillator checked via satellite on a totally secure circuit."

Prevention

CVCA is planning to introduce a preventive cardiology wellness program to provide baseline screening for blood pressure and abnormal cholesterol and offer related information on treatment options and lifestyle modification.

"Coronary artery disease is clearly related to lifestyle: what you eat, how much you exercise, how much you weigh, if you smoke," says Raabe. There are some genetic factors as well, but lifestyle choices count most. Prevention can play a major role.

A second chance

When intervention is required, the doctors at CVCA specialize in cardio-catheterization, performing about 25-30 procedures every week at Fletcher Allen Hospital. Installation of pacemakers and defibrillators is also increasing.

Most rewarding is when a person in the fast lane to a shortened life comes for treatment. Raabe recalls a story of treating three young guys who had never taken care of themselves. "Now they had very serious problems–but I could correct them and I did. They got a second chance and they've made the most of it. To see these guys today, taking care of themselves and leading productive lives–that's what it's all about."

J. Christian Higgins, MD, F.A.C.C.

Joseph Winget, MD, F.A.C.C

Steffen Hillemann, MD

Robert Battle, MD, F.A.C.C.

Karen Rounds, Chief Operating Officer

Gardener's Supply

Gardener's Supply has a mission: to be "America's premiere gardening resource," and to be a model community member – locally and globally. It is achieving these goals with its store and outlet located in Vermont, and by reaching out to a larger community as a mail order and online purveyor of gardening goods and gifts.

ifty-eight-million-dollar businesses are not uncommon these days. But a $58 million employee-owned business that is nationally renowned for product innovation, top notch customer service, environmental leadership, community involvement and philanthropy – now that's uncommon. Uncommonly good.

The company's four seasonal catalogs are chockfull of practical paraphernalia that gardeners employ to grow big, juicy tomatoes; fragrant, pest-free roses; striking, flower-laden window boxes; weed-free, cleanly edged landscapes and the like. From bean trellises to garden clogs, each issue offers hundreds of products that promote earth-friendly gardening.

No matter what the products, the unique personality of Gardener's Supply shines through on every page of its catalogs as well as its www.gardeners.com website – that is – the voices of gardeners themselves. Product descriptions are unmistakably written by people who have garden soil under their fingernails. Most photos feature local customers or employees such as web site coordinator Marianne Balczuk putting seedlings into a cold frame, and president Jim Feinson, well, reclining in a deck chair.

"We're gardeners ourselves, and we use the products we sell in our own gardens," says Kathy LaLiberte, Director of Brand Services and one of the company's founders. Because most of the more than 250 full-time employees are avid gardeners, the products are garden-tested before they ever reach the pages of the catalog.

And like most gardeners, Gardener's Supply employees just can't help but improve already-good things. The company's research and development team has introduced such exclusive products as tomato teepees, self-watering patio gardens, rain barrels, composters and greenhouses. Gardener's Supply backs up all its products with free how-to bulletins and an online question and answer service.

Customer feedback is encouraged and highly valued at Gardener's Supply. All staff are scheduled to spend several hours each month on the phone with customers. This close connection with customers finds its way into customer testimonials, product ideas and personal gardening stories.

The company mailed its first catalog in 1983 offering a handful of tools and other practical gardening equipment, many of which were imported from Europe. Founder Will Raap is a California native and a savvy entrepreneur with degrees in both economics and community planning. He and his wife, Lynette, have gardened together for almost 30 years.

Raap and a handful of like-minded gardening enthusiasts created the employee-owned company with environmental stewardship and good works at its core. The company has flourished financially. It has won awards for its employee stock ownership program and donates 8 percent of pre-tax profits to a wid e range of gardening-related nonprofit organizations both locally and nationally.

While growing a business, Raap has also put his background in community planning to work on the Winooski River floodplain that surrounds the company's main offices. This area, known as Burlington's Intervale, has a rich agricultural history that dates back to Native American times. Unfortunately, like many wetlands located near urban areas, the Intervale had become a forgotten wasteland, filled with trash and old cars. In 1988 Raap established a non-profit organization, the Intervale Foundation, and has led the effort to return this community resource to productive use.

Today this fertile land is a patchwork of more than a dozen small farms, community gardens, a native plant nursery, wildlife habitat, biking and hiking trails, and a community composting program that converts 11,000 tons of food, lawn and agricultural waste into nutrient-rich compost. Intervale's neighbors include an electric plant that turns wood chips into electricity, a fleet of six production greenhouses, a natural history museum, and a demonstration project that uses aquatic plants to purify wastewater. A few years down the road, Raap and others hope the Intervale will be home to an "eco-park" with businesses that support each other in a chain of interdependence – one's waste will be another's resource.

In 2001, Gardener's Supply acquired Dutch Gardens, a well-respected purveyor of bulbs and plants from Holland that has been in the mail order business for 50 years. Dutch Gardens is now based in Burlington, and more than 10,000 Dutch bulbs have enhanced the company's already impressive display gardens in the Intervale.

With its visionary leader, enthusiastic staff, and commitment to doing well by doing good, Gardener's Supply has earned the respect of gardeners far and wide. Says Raap, "We are in business to make a difference. Our company's mission statement is the same today as it was 20 years ago: to spread the joys and rewards of gardening, because gardening nourishes the body, elevates the spirit, builds community and makes the world a better place."

Lake Champlain Chocolates

Lake Champlain Chocolates started on a dare. Now the combination of fresh, pure ingredients and creative product design is putting the Pine Street factory on every chocolate-lover's map

1983 – Jim Lampman in front of the Ice House Restaurant. Photo by Ron Clark

Jim Lampman, owner of the popular Ice House Restaurant in the 1980s, had been buying expensive chocolates as presents for his staff. In 1983, his pastry chef finally broke the news to the boss: the chocolates didn't taste very good. Lampman challenged the chef to do better. The distinctively flavored, hand-rolled truffles that resulted were the best chocolates Lampman had ever tasted.

He began serving them to some of his restaurant's Sunday brunch guests. The response was so positive he founded an upscale chocolate company to keep up with the demand. Lake Champlain Chocolates has been on a hand-roll ever since.

Back then, the finest chocolates were produced abroad, by Perugina in Italy, Lindt in Switzerland and Godiva in Belgium. There were no premium chocolate makers in Vermont, and only a handful around the country. By the mid-1980s, LCC had taken its first steps toward putting Burlington, Vermont on every chocolate-lover's map.

The fledgling company set up a small factory in an alley off Pine Street. Its business plan was geared to wholesale manufacturing, supplying retailers in the New England region. But Lampman had always invited people to taste his chocolates, using the feedback they provided to keep improving the product. Others had sampled the original truffles at brunch or at an event catered by the Ice House. Hooked on the luscious confections, they wanted more.

Would-be retail customers found their way to the factory, interrupting business as usual. "They were knocking and scratching at the door, wanting to buy our chocolates," Jim Lampman remembers. LCC responded by opening the first of three company-owned retail stores in Vermont.

Lampman eventually sold his restaurant to devote his energies to chocolate. Though today some 75% of the company's sales are wholesale – they sell directly to more than a thousand stores around the country, and indirectly to thousands more – 20% of sales are retail. The remaining 5% come from mail order and web sales, a growing source of revenue. The privately-held company employs 90 people, presumably happy as kids in a candy store.

The fudge factor

Jim Lampman's introduction to the business of candy began at age 15 with a summer job on the Jersey shore, "I learned how to cook fudge, and how to manage people," he says, "and I also saw that the demand was there." Jim spent several summers beating vats of fudge, often stationed in a shop window where interested spectators would gather to watch. This theatrical approach works just as well today at LCC's Burlington store on the Church Street Marketplace, which attracts crowds of both tourists and locals whenever the fudge-maker is mixing up a batch of fudge in a copper kettle in the window. Hourly factory tours put visitors on a stage, from which they can watch as skilled staff craft a variety of chocolates by hand, and then enjoy free samples.

Without formal training in marketing, Lampman instinctively knew how important it was to differentiate the product. He never joined any of the national confectioners' organizations, preferring to do things his own way – sometimes with unexpected results. The genesis of the company's Five Star Bars in the late 1980s offers an example. The first one took two years to create – the company didn't own any automated equipment at the time. The result was worth it: a one-of-a-kind, complex combination of caramel, dark chocolate chunks and almonds wrapped in milk chocolate, which launched LCC into the gourmet chocolate bar market, and into its own chapter in a new book called "Candyfreak" (Algonquin Books; Spring 2004).

Sweet spot

LCC produces 1,300,000 pounds of chocolate each year. This figure is likely to increase as people learn the good news: health experts now believe that the antioxidants present in high-quality dark chocolate contribute to heart health and lower cholesterol. Health benefits aside, exceptional quality and taste have earned LCC a sweet assortment of honors and awards; even the artist-created seasonal keepsake gift boxes have received significant recognition.

Fresh, delicious, and fun for the whole family.

Hand-packing chocolate assortments.
Photo by Jeff Clarke

Under the direction of such long-time LCC team members as Dave Bolton, who (sometimes literally) dreams up new products, and Curt Erikson, Director of Operations, the company offers over 200 different chocolate varieties. They make the chocolate every day in small batches. For comparison, most other gourmet chocolate makers produce huge batches, for consumption months later. Chocolate is made to order here; because the ingredients are all natural and preservative-free, they can't make it in advance. A rabbi visits regularly, to ensure the chocolate is Kosher.

LCC ice cream, a staple originally served at the Ice House, is now on the menu at the cafes attached to the three company-owned Vermont stores: in Burlington, in Waterbury, and at the 24,000 square foot factory's present Pine Street location – not too far from the little alley which housed the company's start-up over twenty years ago.

"Pine Street has been great," says Lampman. "It is destination shopping for our customers. And our company is a wonderful place to work, because everyone is coming in for a good reason. They love chocolate!"

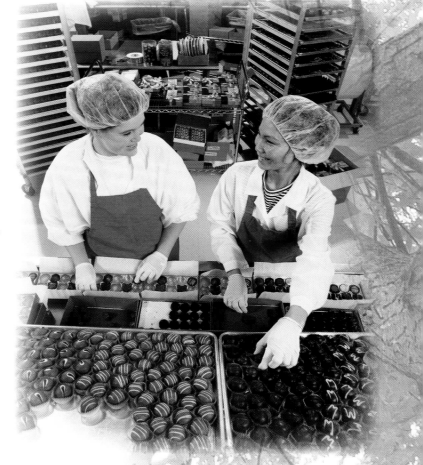

Heritage Flight

This private charter service has found its niche with a deceptively simple strategy: eliminate the barriers and create efficient air travel worldwide.

The airline industry may be tightening its collective seatbelt, but at Heritage Flight business is taking off. The reasons are varied, but convenience, comfort and cost-effectiveness are three important ones.

Ordinary air travel has come a long way from the glamour days of yore – mostly in the wrong direction. In an age of heightened security and diminished budgets, rules governing everything from the number of carry-on items to the number of centimeter fractions between your knees and the next guy's seat back have taken a lot of the fun out of getting there.

Imagine instead that you wake at a civilized hour, finish a leisurely breakfast and head for the airport with whatever gear you care to bring – laptop, or lapdog. Minutes later, you're welcomed aboard a pristine aircraft, arriving minutes before takeoff with no waiting or time-consuming security checks. Seated in a roomy leather recliner, you'll work, hold a meeting with colleagues on board, or simply relax as the plane speeds you efficiently to your destination.

Beginnings

The charter company that was to become Heritage Flight began in 1984 when Eugene Fodor, a retired regional airline pilot, approached three local investors with the idea of starting an air charter operation. Opening for business in August of the same year, Valley Air Services, Inc. served local and regional passenger and business customers. Adding a scheduled freight service, it became the first feeder service in Vermont for DHL World Wide Express.

In 1995, the company was now known as Valet Air Services. With the acquisition of a Beechcraft King Air it was able to enter the turboprop passenger charter market. The thriving company attracted the attention of the Button family. Principals Henry Button and his son Andrew purchased Valet Air in 1997, changing its name to Heritage Flight in 2000. Under the Button family's management, the company continued to flourish. Just two years later, Heritage Flight caught the eye of a veteran Vermont entrepreneur. A new chapter in its history was about to begin.

"This is your captain speaking"

All captains hold Airline Transport Pilot (ATP) certificates, the highest license possible for commercial operations. Several have chosen to work at Heritage after careers with major airlines. Pilots undergo stringent semi-annual training exceeding federal requirements through Flight Safety, the leading pilot training organization worldwide.

A total of 40 people currently work for Heritage. The current demand for private air charters coupled with growing market share is driving plans for future acquisition of both aircraft and personnel.

Who uses Heritage?

Approximately 65% of current customers are business or corporate-related. Companies use us to bring employees to meetings or other company locations. Sometimes we pick up additional employees/clients along the way. They meet and plan en route, conduct business at their destination, and recap on the return. We provide the excitement of creating time by eliminating travel barriers.

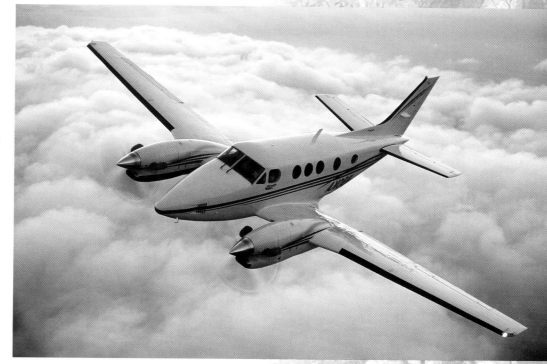

Flexibility is key. You literally create your own itinerary. Heritage flies into more than 5,300 airports, compared to about 500 for other airlines. Stops can be added en route to your destination, and passengers can even change the itinerary mid-flight. Aircraft and crew will be standing by for the return flight when you're ready. "What we really find helpful for customers is coordinating a difficult destination," says Abrams. For example, if you want to fly from Burlington to Toronto, it could take you most of the day. We'll have you there in an hour and twenty minutes – the same with Nantucket, or Portland." This convenience is much appreciated by both the business and the pleasure travelers, who make up the remaining 35% of the company's customer base.

"People who are conditioned to the limitations of commercial airlines are amazed at what we can do for them," says Abrams. "For example, a family wanted to know if we could get them to West Palm Beach. Well, sure. But in chatting with them, I found out they were actually trying to get to a condo complex which was just outside of Boca Raton. So why fly to West Palm? It turned out that they had always flown to West Palm – it was too complicated to fly directly to Boca–but simple for us!"

Keeping 'em running

Maintenance services are a major component of this operation, says Abrams. "Last year our FAA-certified repair station completed over 1,100 work orders covering both maintenance and avionics (the electrical systems, equipment, and other devices used on aircraft). We're the back-up provider for Burlington International Airport. If one of the major airlines has a problem, they'll call us to troubleshoot it."

"We work with Jet Blue – we get the last incoming plane ready for its flight out the next morning. We work closely on maintenance issues with Pratt-Whitney's jets, and help with their inspections. We work on corporate jets and private airplanes – single or duel engine – and on helicopters. We do a wide range of maintenance and avionics, and it's growing."

Currently Heritage is operating out of four separate hangars. Future plans call for consolidation of all the activities of the company under one roof, in a brand new, 40,000 sq. ft. facility. The company is currently considering several potential sites near the airport, including the possibility of expanding or rebuilding at their present location on Valley Road.

Office Environments

Office Environments Inc. has been helping Vermont businesses create offices that work for two decades. The Burlington-based company is the longest standing office furnishings dealer in the area, with staff that brings a unique level of local expertise blended with wide industry knowledge.

ffice Environments' creative and flexible approach enables it to meet the widest range of office needs, from a single chair for an employee with back problems to outfitting complete buildings. It's a company ready and able to provide optimal office solutions for any business, from retail, banking, insurance and medical to education and government.

Office Environments was founded in 1985 and is run by business partners Mark Kelley and Ron Citorik. Their goal from the start was to develop relationships with clients rather than to just sell furniture. That relationship begins when Citorik takes a look at a customer's needs; from the big picture of what will happen in the next five to ten years, down to the nitty-gritty details of optimizing work flow.

"We'll measure the number of inches of filing a person has and try to anticipate the amount of growth they might have. We look at the amount of surface space they might need," said Kelley.

It is a strategy that has worked effectively for the clients and company alike. It has enabled them to plan for the long term while adapting to changing office needs. Office Environments' staff of 20 based at the company's Williston headquarters includes a design staff as well as installation technicians and salespeople to help provide clients with a complete office furniture experience.

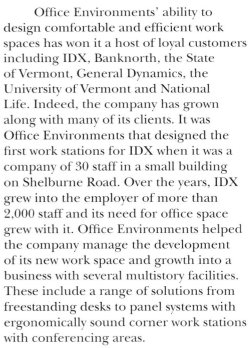

Office Environments' ability to design comfortable and efficient work spaces has won it a host of loyal customers including IDX, Banknorth, the State of Vermont, General Dynamics, the University of Vermont and National Life. Indeed, the company has grown along with many of its clients. It was Office Environments that designed the first work stations for IDX when it was a company of 30 staff in a small building on Shelburne Road. Over the years, IDX grew into the employer of more than 2,000 staff and its need for office space grew with it. Office Environments helped the company manage the development of its new work space and growth into a business with several multistory facilities. These include a range of solutions from freestanding desks to panel systems with ergonomically sound corner work stations with conferencing areas.

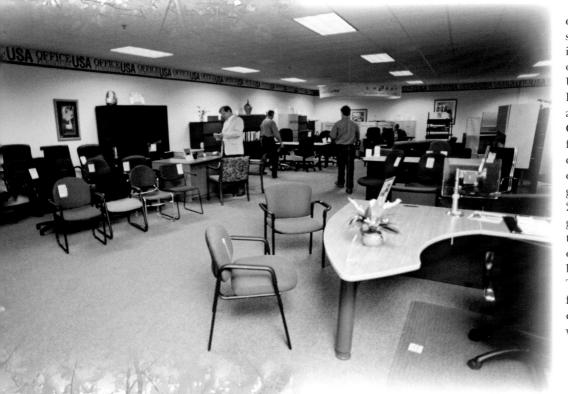

The change in clients' office needs is also a function of changing company styles, so Ron Citorik makes sure that Office Environments keeps pace with up-to-date solutions for modern requirements. For instance, the small "Dilbert" style cubicle systems of the 80s have given way to new and creative styles, bringing new challenges that Office Environments is well equipped to meet.

"The challenge now is how to create privacy and openness in the same space. Different companies and different departments have different requirements. Some people really want individual, private workstations. Others want a lot more openness," said Citorik. "It's our job to identify what their needs are and develop a strategy to meet that."

It's a job made easier by the company's breathtakingly wide range of products. Office Environments represents more than 200 manufacturers as well as being Haworth's Vermont dealership. Michigan-based Haworth is the second largest office furnishings manufacturer in the world and presents Office Environments' customers with a complete choice of office furnishings and systems from metal to wood. In 2003 Office Environments was chosen for the prestigious President's Circle. This represents the top 5% of Haworth's worldwide dealers.

In addition, making sure all those choices fit is made easier through working with Office Environments' design staff who will spend time with customers discussing how some of the specifics will work together. They can help advise businesses on a range of design elements from color coordination to fabric texture. By coordinating carpet, paint and upholsteries Office Environments offers a total design approach resulting in a professional finished product for their customers. The design department also brings blueprints to life with the company's computer aided design system which allows customers to see a 3-D visualization of how an office could potentially look with different furnishings and finishes from a variety of angles.

"It's all about details. That's what separates us from other people in the business, our ability to manage, coordinate and check all these details, that things come in on time and in the right fabric," said Kelley. "We're proud that we guarantee our work 100 percent. Our customers can call us about anything and we'll fix it."

A committed, hands-on approach, attention to detail as well as the big picture and comprehensive knowledge of the industry are the characteristics that keep Office Environments Inc. a leader in creating great offices for all types of business.

Huber + Suhner

Ubiquitous yet unique may seem an unusual combination but in Huber+Suhner's case it's a description that makes sense.

The company is in the communications industry, a business in which today's society is immersed, from families keeping in touch to businesses expanding global markets through the internet. Yet within the broad field of communications Huber+Suhner has carved out a niche for itself with a broad range of interconnect products using radio frequency and fiber optic technology. That cell phone call to let the boss know you're running late, the email you checked on your laptop while on the road, or the guidance system and radar on an aircraft you just safely landed in – these are the kind of communications that Huber+Suhner's products make possible. It is these products that have won the company an international reputation as a leader in the supply of innovative components and systems for telecommunications, military and industrial markets.

A company with deep roots and a modern vision.

While this focus on cutting edge technology may make the company appear to be the new kid on the corporate block, in fact Huber+Suhner may be considered one of the founding families in communications connectors. Its roots reach back into the 19th century when two Swiss companies started making components for industry, such as cable connectors and rubber molding. These were technological parts that were important for major clients like the Swiss army and the railways. In 1969 the two companies merged to make Huber+Suhner and since then the new corporation has grown to become a major supplier of radio frequency and optical fiber equipment to global markets. It continues to develop new markets for its high tech products while also expanding existing relationships with long established client companies, many of them being true Global customers.

The company has its global headquarters in Zurich but growth in North American markets prompted Huber+Suhner to establish a regional headquarters in Vermont in 1995. The company first acquired Colchester-based Champlain Cable and then developed a facility for its North American operations in Essex. Of the company's 2,466 employees, about 150 are based in Vermont, with 100 of those in a light manufacturing plant that services domestic customers.

While the two headquarters are literally an ocean apart, they have a great deal in common. Ian Shergold, President and General Manager of the company's North American Region, said Vermont had been chosen as an ideal location for the company's North American headquarters because of its culture, climate and topography.

"It was the proximity to component suppliers for our products which were in the New England area, the setting here – the mountains and lakes similar to those in Switzerland - along with help from the state when the North American company was formed that encouraged our people to come here," he said.

At the same time, the company's high standards remain a constant on both sides of the Atlantic. Huber+Suhner prides itself that high quality is a hallmark of its products. The company is one of a small number in Vermont who are certified to the ISO14000 Environmental standard, which recognizes the controls and minimal impact the operation has on the environment in terms of waste and pollutants.

"We sell at the top end of the market in terms of technical performance and quality. Our products are selected by customers who require the leading edge for technical capability and the highest reliability." said Shergold.

While its markets are global, the company has become an active and much appreciated member of the local community. Tours and visits of the Essex headquarters by school children and college students are encouraged. The company employs interns each summer and aims to attract local graduates. The company also approaches hiring with an eye to diversity, helping to train a broad range of employees, both new and established.

In addition, each year Huber+Suhner plays host to a variety of functions to support area non-profits and to reach out to its neighbors including cookouts and fundraisers such as car washes and company yard sales for the United Way.

While all this makes the company highly respected among its neighbors, probably the thing that makes it most valued is that it operates in a market that continues to grow. Globalization trends have spurred quests for uninterrupted communication across wider fields. At the same time, there are increasing demands for the kind of improvements that communications technology can bring to infrastructure such as transportation, safety and security systems. It is such markets that Huber+Suhner continues to supply and develop products for, while remaining true to its mission for 'Excellence in Connectivity Solutions'.

PKC

Problem-Knowledge Coupler Corporation is changing the way medicine is practiced and experienced. Will doctors be ready?

Physicians cope with an ever-growing mountain of information that strains the limits of human memory. Often the result is a delayed or incorrect diagnosis, needless suffering, and wasted time and money. But thanks to PKC, now there's cure. Tucked away behind the sturdy walls of a former textile mill, the company is building an information-age loom, designed to weave this raw data into the fabric of medical care.

Problem-Knowledge Coupler Corporation is a clinical software company, one of only a handful in the world. Its proprietary software collects health information from patients into a database, matches it against the vast universe of current medical knowledge, and suggests a broad but individualized array of possible actions for both doctor and patient. It "couples" the medical "problem" to the literature, or "knowledge," hence the company's name.

The company was founded in 1982 by programmer Richard Hertzberg, Chris Weed, and Lawrence L. Weed, MD. Larry Weed, for decades viewed by many as one of the most provocative thinkers in the field of decision support, invented the Problem-Knowledge concept. The next eight years were spent in research and development." CEO Howard Pierce came on board in 1990, when the company, having proved the concept, turned its attention to building the company's infrastructure: raising money, hiring staff, and designing a market-ready product.

Putting couplers to work

Problem Knowledge Couplers are software "tools" which provide decision and management support to clinicians and patients. Coupler software presents a detailed series of questions to the user. Based on the responses, the doctor and patient receive informed guidance in three areas: assessing risk factors and positive factors for a well patient; diagnosing a specific problem; and managing a diagnosed condition. The company has produced over one hundred couplers, covering topics from depression to general health, and more are in the works.

PKC corporate headquarters in Burlington Vermont. Photo by Rose McNulty

Music, math… and medicine?

About seventy-five people work for PKC, most of them in the company's Burlington headquarters. Some are software engineers, physicians, or client support people. But most of the employees are medical content librarians. Their assignment: to read the medical literature objectively. This bias-free research provides the content of PKC's products. Howard Pierce says it's surprisingly hard to find people to perform this task to the company's standards. "A key thing we look for are people who've been trained in library science and research techniques. We also look for mathematical and musical abilities, because people with those kinds of minds are particularly precise in the way they interpret things."

The doctor is out

Although Larry Weed's latest brainchild has been generally well received, some find the data-driven approach to medical practice perplexing, if not threatening. Coupler software challenges the paradigm of the patient surrendering control to the all-knowing doctor. "We knew it would take some time to get people to say, well, OK, I'm going to share some of this process with a machine that's been pre-loaded with a lot of information, so that I can make decisions more rationally," says Pierce. "Our system isn't trying to take the decision away from anybody. We're just trying to sort though all of that knowledge, and figure out the right amount to put in front of the doctor and the patient. So that they – particularly the patient – can make the right decision."

In fifty years, society may look back and wonder how people got along without these valuable tools. But for the Department of Defense, PKC's largest customer, the future has already arrived.

Leahy and the DoD

Since 1996, PKC has developed a number of custom modules – covering health risk assessment, deployment monitoring, and healthcare delivery – for the U.S. Department of Defense military health system. This successful collaboration is handled by PKC's Washington, D.C. area facility in Falls Church, Virginia. Pierce recalls how a small Vermont company was able to get the attention of a huge governmental entity.

"In 1996, I went to Washington, with no experience in the medical world. No experience in the federal business world, and certainly no experience with the DoD. My first stop, because I didn't know where else to go, was Senator Patrick Leahy's office." Pierce met with a couple of his staff people, explaining what PKC did, and their interest in exploring whether it would be useful to the Department of Defense.

Over the next year, Leahy's staff worked with Pierce on strategies for going after federal contracts. Without that help, he says, the company wouldn't have got nearly as far as it has. "It's one of the advantages of being from a small state. You can actually go see your representatives and get their attention and help." In fact, one of those staffers, Bill Delaney, now runs PKC's Falls Church office.

Prognosis favorable

With the web-based availability of problem-knowledge couplers, PKC has evolved from a company that was focused on the medical side to a company that is focused on the consumer side. "We actually think there's only one side," says Pierce. "There's a person with a medical problem that needs to be fixed and a team or a system to fix that person's problem. But the person that drives the system, the person who makes the decisions, the most important person is the patient. The web lets us start there."

PKC's mission is audacious: to change the way the medicine is taught, practiced and experienced. Fueled by Larry Weed's maverick genius, savvy management and a stable of peculiarly gifted and dedicated people, the company has a healthy chance of doing just that.

A sculpture from the PKC art galley which features Vermont artist.

A coupler in action

Let's say you have a headache. Nothing's helped, and now you're seeking relief at your doctor's office. Before you see the doctor, you'll complete the headache coupler in front of the computer (not so much fun with that headache, but you know itís for a good cause). You'll answer a lot of questions that help to precisely define a very general symptom: (does your vision or speech change before the headaches come? Does your eyelid droop when the headache hits.

Once the questionnaire is completed, the doctor clicks on 'review options.' The computer goes into its vast database of medical knowledge, compiled by PKC Corp librarians and updated every six months on CDs or over the Internet, and matches up the patient's answers with all the known symptoms for various causes of headaches. The coupler may also warn the doctor to check for other life-threatening conditions that, because at least one sign is present, need further investigation before they can be ruled out. The doctor can click on each condition to learn more about it or get references to medical journals in which the condition is described.

Adapted from What Your Doctor Doesn't Know could Kill You, Boston Globe Magazine, July 14, 2002

Inn at Essex

In 2004 the Inn at Essex took a well-calculated risk. Though already popular for business travelers and conferences in northern Vermont, the Inn's managers saw several reasons to shift priorities to fully embrace leisure visitors too.

he clincher was not the 18-hole golf course, six har-tru tennis courts, in-room spa services, outdoor pool and nearby theater and designer-outlet shopping. Nor was it the fully-enclosed atrium and extensive gardens attracting up to 100 weddings annually.

It was one thing so much a part of the Inn at Essex since 1989 that it was hard to see the irresistible attraction it is. Like a delicious dessert on the plate right in front of them, managers finally realized that being home to the northernmost campus of the New England Culinary Institute (NECI) not only meant gourmet fare on the tables of the Inn at Essex's restaurants, but also culinary vacations.

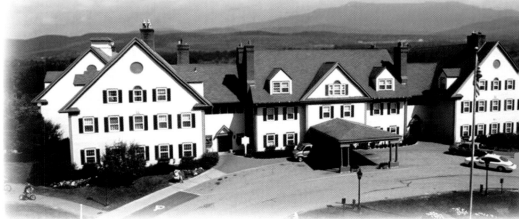

Today the Inn at Essex *is* "Vermont's Culinary Resort." Vacationers may watch students and Chef Instructors perfect tiramisu in the state-of-the-art Dacor demonstration kitchen, participate in tastings, watch ice sculpting or attend the likes of Baking II – culinary equivalent of sitting in on Harvard Law School class! The Inn offers overnight packages with cooking classes and private custom dining.

Whether it's light fare in the Tavern or dinner of pan-roasted quail, red onion and maple tarte tatin in the formal Butler's Restaurant; every sandwich, pastry and cup of coffee is prepared as if it were a final exam.

"Everything is made from scratch," emphasizes Inn General Manager Jim Glanville. "From sauces to sausages, it makes Inn at Essex cuisine noticeably different."

Need it be mentioned that the fitness center is fully stocked? Or an after-dinner stroll in the garden stretches muscles and imagination. Here "Phlox of Sheep" flourish with woolly thyme. Redbor kale nods alongside tufts of millet. The several gardens' raison d'etre is to please eye and palette. Chefs harvest the potagers for ingredients.

After a full day, guests witness the Inn's distinctive touch once more in room decor. Says Glanville, "120 rooms and no two are alike."

What's more, the Inn is at the forefront of a new national trend – Color. Vermont interior designer Susan Sargent, who sells well on Boston's Newbury Street, gave this Inn a makeover that rivals Vermont's famous foliage. Expect traditional style/bright colors – a chaise in raspberry with periwinkle pillows perhaps. Anticipate rugs cut from vociferous patterns of geometry, feathers or dogs. Bathrooms and accessories coordinate. As an added bonus, the Inn periodically holds Bright House Color Workshops.

It turned out to be prophecy about decor as well as cuisine when Gourmet magazine wrote, "A brief stay is as good a way as any, perhaps better than most, to get a taste of what is cooking in America."

RD is a major innovator in helping developing and transition countries promote good governance and effective institutions that are essential to achieving equitable economic growth, social development, human rights, and security. ARD's current Rwanda Parliament Support Project team, pictured here, focuses on legislative capacity building and improved citizen involvement in the legislative process.

ARD emphasizes the integration of business, education, government, and community groups and individuals in problem definition, needs assessment, and strategy development for constructive change. In the photo on the right, a Sri Lankan facilitator conducts a village-level planning workshop in the Minneriya National Park buffer zone for ARD's five-year Protected Area Management and Wildlife Conservation Project.

Providing for Basic Needs

ARD's infrastructure solutions integrate traditional physical systems into the environmental, social, institutional, and economic realities of countries and communities. With expertise in water supply, sanitation, roads, and energy, ARD focuses on helping our clients support the needs of rural communities and peri-urban settlements within the context of available resources, environmental impacts, and

community interests. In Indonesia, ARD completed a Community Water Services and Health project to help low-income people in rural and peri-urban communities improve their quality of life and health status through better hygiene and water-related family health practices, supported by improved access to clean water and sanitation.

Sustainable Solutions

ARD addresses the important balance between development and the environment. In Rila National Park, one of Bulgaria's most important biodiversity centers and the site of the Rila Monastery, ARD was instrumental in guiding the content and negotiations between the Government of Bulgaria and the Bulgarian Orthodox Church to develop the nation's first park management plan. The land covers over 60,000 acres of wild and rugged forested territory and is a World Heritage Site.

ARD's multidisciplinary teams provide integrated solutions from five technical sectors for clients such as the US Agency for International

Development or the Inter-American Development Bank (IDB). For the IDB's Administration and Supervision of Agricultural Technology Transfer and Generation project in Honduras, ARD utilized multiple talents in our Agriculture, Information Technology, and Institutional Development sectors to support the privatization of agricultural extension, technological, and research services. ARD experts worked with the national and local governments, small- to medium-sized landholders, and farmer organizations.

Fletcher Allen Health Care

With a mission that links research, education and patient care, Fletcher Allen is committed to helping improve our region's quality of life with innovations in medicine and health care that arise from new knowledge and discovery.

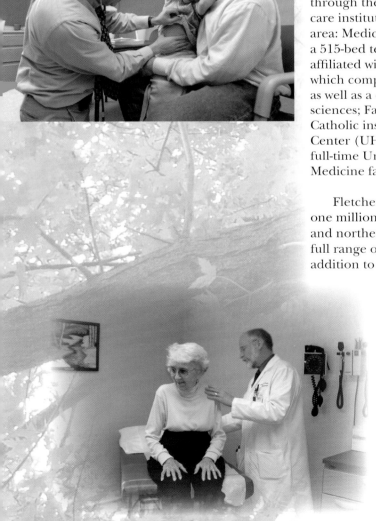

letcher Allen Health Care enjoys a unique position in Vermont because it is both a community hospital serving Chittenden and Grand Isle counties, as well as an academic health center serving Vermont and northern New York.

In alliance with the University of Vermont College of Medicine, Fletcher Allen Health Care is one of 126 academic health centers in the nation. As an academic health center, Fletcher Allen has the special responsibility of educating the next generation of health care providers and researching tomorrow's cures. Physicians, nurses and other health care professionals in training at Fletcher Allen have access to the latest therapies, treatments and techniques, and are taught by some of the world's leading experts. Nearly 40% of the physicians in Vermont graduated from the University of Vermont College of Medicine and/or trained at Fletcher Allen.

The University of Vermont College of Nursing and Health Sciences also partners with Fletcher Allen, educating students in health care fields including nursing, physical therapy, nuclear medicine technology and radiation therapy, and researching a wide range of health care issues.

In addition to its blend of academic and community medicine, Fletcher Allen has a rich history with strong ties to the past. Fletcher Allen was formed in 1995 through the integration of three health care institutions in the greater Burlington area: Medical Center Hospital of Vermont, a 515-bed teaching, tertiary care hospital affiliated with The University of Vermont, which comprises a college of medicine as well as a college of nursing and health sciences; Fanny Allen Hospital, a 100-bed Catholic institution; and University Health Center (UHC), the 10 practice groups of full-time University of Vermont College of Medicine faculty.

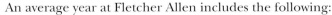

Fletcher Allen serves a population of one million people throughout Vermont and northern New York, providing a full range of advanced specialty services in both inpatient and outpatient settings. In addition to serving as the primary referral center in Vermont, Fletcher Allen is the community hospital for the approximately 150,000 residents of Chittenden County and provides primary care services at nine sites. The health center extends beyond its three main campuses to include more than 40 patient care sites and 100 outreach clinics, programs, and services throughout the region.

An average year at Fletcher Allen includes the following:

- 22,500 inpatient admissions
- 69,000 Emergency Department and Walk-In Care Center visits
- 925,000 professional visits
- 2,150 births
- 700 heart and valve surgeries
- 12,000 outpatient surgeries
- 7,000 inpatient surgeries

Specialized Services

Among Fletcher Allen's standout specialized services are the following:

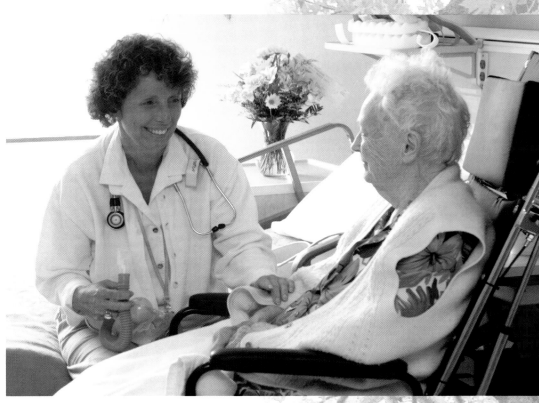

- The only certified Level I Trauma Center in Vermont, Fletcher Allen also serves trauma patients throughout the northern New York region.
- The Vermont Children's Hospital at Fletcher Allen, a full-service hospital within a hospital, provides family-centered care to children throughout the region; Vermont Children's Hospital includes a Level III Neonatal Intensive Care Unit, caring for critically ill and premature infants.
- The Vermont Cancer Center at the University of Vermont/Fletcher Allen is one of 39 National Cancer Institute-designated comprehensive cancer centers in the nation; the Vermont Cancer Center coordinates multidisciplinary approaches to cancer research, prevention, patient care, and community education.
- Fletcher Allen's Breast Care Center offers patients all the necessary services and experts in one location and is the model for care delivery in the new Ambulatory Care Center.
- Since the 1950s, Fletcher Allen's cardiovascular services have provided an extensive range of heart care specialties, including more than 15,000 open-heart surgeries, and offer unrivaled experience in the region. Our cardiologists and cardiothoracic surgeons are committed to not only treating individual patients but also to advancing knowledge and innovation in their fields.

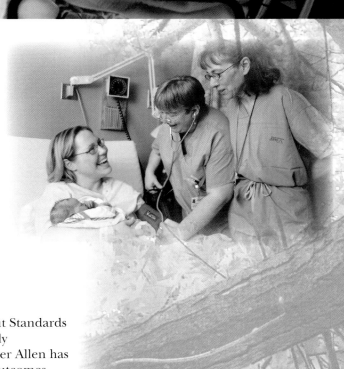

Other specialized services include the Telemedicine Program, which links tertiary care expertise to 10 community hospitals in Vermont and New York; and the General Clinical Research Center at Fletcher Allen/University of Vermont, where researchers pioneer treatments for heart disease, cancer, Parkinson's disease, diabetes, ALS, and many others.

Community Focus

In 1995, Fletcher Allen's Board of Trustees adopted Community Benefit Standards designed to improve health status, address the health problems of medically underserved populations, and contain health care costs. Since then, Fletcher Allen has partnered with many community-based organizations to improve clinical outcomes. Each year, Fletcher Allen provides millions of dollars in charity care, with funds also going towards community education, outreach, health screenings, and medical education.

Fletcher Allen recently relocated the majority of its outpatient specialty clinics to a new state-of-the-art Ambulatory Care Center on the Medical Center Campus. The ACC includes a Patient Access Center, which serves as the central, user-friendly entry point to the Medical Center Campus; outpatient specialty care centers, which bring a wide range of services and experts to the patient in one area of the medical center; a new surgery center, with eight new operating suites; a new central clinical laboratory; and an Education Center, a joint Fletcher Allen/University of Vermont facility that serves as a resource for health care professionals and students and meets the increased demand of patients, families and the public who wish to research health care issues and treatment options.

Fox 44 TV

This young station's viewership has almost doubled since 1997, thanks to smart programming, innovation, and just plain hard work.

The station; looks out on panoramic views and a very bright future.

O n August 31, 1997, Fox 44-TV signed on with Fox's first regular-season National Football League game. This broadcast marked the arrival of the fourth major broadcasting network affiliate serving the Burlington and Plattsburgh area.

Fox 44 was then based in quarters it shared with WPTZ, the local NBC affiliate, who was managing and operating the new start-up station. Just one year later, Smith Broadcasting Group assumed the day to day operations of the station. Fox 44 was off and running.

Smith Broadcasting Group owns and operates television stations in New York, California, Vermont and Alaska. All of their stations are network affiliates. Most are leaders in their respective markets. Under SBG's direction, Fox 44 has seen dramatic growth.

New state of the art broadcast facility in Colchester.

Growth spurt

"When I arrived at the station in 1998 there was a staff of just four," remembers General Manager Bill Sally. "We quickly ramped up, tripling the staff and eventually growing to 24 employees." The staff isn't all that has grown. During its first seven years, FOX 44 has nearly doubled its viewership. Today it reaches well over 100,000 homes a week, making it the fastest growing station in the market. These figures don't include the station's vast international audience, and access to 2.5-million Canadian homes.

Significant numbers of people are tuning in to FOX 44 because of its compelling programming. The station offers diverse content ranging from court shows in the morning, to talk shows in the afternoon, successful off-network sitcoms in early evening, and shows like the wildly popular American Idol and the intense drama of 24 at night.

Public Service

As Fox 44 has grown, so has its involvement in activities that benefit the community. Most are either educational or informational. One daily program uses 30- and 60-second segments with tips on understanding and preventing breast cancer provided by area medical experts. Another program raises awareness about heart disease and stroke in a Q & A format.

But the station takes the most pride in its own Kid's News. "This original program introduces a team of young kids to an exciting career in television," explains Sally. "We audition local students between the ages of ten and fourteen and teach them to become reporters, while providing them a forum for engaging their peers on topical issues and teenage community concerns," he explains.

Master control; the hub of the station's technical operations.

News at 10?

The next step will be to produce a local newscast. "We will be the first station in the market to offer an evening news program at 10 p.m.," says Bill Sally. "The time would certainly give us a competitive edge since we'd become the first station to offer a local, primetime newscast. The other two news-producing stations in this market do a very fine job of meeting the needs of the local viewers. Our philosophy is to offer our viewers and the community something they can't find elsewhere."

The 256-room hotel is located just blocks from Burlington's vibrant entertainment and shopping district and is just 10 minutes from Burlington International Airport via the hotel's courtesy shuttle and easily accessible by car from Interstate 89.

Significant changes occurred at the Burlington landmark hotel in late 2003 as Wyndham International took over ownership of the facility. Following months of renovation to guest rooms, public meeting rooms and conference facilities, the former Radisson officially joined the Wyndham family on January 1, 2004. Wyndham International is the fastest-growing upscale brand and fourth largest hospitality and lodging company in the United States.

Herman Miller ergonomic chairs, pillow-top mattresses and luxurious pillows, Airstream showerheads and other improvements are among the latest features, all designed to enhance the Wyndham Hotel and Resort experience. The Wyndham Burlington also includes an exercise facility complete with heated indoor pool and Jacuzzi. Business travelers and guests have access to the fully equipped business center's computer, color printer, copier and Internet access. Guests can dine in the Oak Street Caf Lobby Bar across from the gift shop.

Everyone can join "Wyndham by Request," a signature guest recognition program designed to customize each stay to a guest's individual needs and preferences at no additional cost. Another signature Wyndham service, "Women On Their Way," is a program designed by women, for women, to enrich how women business travelers spend their time on the road. "It includes attention to every imaginable detail, from healthier room service items right down to the toiletries inspired by the Golden Door Bath Care Collection," explained Joseph Carton, Wyndham's longtime general manager.

The Wyndham Burlington hosts numerous meetings, conferences and conventions throughout the year from large national meetings to smaller local business events, conferences or dinners.

The Wyndham Burlington is perfectly located near many attractions. It's just a short walk to stroll along the lakeside boardwalk, tour the new ECHO Center for Lake Champlain, take a sailing lesson or experience a music festival. Head up the hill for shopping on the charming pedestrian Church Street Marketplace featuring sidewalk cafes, local boutiques and nationally known clothing stores and retail shops. World-class golf, skiing, hiking and tourist attractions are all within an hour's drive.

The Wyndham's experienced staff is always on hand to make every visitor's stay everything they desire.

Wyndham Burlington Hotel

The Wyndham Burlington Hotel offers visitors a commanding view of Lake Champlain, the Burlington Waterfront and the Adirondacks. As the city's largest full-service hotel, the overlook setting provides the perfect base for business and leisure travelers to enjoy the multitude of regional attractions.

Lark-Inn Hotels

Standing sentinel at Burlington's eastern gateway, the University Inn & Suites welcomes travelers for a night, or the rest of their lives.

From the lobby, themed in gentle rose and green and warmed by a fireplace, to the generous dimensions and amenities of the suites, John Larkin's hand is everywhere apparent. Larkin, a major Burlington developer, is the founder and CEO of the hotel's Vermont-based parent company, Lark-Inn. Under his direction, the Inn and Suites were designed with a Vermont flavor – warm maple accents and a gracious simplicity.

His concept was to offer more living space than standard hotel or motel rooms do, along with a cornucopia of domestic comforts. All suite rooms come with a microwave oven and refrigerator. Extended-stay suite kitchens are lavishly equipped with everything from a full-size refrigerator to a dishwasher. Every suite also boasts a large, cable-equipped TV, a comfortable couch to watch it from, a desk, a two-line phone and data port, high-speed Internet access and most other essentials of modern life. Guests retire to king- or queen-sized beds, depending on the suite. In the morning, it's a short 'commute' to the business center, located just off the lobby.

University Inn and Suites opened for business in August 2000. It quickly became the accommodation of choice for savvy business people, relocating families and anyone looking for a haven away from home.

Something for everyone

The site design includes the four-story Suites building with an elevator, and just across a courtyard, the two-story Inn. The taller structure houses the lobby, with complimentary gourmet coffee, tea and hot chocolate available at any hour, and continental breakfast served daily. Travelers planning a longer stay, or business people needing a temporary base of operations in the Burlington area prefer accommodations here.

The Inn offers a more comfortable edition of the standard motel room, tastefully furnished and well-equipped, with non-smoking rooms optional. The fitness center, large heated indoor pool, sauna and whirlpool are all conveniently located in the Inn building. There is an outdoor pool, as well, for the warmer months.

Location, location, location

Although it's at the intersection of three bustling thoroughfares, University Inn and Suites is unexpectedly quiet because it's tucked back from the road. There is no restaurant on the premises, but a Friendly's is just a few steps away.

This award-winning hotel is located two miles from the airport, next door to Vermont's largest mall and near everything Burlington is known for: the vibrant downtown and waterfront, the Flynn Center for the Performing Arts, The University of Vermont, Champlain College, the medical center, the new ECHO Science Center, galleries, shopping and restaurants. With I-89 just around the corner, it's a short hop to a myriad of area attractions, from Ben & Jerry's factory to the world-famous Shelburne Museum, the ski trails of Stowe to the cosmopolitan boulevards of Montreal.

The most important person

Creature comforts abound here, but comfort alone doesn't fully account for the number of guests who return again and again. Perhaps the most important reason for the repeat business is the attentiveness of the staff. Returning guests are likely to be greeted by name. If a guest lacks something, the staff does their best to supply it. Dogs and cats are invited to stay in designated rooms with their owners at no extra charge...because they're part of the family.

By putting the well-being of each guest foremost, University Inns and Suites presents hospitality in the finest Vermont tradition. Added to all the facility's appointments and amenities, it's a winning combination.

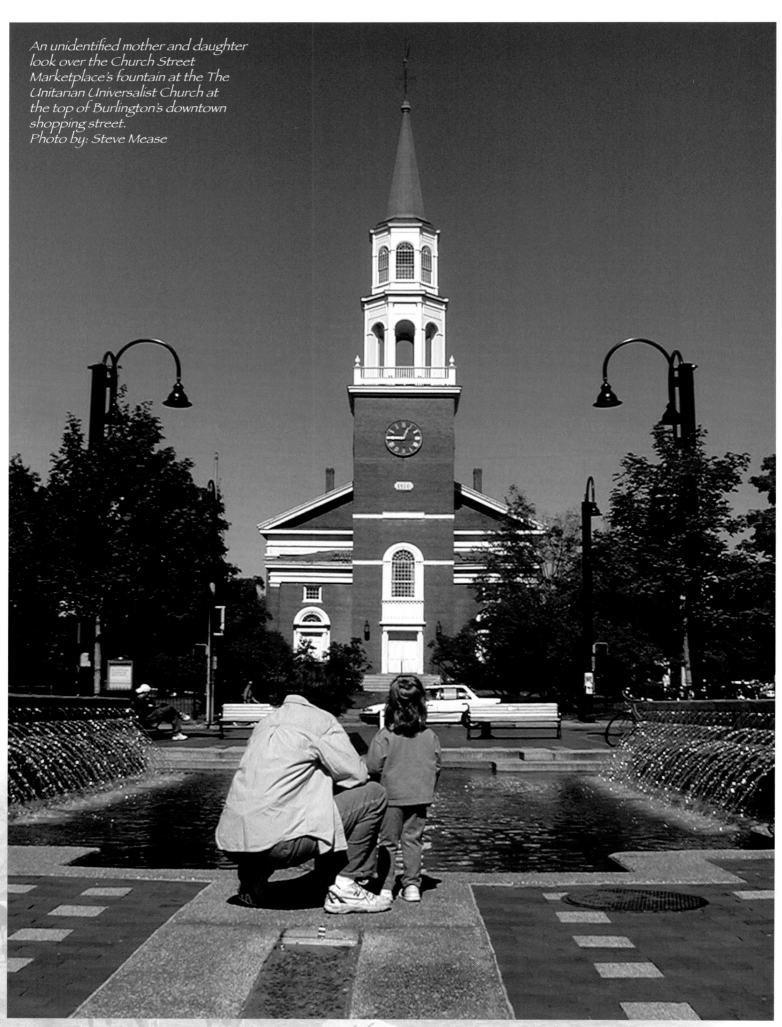

An unidentified mother and daughter look over the Church Street Marketplace's fountain at the The Unitarian Universalist Church at the top of Burlington's downtown shopping street.
Photo by: Steve Mease

Paul Boisvert

Photographer Paul O. Boisvert grew up on Lake Champlain, it was and still is the subject of his most intense photography. He now travels far and wide to take his acclaimed photographs for such publications as The New York Times, Vermont Magazine, Vermont Life Magazine, Yankee Magazine, and many others. But Lake Champlain always draws him back to its shores.

Jeb Wallace-Brodeur

A native Vermonter, Jeb Wallace-Brodeur grew up in Montpelier, graduated from Middlebury College and now lives in Montpelier with his wife and son. He is the Chief Photographer for the Barre-Montpelier Times Argus, Design and Photo Editor for the Vermont Sunday Magazine, and a Staff Photographer for Seven Days. His photos have appeared in Time Magazine, The New York Times, The Washington Post, The Boston Globe, The Village Voice, Ski Magazine, Skiing Magazine, Vermont Life, Vermont Magazine, Audubon Magazine, Yankee Magazine, Ski Press and in the America 24/7 book project. He was design and photo editor for the books: "A Vermont Century" and "Howard Dean: The Man Who Would Be President".

Cheryl Dorschner

Cheryl Dorschner's newspaper and magazine articles are often accompanied by her own photographs. She has published nationally and exhibited her photographs. Dorschner is currently senior communications specialist at the University of Vermont.

Andy Duback

Andy Duback resides in Hinesburg, Vermont. His commercial and personal works include photography for business and editorial purposes, and special occasions. His photographs have been published and exhibited regionally and nationally, specializing in portrait, photojournalistic and product photography for weddings, advertising, and other corporate needs. His workflow brings him on location and draws from the newest technologies, offering a complete digital workflow. Andy is also an educator, both in the photographic and outdoor arenas, having taught high school and middle school photography. He recently developed an outdoor photography program, whereby students were introduced to both backcountry travel and digital photography, culminating with an intensive workshop in computer graphics.

Sandy Macy

Sandy has been photographing a professional since 1978 when he worked for United Press International. In 1986 he started work at the Times Argus in Barre, Vermont as a staff photographer until 2001. Presently he is a freelance photographer and a professional ski patrol working Sugarbush Ski Area. In addition, he photographs for the Associated Press, Vermont Life Magazine Vermont Magazine, New York Times, Farm & Ranch Living Magazine, the state of Vermont, and a number of commercial clients.

Adam Riesner

Adam Riesner is Director of Medical Photography and Digital Imaging at the College of Medicine at the University of Vermont in Burlington. Before working at UVM he was an award winning photographer for the Burlington Free Press for nearly 15 years. Adam lives in Shelburne with his wife and 5 children.

Natalie Stultz

Natalie Stultz has 20 years of experience as a free lance commercial and editorial photographer. As a Vermont native, Natalie's work reflects great appreciation for the natural beauty of the state's landscape and people. Although she shoots for a diverse clientele, and in a variety of locations around the world, all of Natalie's photographs share the strong sense of people and place that is intuitive to her as a Vermonter. Natalie's photographs appear regularly in many Vermont and national magazines, as well as catalogs and brochures. To view more of her work visit www.nataliestultz.com

Tom Way

Tom Way was born in Burlington, Vermont in 1951 and spent his childhood summers and weekends on North Hero Island, Lake Champlain. He completed two years in the United States Army with his major tour of duty in Italy, where he purchased his first 35mm camera. Tom attended Lyndon State College, graduating with BS Degrees in Behavioral and Social Science with a minor in Photography. After school he volunteered for the Peace Corps working on community development projects in Honduras, Central America. He has been a Communications Photographer for IBM for twenty-three years, specializing in semiconductor macro photography. This work has been widely published in the media. In 1989 Tom bought a large format field camera and started producing archival black and white art prints of Vermont and other regions. He works in all camera formats including digital and continues to produce and sell art and stock photography which can be seen on the web at (tomwayphotography.com).

Jim Westphalen

Jim Westphalen has been a commercial and fine-art photographer for more than twenty years. His work has been published widely in advertisements, magazines, and calendars nationally and abroad and can be seen in numerous galleries throughout the state of Vermont.

Motivated by the natural beauty and mystique of New England, Jim moved in 1996 from his home in Long Island, N.Y., to Vermont, where he now runs a successful studio. Though he spends much of his time on commercial assignments, his first love and inspiration is photographing the timeless Vermont landscape. See more of Jim's photography in his latest book Vermont Impressions.

Index of Profiles

ARD, Inc. ... 215

Banknorth ... 158

Burlington Electric .. 170

Burlington International Airport.. 174

Burton Snowboards ... 192

Champlain College .. 166

Champlain Valley Cardiovascular Assoc. .. 200

Champlain Water District.. 190

Dinse, Knapp & McAndrew .. 172

Fletcher Allen Health Care ... 216

Fox 44-TV ... 218

Gardener's Supply.. 202

Gravel and Shea .. 180

Green Mountain Coffee Roasters ... 198

Heritage Flight... 206

Huber + Suhner ... 210

The Inn at Essex.. 214

Lake Champlain Chocolates .. 204

Lake Champlain Transportation .. 160

Lang Real Estate.. 196

Lark Inn Hotels.. 220

Main Street Landing.. 197

Merchants Bank ... 162

New England Air Systems ... 188

Office Environments, Inc. ... 208

Overhead Door Co. of Burlington .. 176

PKC ... 212

Pomerleau Real Estate... 177

Vermont Catholic Charities... 164

Rossignol ... 194

Sheraton Burlington... 186

St. Michael's College... 168

United Way .. 175

University Mall .. 195

University of Vermont.. 156

Vermont Business Magazine.. 187

Vermont Rail System ... 182

WCAX-TV ... 178

Wiemann & Laphere ... 185

WJOY... 184

The Wyndham Burlington ... 219